A MOUNTAINEER'S LIFE ALLEN STECK

FOREWORD BY STEVE ROPER

patagonia®

A Mountaineer's Life

At Patagonia, we publish a collection of books that reflect our pursuits and our values—books on wilderness, outdoor sports, innovation, and a commitment to environmental activism.

First edition
Printed in Canada on 100 percent postconsumer recycled paper

Editors – Michael Kennedy, John Dutton
Book Designer – Monkey C Media
Photo Editor – Jane Sievert
Creative Advisor – Jennifer Ridgeway
Creative Director – Bill Boland
Project Manager – Jennifer Patrick
Production – Rafael Dunn and Michaela Purcilly

Front cover: The Hummingbird Ridge; Back flap: Andy Selters
End sheets: Artwork by Samivel

Hardcover ISBN 978-1-938340-70-3
E-Book ISBN 978-1-938340-71-0
Library of Congress Control Number 2017909202

DEDICATION

To my daughter, Sara, son Lee and their families; and especially to Sara's son, Michael Allen Steck White, who now will have a better understanding of his grandfather. To Ardie Jenkins, my partner in life for more than thirty years. To my nephews Stanley Steck and Michael Steck and my niece, Ricia.

"Mountaineering is not always thought of as a sport: it seems an arguable point. However that may be, it differs from other sports in that there is in principle no contest for glory among men, only between man and the forces of nature, or man and his own weakness. With a few rare exceptions the climber has no renown to hope for, and no audience to encourage him apart from his companion on the rope. Alone among the silence and solitude of the mountains he fights for the joy of overcoming his chosen obstacle by his own unaided powers. In its simple, original form no other sport is so disinterested, so removed from human considerations, and it is precisely in this kind of purity that much of its grandeur and attraction lie."

—Lionel Terray, *Conquistadors of the Useless*

CONTENTS

FOREWORD

Twenty-five years ago I wrote that Allen Steck was "laboring on his autobiography, having reached 1942 recently." This was not entirely accurate, since instead of following a strict time line he preferred to concentrate on telling his story, when the mood struck, about disparate episodes of his marvelously varied life. "I don't want this to be a year-to-year diary of my so-called exploits," he told me. "I've read far too many of those." The result of his long journey hunched over a typewriter and various word processors is now for us to savor.

Although I shared a rope with Allen many a time during the past fifty-five years, these memories fade. After all, we generally did routine ascents and had few problems, thanks to our expertise and generally benign environments. One example: in 1977 we climbed the north face of the Grand Teton in one day from the valley floor and were back in the lowlands before the sun had set. Just another fine day on the cliffs.

On the other hand, I vividly recall images that took place far from the "brotherhood of the rope." What first comes to my mind are the hundreds of lunches at Allen's Berkeley home, nestled on a cul-de-sac in the East Bay Hills. Many of these affairs were work related, as Allen mentions in this book. For dozens of years we collaborated on producing *Ascent*, the Sierra Club's mountaineering journal. Before lunch we would spend a few hours on editing chores, but then, as Allen fixed delicious roast beef sandwiches or deep-fried calamari rings, our conversation would revert to topics such as Vietnam, Watergate, space exploration, or a currency crisis in some far-off land he had just visited.

Allen and his wife loved entertaining and often invited noted climbers to lunch or dinner. A partial list from memory includes Lionel Terray, Barry Bishop, Ax Nelson, Galen Rowell, Raffi Bedayan, John Cleare, Willi Unsoeld, and David Roberts. The table talk with these gentlemen (not many female climbers back in the day) ranged widely, but most of it was about facets of climbing, of course. We sifted through rumors, discussed inside information, and, far too often, somberly related stories about friends who never returned home from the crags.

Allen is too modest to mention what I regard as the mark of a great all-around mountain man: his skill on both rock and ice. Two examples suffice. In the summer of 1950 he did a fine first ascent of a new route on British Columbia's fierce Mount Waddington, this just five weeks after his epic ascent of Yosemite's Sentinel Rock. Then, fifteen years later, his climb of Mount Logan's Hummingbird Ridge was followed the next year by an early ascent of El Capitan's Salathé Wall. No one in North America at the time could boast of such a record.

We have in this book Allen's version of just a few of the happenings in his ninety-one years. He doesn't mention, or barely alludes to, minor adventures like sleeping in remote Greek churchyards with his Mountain Travel clients, some of whom presumably enjoyed "getting off the beaten track." He doesn't mention the enormous convocation of flamingoes he once filmed at a lake in Kenya. He delighted in showing this short movie to friends back home. He doesn't mention exploring the deep slot canyons of southern Utah, where I once heard his yodels echoing off those glorious red walls. Time for another book, Allen!

—Steve Roper

PREFACE

I no longer remember how many times I thought of writing an autobiography during my forties and fifties. After Mountain Travel started, things were happening so fast that there was no time for writing anything that consuming. The years continued to pass by until one day in the spring of 2009 when my daughter, Sara, suggested that I put something on paper about my climbing life that would be of interest to her son, Michael.

And so this book slowly began to take shape. Steve Roper, who knew my climbing life so well, made copious incisive, often acerbic, comments on the chapters as they appeared, cleaning up all my sloppy writing and steering me in directions that greatly improved the work. His assistance was invaluable. Equally important were suggestions by John Thackray. After reviewing chapters, he focused more on ways to improve the flow of my stories. He often urged me to provide a more intimate description about the people I was climbing with, which was often difficult for me to achieve. Lynn Hammond also provided thoughtful suggestions about how to put ideas in their proper order.

Finally, after the stories were put together properly, Kit Duane helped me immensely in tightening and cleaning up sentences, and creating a table of contents. At this point I submitted a proposal to Mountaineers Books in Seattle, but ultimately, when they agreed to publish my memoirs, I declined their offer because they planned to produce my book in a small, soft-cover format with only a few photographs. I felt my stories deserved more. At one point I considered self-publishing. Then Iain Allan, who manages Tropical Ice, a safari organization in Kenya, suggested I send a proposal to Patagonia Books in Ventura, California.

At the request of Patagonia Books, Michael Kennedy undertook a very serious, invaluable edit of the book, providing many insightful additions (and deletions). Patagonia editor John Dutton also had many comments to improve the text. At this point my workload increased dramatically, hard days ahead for this ninety-one-year-old semi-recluse. Andy Selters spent many hours getting photos scanned and color-corrected. Jane Sievert,

photo editor at Patagonia, and I spent days selecting photos to include in the book, the captions of which I struggled to write. So my deepest heartfelt thanks to all of you who made this project possible. I smile now as I also give my thanks to this insentient device in front of me: my trusty 20-inch iMac computer, perhaps the most important component of all.

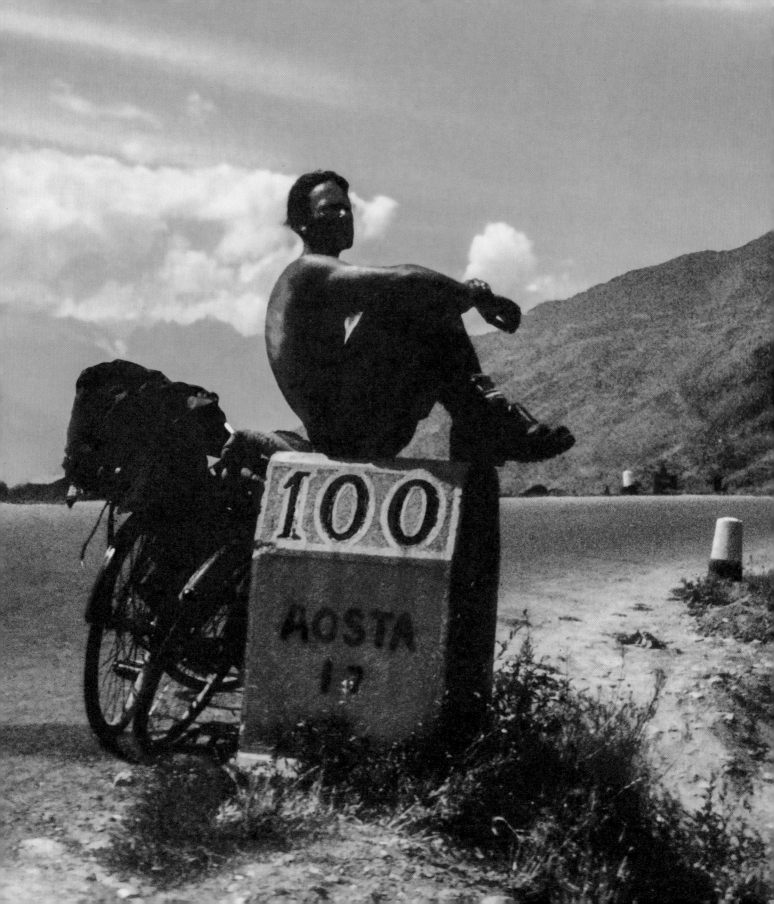

Formative Years

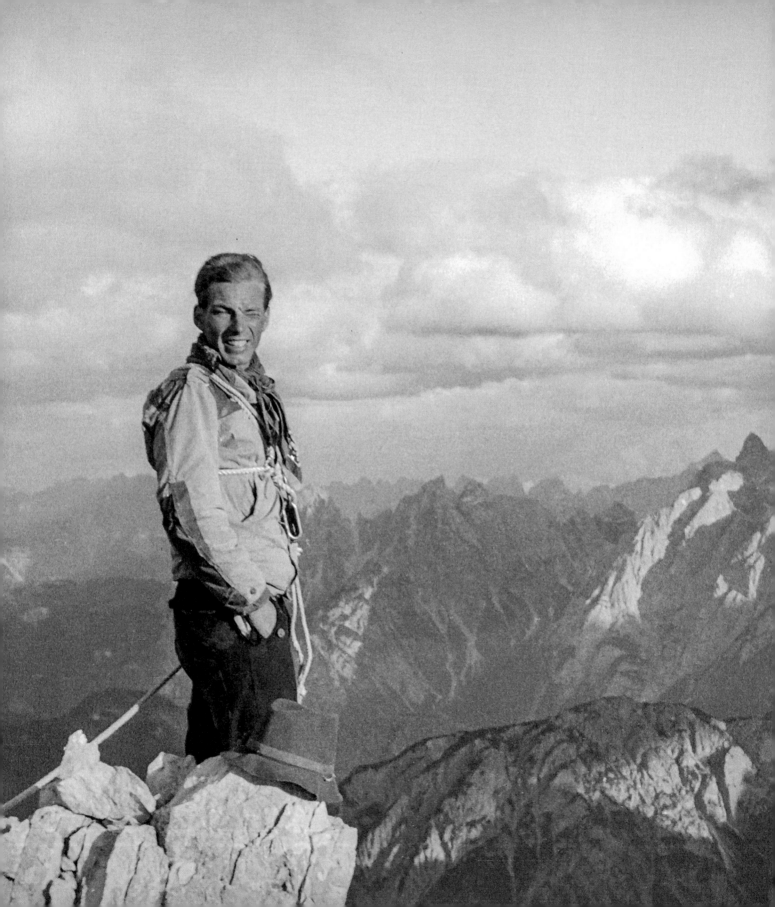

CLIMBING IN THE ALPS WITH KARL LUGMAYER

One is very often unaware of the significance of events as they unfold. Such was the case when I stepped off the Arlberg Express in the Vienna train station in early May 1949 and met Karl Lugmayer. How was I to know our adventures that summer would be so profound?

I planned on re-entering U.C. Berkeley in the fall after doing a stint in the Navy in WWII. With the summer before free, I found a Sierra Club outing schedule that listed many activities and joined the Rock Climbing Section. Every Sunday we'd meet in downtown Berkeley and proceed to local areas such as Indian Rock and Cragmont, where we beginners would learn ropework, knots, rappelling, and other basic rock-climbing skills. Climbing soon became a passion, yet I still had absolutely no idea what to do with my life and just drifted along.

I chose business administration as my major and became engrossed in my studies for the next three years. Thanks to my father I had funds to cover my living expenses. After graduation in the spring of 1948 I took a job as a seasonal ranger in Yosemite National Park, and that fall went to Zürich, Switzerland, a fortuitous turn of events that would have a profound effect on my journey through life.

I first met Karl through correspondence. He had written to the Sierra Club in San Francisco asking about climbing possibilities in the mountains of California. In reply the Club

[Previous Spread] Here I am resting on a 100-kilometer marker in Austria on the way to the Dolomites by bicycle and nearing the Italian border, 1949. Photo: Karl Lugmayer [Left] Karl Lugmayer standing on the summit of one of the Vajolet towers.

mentioned that two members of the local Rock Climbing Section, Fletcher Hoyt and myself, were attending school in Zürich over the winter, and suggested that Karl contact us. Hoyt and I had climbed together in Yosemite and hoped to tackle some of the great routes in the Dolomites after our studies were complete. We were obviously excited to receive Karl's letter introducing himself and proposing that we climb together in the eastern Alps.

Unfortunately, once there, Hoyt would not be able to participate in our adventures owing to an unfortunate accident on our return from an Easter ski excursion. We had managed an ascent of the Tödispitze, but were hit by an enormous storm and struggled through heavy snow to get back to a cart track that led down through the forest to the valley. The slope above us was very steep, and as we were skiing across a small gully an avalanche came down upon us. My ski tips were stuck under some ice blocks in the track and the snowy torrent went over my back; the slide swept Hoyt, who was right behind me, forty-five meters down the slope. He was initially unhurt, but badly damaged his kneecap when a second small avalanche struck us. Luckily, he had a small tube of morphine, which lessened the pain during our eight-hour descent to the village for help, a distance we normally would have covered in forty-five minutes. Despite one surgery in Zürich and another later, he wasn't able to climb again for several years.

Karl and I stood there at the Vienna train station and looked each other over. A member of the Österreichischer Alpenklub, Karl was a student of physics at the Technische Hochschule in Vienna. He was a handsome fellow with an easy manner and a classic climber's look about him: broad shoulders with a thin, wiry frame. We liked each other instantly and soon began to discuss a plan for the summer. His knowledge of the classic routes in Austria and Italy, which he called "Die schöne Rosinen," was extensive. I was aware of some of these, but the immense 1,100-meter northwest face of the Civetta, which would be one of our adventures in northern Italy, was unknown terrain for me. I knew a bit about the history of European climbing, which surprised Karl, and of course I knew about the first ascent of the north face of the Eiger in 1938. I was therefore pleased when we went to visit a climbing shop in Vienna owned by Fritz Kasparek, a member of the team that made that historic ascent only eleven years previously.

Karl's studies would end on July 9 so he suggested that I stay at his parents' home in Wolfern, near Steyr in Upper Austria, during the interim. My German improved enormously during those weeks. Karl's father was a teacher in the local school and my lodging was in the school, so it was pretty noisy during the day. Karl's parents were most gracious

Karl Lugmayer, resting on a fence in Austria near the Italian border, while cycling to the Italian Dolomites.

and hospitable. His mother told me with great enthusiasm about how their village was liberated by American forces. The US troops, all carrying rifles, shouted *"Raus, raus,"* ordering everyone to come out of their homes, with hands high, to be searched. It was not exactly pleasant, but certainly better than being under the Russians, whose line of control was not too far to the east.

Karl had a free week in late May so we met in Wolfern and left for the Kaisergebirge, he by bicycle and I by train and bus. Our first stop was the Gaudeamushütte, the famous approach to the Kaiser from the south. A few training climbs gave us a chance to become a moderately skilled team, though I had trouble convincing Karl to use the hip belay instead of his shoulder belay. I had been climbing only a few years, but my training with the Sierra Club had convinced me that the hip belay was far safer. We had two 120-foot nylon ropes, of the type that was used by the US mountain troops in the Italian campaign. I brought one and the Sierra Club had sent Karl one earlier in exchange for some German climbing books. To my knowledge this was the first time synthetic ropes were used for recreational climbing in Europe, certainly in the eastern Alps.

Eventually we hiked up to a pass and scrambled down a rocky gully to the Stripsenjochhaus, which was close to our first major adventures, the famous routes on the Fleischbank. Not many people were in the mountains in those days and the hut keeper, Peter Aschenbrenner, welcomed us warmly. Peter was a member of the tragic German expedition to Nanga Parbat in 1934 where nine climbers and Sherpas perished during a fierce, lengthy blizzard. We had lively discussion about the benefits of nylon ropes, the first he had seen, and many other topics of mutual interest.

The rock of the Kaiser, particularly on the Fleischbank, is solid, well-featured limestone with a blue-gray hue, unlike much of the rock of the Italian Dolomites. After training climbs on the Christaturm, the Predigstuhl, and the east face of the Fleischbank, the latter a grade V, we turned our attention to the southeast face of the Fleischbank. Fritz Wiessner and Roland Rossi first climbed this classic climb, rated grade VI, in 1925.

The lower third of the wall was relatively easy until we came to a pendulum, an acrobatic maneuver that normally cannot be reversed and thus obliges you to complete the route. I lowered Karl some six meters from the pendulum piton where he made several attempts to swing across to some small holds on the other side of a smooth, blank face. People walking on the trail below watched in fascination as he danced repeatedly across the wall. Finally, he succeeded, set up his anchor, and called for me to follow. Once by his side I untied and

My rope and gear in a Dolomites meadow, 1949. The state-of-the-art gear of the day. This was probably the first nylon climbing rope to be used in the Eastern Alps.

pulled the rope through the piton. As I retied my knot, we realized that the climb had become serious. There was no way but up to get off the wall. Karl recounted the story of his four friends who only eight months earlier were overtaken by a massive thunderstorm on the east face. Forced to bivouac on tiny ledges, by the time help arrived three had perished.

Several aid pitches followed and we surmounted the famous Rossi overhang where we pondered the final, nearly vertical 120-meter wall above us. We knew exactly what was ahead: several difficult pitches up a chimney system and then the infamous traverse known as the Ausstiegsriss, the exit crack. This last problem, my lead, began in an overhanging chimney. By stepping on Karl's shoulders and using direct aid I barely reached a point where I saw the beginning of the small crack, obviously a hand traverse, that led some nine meters right across the smooth wall. I grabbed the lip and moved across, placing a few pitons on the way until I reached a good ledge for the belay. The climb was ours. On our return to the hut, we said goodbye to Aschenbrenner and made the trek back to the roadhead, where Karl and I again parted ways.

Karl's studies were eventually over and we assembled at the family home in Wolfern. We packed our rucksacks with all our gear, including light sleeping bags, a nylon bivouac sack I had made in California, and much climbing equipment. Earlier, we had made the decision to travel by bicycle rather than by train; this was not only cheaper but we had more flexibility in choosing our destinations. It was, Karl explained, the way that many climbers in Austria used to get to the mountains before and just after the war. We each carried an extra sixty pounds of food and equipment. I began to realize this trip was going to be a demanding one.

Even though hostilities in the German theater had ended in 1945, travel restrictions still existed. There were few cars on the roads due to the shortage of gasoline, and the range of food available was limited. For instance, there was no white flour to be had but we could find oatmeal and other grains, along with such delicacies as speck (a type of bacon) and sausages.

Karl was an expert at riding a bike, but I was a total neophyte. After loading the bikes, we bade farewell to his family and started down the road. I hadn't gone 500 meters when I attempted to ride around a curve, lost control, and crashed into a hedge. It was a bad start. But I eventually learned and we rode on to our destination at the foot of the Dachstein. Here we made an ascent of a beautiful peak called the Däumling by its southeast buttress. The climbing was spectacular. The ridge was solid limestone and offered a variety of intricate problems. Not only did we climb the route in fine style, we also pioneered a more direct line to the summit on the last pitch.

On returning to the valley we went to the next town and sent our rucksacks by bus to a trailhead near the foot of the Grossglockner, at 3,798 meters the highest and most spectacular peak in Austria. Here we would go up the Pasterze Glacier to the Oberwalderhütte across from the north face. But first we had to negotiate the Glocknerstrasse, which involved crossing a high pass in a thunderstorm. As we rested at the entrance to a tunnel we were soundly trashed by lightning. Karl was on his bicycle, leaning on a metal rail, when he was nearly thrown to the ground. As we began the descent my overheated brakes failed and I landed in a ditch. I would face this problem a few more times during the coming weeks. We left our bikes in a shed and hiked up toward the hut as soft rain fell. Our arrival there was a welcome end to the day's trials.

Karl had been interested in climbing the north face of the Grossglockner for several years. Willo Welzenbach and Karl Wien first climbed the route in the fall of 1926, the year Karl and I were born. They took eleven hours, including four hours for the approach to the face. Willo had an inclinometer and measured the angle of the lower slopes at fifty-three degrees and the upper rock wall at around seventy degrees, a rather normal configuration for Alpine faces.

At 3:30 a.m. we were rudely awakened by our pocket alarm. A fresh breeze had come up during the night, sweeping the skies of the lingering clouds, and the moon shined down on the north face, accenting the ridges and buttresses with startling clarity. As we looked out over the landscape, Karl clasped my shoulder and said, "This is our world." We were indeed at peace with ourselves. We stumbled down the stairs and made a quick breakfast. Ice pitons, carabiners, crampons, warm clothes, bread, cheese, and speck went into our sacks, and soon we found our way down to the glacier. Once across and up the opposite slope we stopped to put on our crampons and began to feel our way through the labyrinthine icefall that drained the snowfields under the north face.

I was particularly cautious since, unlike Karl, it was the first time I had used crampons. We moved quickly though the shattered séracs and crevasses that formed this mysterious crystalline palace. It was an unearthly world. Karl's ax sparkled in the sunlight as it fell methodically into the ice under the immediate problem before us, the bergschrund. After chopping some steps and hammering in an ice piton, he was over the top and soon set up his belay. The sun shined fiercely and we became apprehensive as small avalanches began to slide past us. We had spent too much time in the icefall and now it was imperative to climb as quickly as possible. The crunch of iron on snow, an occasional shout, and the hissing of the avalanches were the only sounds that penetrated the silence.

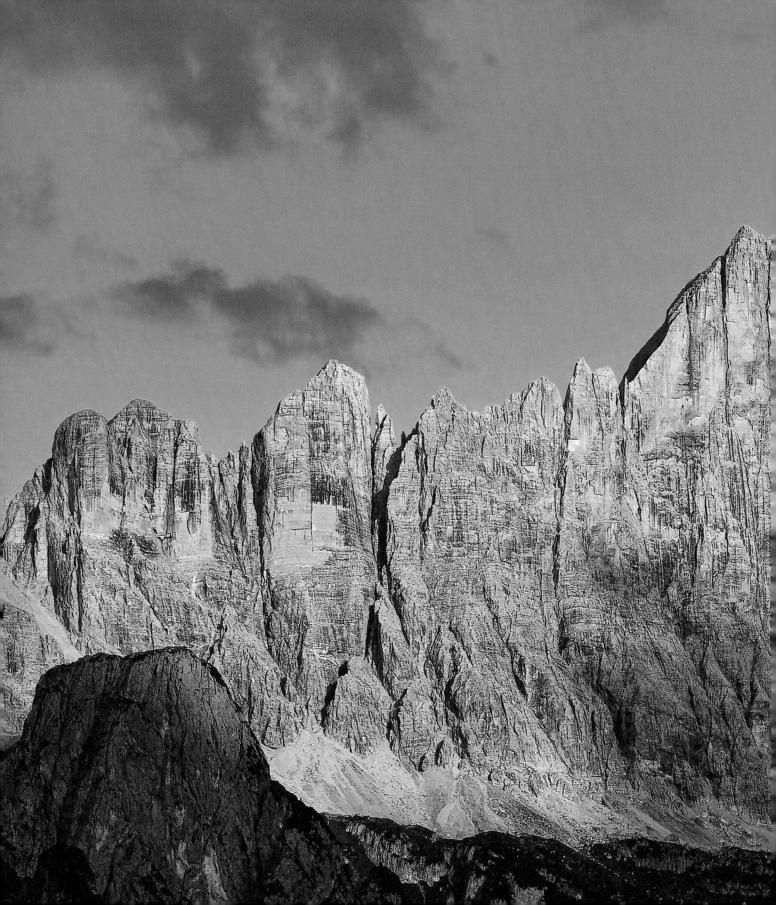

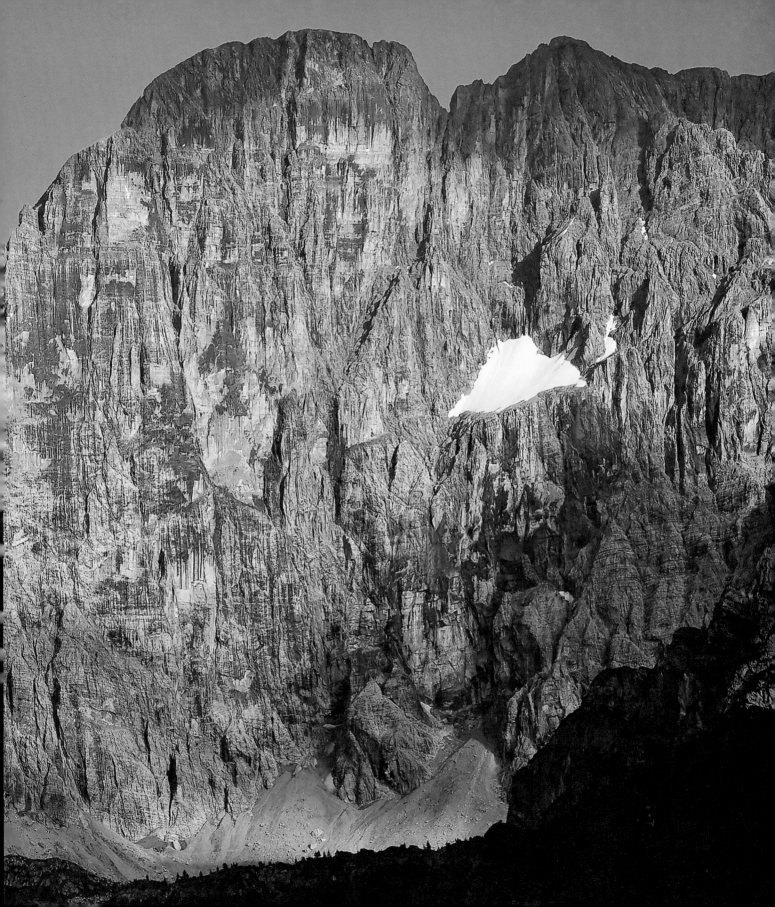

As we approached the rocky final buttress we became aware of threads of mist weaving around the summit and dark clouds sweeping the glacier below. Our plan had been to climb the couloir to the right of the buttress, but it was two in the afternoon and the snow was dangerously soft. We chose to climb the rocks. The distant roar of thunder to the south caused us even more anxiety. Soon it began to snow. But the rock was good and we managed to move up quickly to a point just beneath the summit ridge.

I had passed Karl and was leading up a chimney when a blinding flash hit so close that we felt the jolt run through our limbs. The sound died away and we stood there, our ears ringing, listening to the buzzing of our axes. "*Schöne Musik*, beautiful music," said Karl, rather too philosophically. The snow increased in intensity and we began to feel the bite of the cold. A rope-length below the summit, more lightning crashed onto the ridge and the overwhelming precariousness of our situation forced us to almost run by the enormous buzzing iron Gipfelkreuz on the summit. As we passed the Kleinglockner on our way to safety, another blast shook our bodies. Luck was with us as we eventually reached shelter that evening, our clothes dripping with water, in the Adlersruhehütte on the ridge a hundred meters below the summit.

We hiked back down to the road, retrieved our bicycles, and reached Lienz in a dismal rainstorm. We continued on to Sillian, where we bought supplies just before crossing into Italy. We paused and cast a fond glance back over the mountains of our beloved Austria. I say "our" with feeling, for in the course of the few weeks that I was with Karl and his family it seemed to me that Austria had become as much a part of me as it was of him.

We turned our eyes southward to the towering cliffs and spires of the Sexten Dolomites. My papers for the bicycle were in order, but my visa for Austria had expired. Fortunately, the border guard did not press the issue and let me cross into Italy. The whole aspect and tempo of life changed before our eyes; there was much gaiety, laughter, and untiring activity. Soon we reached the Dolomitenhof where Karl knew the owner, the guide Sepp Innerkofler. A group of students from a Catholic school in Milan had rented the inn and since it was completely full, we slept in a nearby hayloft. Karl was a master at finding us lodging throughout our travels and I doubt that this was the first time he had found shelter in such a place.

The next day after storing our excess gear and the bikes we hiked to the Drei Zinnenhütte in a few hours. Here at last we had our first view of our objective, the fantastic north face of the Grosse Zinne (Cima Grande in Italian), first climbed by Emilio Comici and the Dimai brothers in 1933. Comici was the most gifted Italian climber of his time and he made

[Previous Spread] The northwest face of the Civetta. Photo: Andrea Gasparotto [Right] Karl Lugmayer leading a pitch on the northeast face of the Preussturm, one of the towers on the Kleine Zinne. Lots of chimney climbing here.

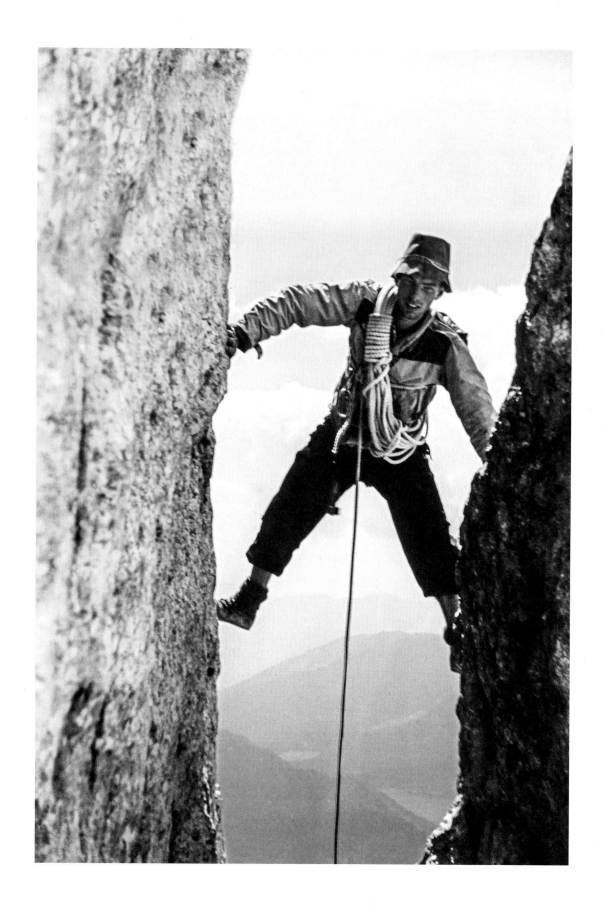

many first ascents that are still regarded as classics today. He was one of the first to use double-rope technique and slings for aid climbing. His writing shows a deep pleasure at simply being in the mountains, in close association with rock, sky, sun, snow, cloud, and storm. Sadly, Comici's outstanding career ended in 1940 with a fatal accident on his favorite crags, the Sella Towers, near his home in Gröden not too far from the Drei Zinnen (Tre Cime in Italian). He was only thirty-nine.

By now Karl and I were very fit, but I still lacked experience in big-wall climbing, even though I had learned my craft in Yosemite. In those days it was unthinkable that Yosemite's enormous walls would ever be climbed. This 550-meter north wall in the Dolomites, glowing with its characteristic yellow-orange color, seemed more overwhelming than any Yosemite cliff, yet it had been climbed in 1933! Karl and I stood in awe of this monstrosity, our minds in turmoil as we contemplated coming to grips with it. Karl had an idea of what the climbing was like from talking with Fritz Kasparek about his earlier ascent. The rock, like most of the Dolomites, was nicely fractured and thus well suited for the placement of pitons. In fact, many were still in place from prior ascents.

After a couple of training climbs on nearby crags, we approached the beginning of the first difficult lead early one morning. We stopped on a spacious ledge and looked up at the 200 meters of overhanging rock above us. Falling icicles twisted and twirled in the air until they crashed into the talus a full twenty meters out from the base of the wall. It seemed amazing that this face had been climbed, but there were the pitons arching up in the yellowish rock. Karl tied into the ropes and started off. Using double-rope technique he reached a piton four meters up and took tension while he surveyed the rock above. He called down in a rather surprised voice that he could see no more pitons for some four to five meters. The wall was still quite steep. I saw him reach up and start to free climb with delicate balance on tiny holds. Much higher, after clipping into some anchor pitons, he called out again. "Al, I've got it." With difficulty, he pulled up the slack and gave me tension as I seconded the pitch. I snapped the ropes out of the carabiners, collected them, and was soon by his side. I belayed him as he traversed out to a crack on the right that led up to the next ledge.

But we never got to see the ledge that day, for in the next few minutes there was a near catastrophe. Karl had climbed far above me when he ran out of rope before reaching the ledge with the next anchor. He was out of sight but I heard his call asking if I could give him more rope. I yelled up that it was possible but my position would not be good. I left the anchors and climbed four meters to a small ledge. But there were no pitons and I had to use

Torre Delago (on the left in the image), the most beautiful of the Vajolet Towers. H. Delago made the first ascent of this tower solo in 1895. Lugmayer and I climbed the striking sun-shade arête of this tower, a route now rated 5.7 or 5.8.

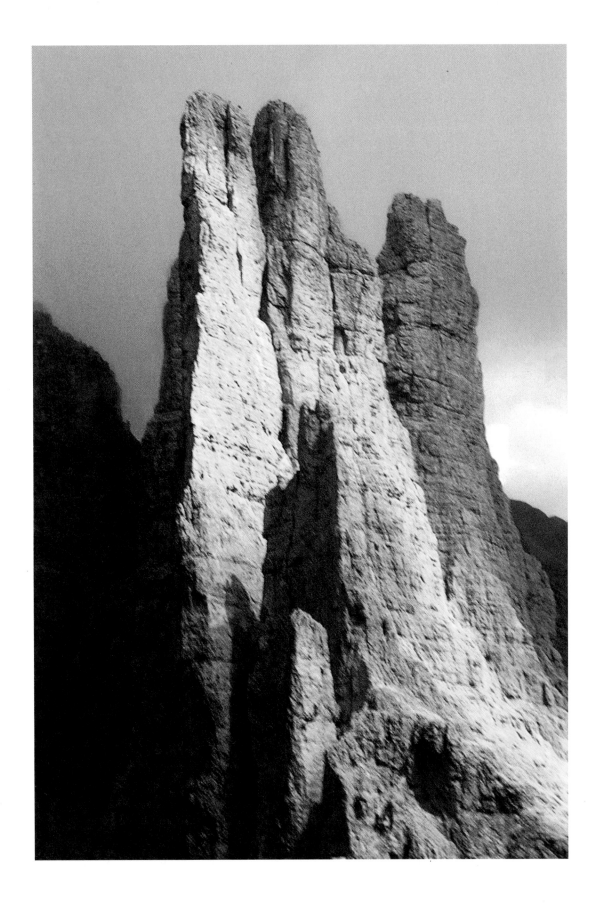

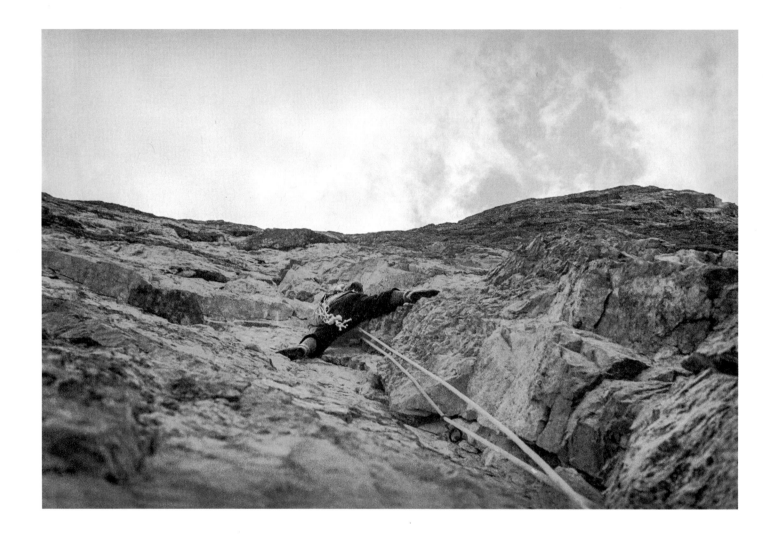

Karl Lugmayer leading on the north face of the Cima Grande, 1949.

The Tre Cime di Lavaredo from the north. Cima Grande is the center peak. Lugmayer and I climbed this central peak's north face via the right, western third of the face shown, going through a majority of darker limestone in the two-toned peak.

a hold above me to keep my balance. I told Karl that I could belay with only one hand. He was in a difficult spot just below a bulge and had to use direct aid to get to the ledge. With a determined effort, he raised himself up high. But as he struggled to reach a good hold, a rusty piton pulled out with jarring suddenness. Karl flew headlong past my shoulder. The rope was jerked from my grasp and the whole length of it went buzzing through the carabiners until it came tight against my waist and brought him to a stop. I looked down after that frightening moment and saw him climbing up to the starting ledge, rubbing his head. I managed to get to pound in a few secure pitons and rappelled. "Yes, Al, I had some luck there," he said with a rather somber look.

Karl had suffered a noticeable cut on his head, so we retreated and hiked down to the Dolomitenhof. On the way, we met three Swiss climbers who had witnessed Karl's fall. They had intended to start the climb that morning, but seeing us on the wall they had decided to watch through binoculars. They told us that it looked like Karl had fallen on a rubber band, such was the elasticity of the nylon rope. Once at the Dolomitenhof, one of the students we'd met earlier patched up Karl's wound and put a bandage around his head. As the young woman applied iodine, he went limp momentarily, but when Sepp Innerkofler produced a bottle of brandy, Karl came around quickly enough. We talked for hours until at 11 p.m. we realized that we had to get back to the Drei Zinnenhütte in order to start the climb again the next morning. I remember clearly on our departure one of the priests, who was accompanying the students, on his knees, begging us not to go up on the wall again.

Around 10 a.m. the next day we reached the scene of our accident. I was leading and noticed that the rock was loose where the piton had been. I hammered the same piton back into a crack a little to the right and went up on tension to a tiny ledge where I set up an anchor. Karl followed, still a bit dizzy, with a large bandage over the top of his head and tied under his chin. I took the lead and we went on for several hours until we reached the famous "escalator" crack. This thirty–meter lead required twenty-five pitons for direct aid and had defeated many of the early attempts.

Twelve hours after we had started we reached the Aschenbrenner bivouac ledge, named after the hut keeper we'd met at the Stripsenjochhaus. He had made the second ascent of the wall. We spent a reasonable night in our nylon bivouac sack and continued climbing with Karl in the lead at first light. The face was much less steep now and we were soon on the summit basking in the sunlight.

We often discussed the fall, which I guessed was about twenty meters. Karl was spared more serious injury because of the overhang and the fact that he not only tied-in at the waist, but had also threaded the rope up and over both shoulders so that when it came tight he would be facing up. I asked Karl what he recalled during that brief interval between the piton coming out and the rope finally catching him. "I went over backwards, head down," he said. "At first I thought I'd tumble onto the next piton, which was about three meters below, but the expected jolt never happened. I heard the ripped-out piton pinging against the rock and saw coils of rope swirling in the air. I was swirling too, of course, and saw flashes of yellow rock mixed with blue sky speckled with cloud. My shoulders, then my head, brushed against the wall, and I lost my hat."

"Strangely, I had no sensation of fear," he continued. "Somewhere along the way I felt a thud on my head and my teeth were jammed together. There were stars, and then darkness followed by brightness. I had stopped, and after a moment managed to climb back up to the ledge where we had started." The piton had the letters KF stamped on it and became part of my collection until I gave it to Karl on his eightieth birthday. We always wondered if Fritz Kasparek had placed it there.

It was sad to leave the Drei Zinnen area but we wanted to get to Alleghe for our next adventure on the Civetta, a 3,220-meter peak in the eastern Dolomites. The ride was troublesome because I had another brake failure, but we spent a nice night in our sleeping bags on the Falzarego Pass. Karl arranged for us to stay in another vicarage in Alleghe just across the valley from the Civetta.

The 1,100-meter northwest face of the Civetta is one of the most impressive of all the walls in the eastern Dolomites. Many climbers had set their sights on the route, but it was not until 1925 that the first ascent was made by Emil Solleder and Gustav Lettenbauer, who chose a fairly direct line to the summit. Pillars on the multifaceted face rise up like the pipes of a gigantic organ. Chimneys and ledges abound, and finding a route through this maze is complex in the extreme. Emilio Comici pioneered a more circuitous route in 1931 but it was not the *direttissima* that he loved, a line defined by a drop of water falling from the summit. Nonetheless, his route was a severe undertaking and thought to be more difficult than the Solleder, according to Kasparek, who had made the second ascent of the Comici in 1935.

As we prepared our gear at the vicarage we learned that the Comici had seen only four ascents, the last in 1936. Many thought we were mad to go up on the wall, a common

Karl Lugmayer leading a crux pitch around an overhang on the Civetta, 1949. This lead was very committing and runout, as there were a few fixed pitons but previous climbers had hammered them in too deeply for Lugmayer to clip a carabiner into their eyes.

sentiment among nonclimbers. Karl and I decided to climb the Comici and made a plan to start late and bivouac on a sloping ledge low on the wall. We reached the scree slopes beneath the face at around 4 p.m. I'll let Karl tell the story, in a translation of a fine article he later wrote for the *Edelweiss Nachrichten*.

Right away we had problems finding the proper start. According to my type-written route description, we were to climb a difficult rib and descend into a gully where there was a very large cairn. But wherever we looked we could not find the cairn. I thought of climbing a very unappealing yellowish overhanging crack, at which point Allen uttered that this was madness and started climbing quickly up the gully on easy terrain. I called out to him in vain that this was not the way. The rope ran out and I was forced to follow, urging him to return. We had a heated exchange when I suggested that we should choose another direction. All he said was "Your route cannot possibly be the right way to go. Enough of your route description and your European traditions." I quietly ad-mitted to myself that he wasn't all that wrong and so took the lead and contin-ued on. We kept a fast tempo, simulclimbing various cracks and chimneys and pausing occasionally to belay. We moved up rapidly, and it seemed as though we never had disagreed; we both, I thought, are so much alike, being pigheaded as we are.

Finally, when our view of the wall became more clear, we realized to our satisfaction that we couldn't have deviated much from the original route. I was now grateful for Allen's stubbornness, or we might still be wrestling with those overhangs below. We were so elated that we raced along hoping to find a prominent reddish tower on our route. On our left the face was vertical, often overhanging, and the right was no better. Our eyes scanned the cliffs but there appeared to be no way through them. Dusk was settling in slowly and we de-cided to set our bivouac on the talus ledge we had seen from below. It was steep-er than expected, but we still managed to scrape out some flat places where we could sleep. The approaching evening was clear and crisp. The Langkofel Group and the steep south face of the Marmolata emerged from the glowing horizon. I hammered in some pitons to which we anchored ourselves and we began to dine on our meager rations. We crawled into Allen's nylon bivouac sack after

putting on all our extra clothes. I surrendered to the silence and thought how tiny and vulnerable we were in the grip of this gigantic mountain.

Morning arrived eventually. Patches of fog crept up the wall indicating a change in the weather. Our bones ached as we consumed our lone can of sweetened condensed milk. Before we got underway, I again read Comici's route description, which was hard to equate with the terrain in front of us. We were constantly looking up at smooth overhangs split by dark chimneys occasionally capped by huge roofs. Finally, we found a way to the red tower and went past it through some difficult chimneys into a spacious cave from which it appeared there was no exit. Then I remembered: the giant roof! "We have to go right," I told Allen, who looked at me in disbelief, as the route description had deceived us before. He belayed me as I stepped right around the corner into the unknown. Handholds were obscure and footholds were few. Scrambling for a secure stance, my fingers began to weaken, but I was able to get into a stemming position. Suddenly I saw a piton but it was buried so deeply that I could not get a carabiner into it, so I came back and asked Allen to get the other rope out so I could use double-rope technique. I felt a little more comfortable with the moves and I was able to pass the buried piton and find some more that were better placed higher up. These I used for direct aid and eventually after some wonderful stemming and another chimney, reached a stance where I could bring Allen up.

The next pitches were his and soon he tackled an enormously difficult groove, where, protected by a piton, he mastered what might have been the most difficult section of the wall so far. We were continuously surprised at how many cracks and chimneys we were able to climb free.

About this time sunlight fell on the wall and a soft fog started to cover the mountains, yet no major weather disturbance seemed to be forming. We had trouble belaying in a 200-foot crack, described by Comici as being extremely difficult, then after a few more chimneys we reached a ledge where we rested a while. We were unable to estimate how far away the summit was, so we decided on another bivouac here. We found a nice rocky bench to sit on beneath an overhang, but I thought it best to be in an uncomfortable horizontal position than to sit up all night. Our food and water were now gone, but there was

enough ice lying around to moisten our parched lips. We watched the lights of Alleghe and then crawled into our nylon sack and tried to sleep. Early in the morning I nudged Allen and told him it was raining. "So what," he replied before falling back asleep. The drops became more intense and after much time trying to avoid getting too wet I ran out of patience and stuck my head outside. Much to my surprise I saw the lights of Alleghe through the mists and stars in the sky. I realized we had set our camp under a waterfall and so we fled to the bench where we shivered until dawn.

We began climbing unroped even though the terrain was still somewhat demanding. Our fingers were bleeding from the constant contact with ice and wet rock but we soon reached the summit and started down some warm, sunny slabs. A thick fog lay below and soon we came to a tiny meadow not far from the summit and saw a small shelter. Our second bivouac hadn't been necessary after all. Nevertheless, I wouldn't have missed, nor Allen either, one minute on that wall.

We'd done a magnificent climb under harrowing conditions and become a remarkable climbing team. These were big routes, no comparison to the tiny climbs I was used to in Yosemite where big-wall climbing was only just beginning.

Almost three weeks after leaving Wolfern we continued our journey to the Rosengarten group, climbing on the way the famous Schleier Kante (The Veiled Ridge) on the Cima della Madonna. Near Predazzo, I had another brake failure on the bike (I was slowly getting used to the crashes), but we eventually made it to the trailhead at the base of the Vajolet Valley. We took a cable railway up a steep section and hiked to the Vajolet Hut just across from the incredible Vajolet Towers. Pia Piaz and her husband were the hut keepers and they welcomed us with great enthusiasm; on seeing Karl's colorful head bandage they realized that he was the one who had taken the famous "flight" on the Grosse Zinne *nordwand*. The news of this sensational event had traveled rather quickly through the small climbing community.

The weather was excellent and our first tour, a traverse of the Vajolet Towers starting with the unbelievably steep Delago Kante, went by without incident. Our stay at the hut was delightful, and when it came time to leave, the generosity of our hosts touched our hearts. Frau Piaz would not take a single lira from us for our lodging at the nearby unused Preuss hut.

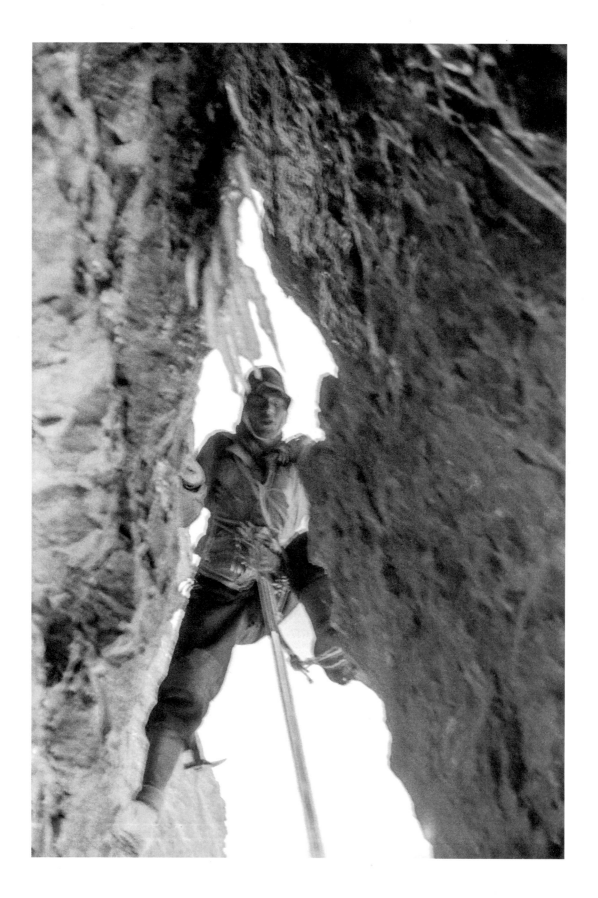

The former hut keeper was her father, Tita Piaz, who had died just the year before in a bicycle accident. He was the famous Italian mountain guide who was responsible for the development of *piaztechnik*, known to us in America as layback technique.

Back with our bikes, we pedaled our way over a small pass to Bolzano, where we managed, in spite of the language difficulties, to send most of our gear to Aosta, close to the southern ice-and-snow-covered faces of Mont Blanc. We then climbed on our bikes for the six-day ride.

Our nights were spent in a variety of ways. Often we managed to sleep in small vicarages; one time we slept in a cornfield. Mostly we slept in haylofts, which involved going up to a farmhouse and asking if we might lodge there. Once a bearded old man up in the barn behind the house was screaming in French about the *Boche* and waving a pitchfork as he climbed down the ladder. The lady of the house probably would have let us stay but the older member of the family made it clear that German-speaking folks were not welcome. We took our meals in small inns; sometimes a family would feed us. At lunch we would stop at the village water fountain and eat a bowl of cereal.

On the way across Italy, we pushed our bikes over the 2,757-meter Stelvio Pass, the highest in Europe, and again I suffered brake failure on the descent. The days passed quickly. We slept on wood chips at a cabinetmaker's shop near the Swiss border, cycled through St. Moritz and over some passes almost to Chiavenna, then back into Italy, where we spent the night in a peasant's hayloft. We slept in a bicycle repair shop while my brake was being fixed. Back on our bicycles, Karl managed to catch the bumper of a slow-moving truck, but I was not quick enough and so didn't see Karl again for a whole day.

Finally, we reached Aosta and sent my bicycle back to Wolfern by train. I rejoiced in the termination of my struggles with the infernal machine. We were able to ride on the roof of a bus to Courmayeur, where we found our way to the cable railway up to the Torino hut just east of Mont Blanc. Fantastic thoughts surged through my mind as we entered this new world of granite and ice.

A stupendous array of icy peaks, ridges, and glaciers was visible from the hut in the soft evening light. What were we going to climb? The Walker Spur on the north face of the Grandes Jorasses interested us greatly, but such an idea reeked of hubris because the difficulty and danger were far greater than anything we had yet experienced. We finally decided on the traverse of the Aiguilles du Diable, five pinnacles on a ridge leading up to the summit of Mont Blanc du Tacul. The Walker Spur option could be decided later. The traverse went quite well, but I injured my ankle on the descent. It took us some extra time to get down the

Karl Lugmayer leading out an icy overhang on the Civetta, Dolomites, 1949.

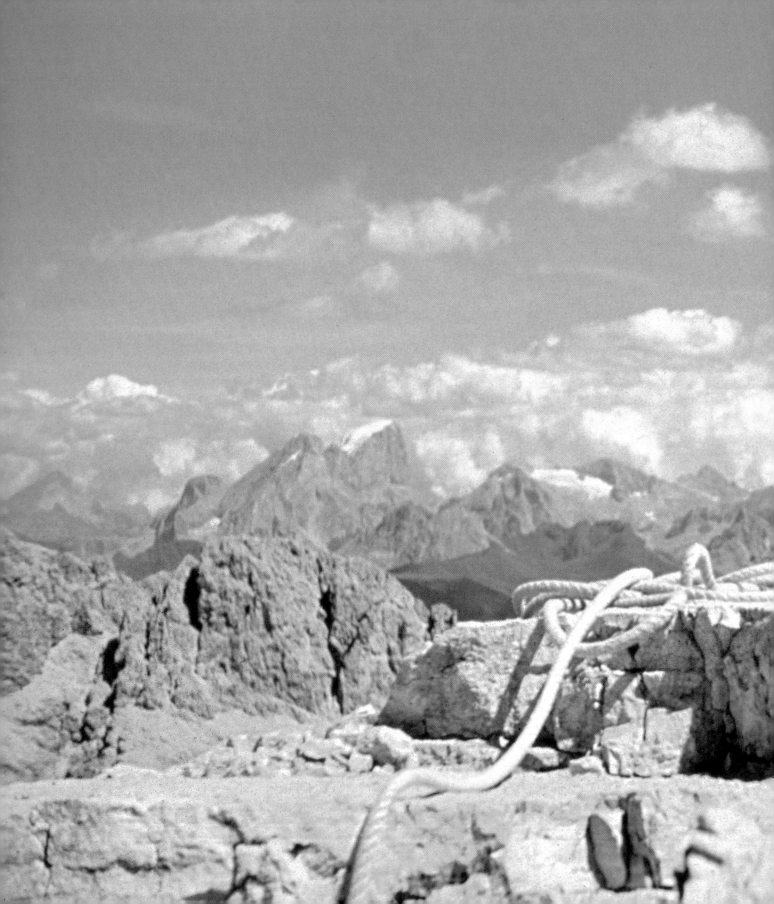

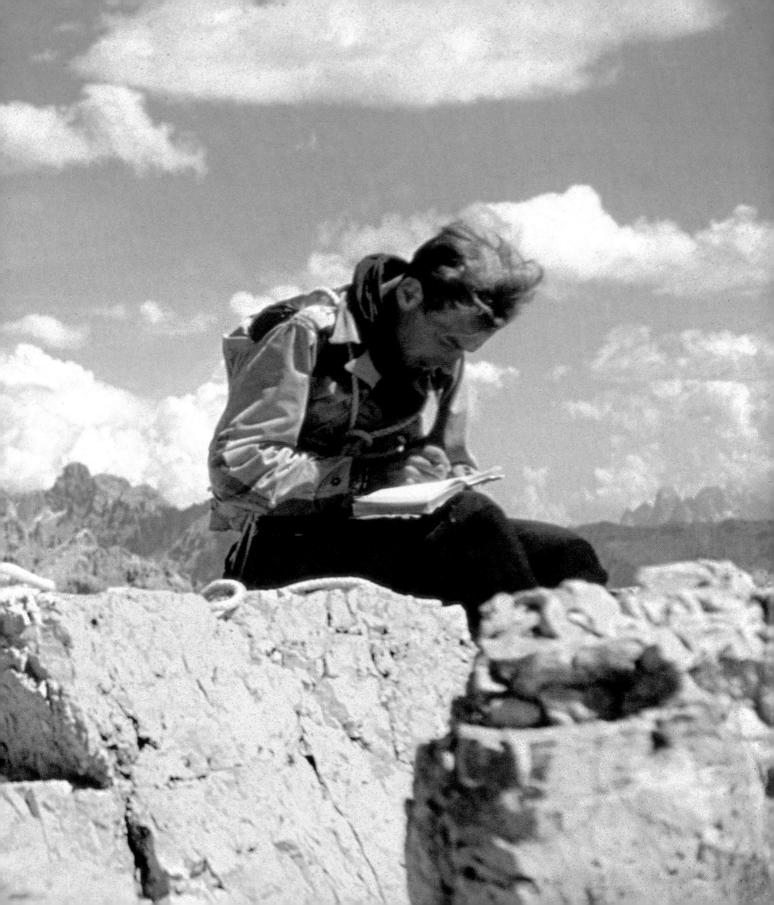

Mer de Glace and ultimately to Chamonix. On the way, we looked up with great longing toward the Walker Spur, now only a dream for the future.

Karl and I went our different ways in Chamonix. I took the train to Zürich with Karl's pack (he would pass through Zürich on his way back to Austria), picked up my luggage, and arranged for my journey back to America. Karl returned to Aosta, where he would start a three-day bike ride to meet me in Genoa. While passing through Entrèves, just above Courmayeur, Karl met Hermann Buhl, the Austrian mountaineer who would make the first ascent of Nanga Parbat four years later. Buhl urged Karl to join him for a second ascent of the Aiguille Noire de Peuterey, a major peak on the south ridge of Mont Blanc. It was a challenge, but Karl declined since he had promised to meet me.

We had a wonderful reunion. We met at the American Express office and took lodging in a small hotel overlooking the harbor. Sadness marked our last hours together. We talked of many things and of course those intense moments during the past six weeks. A subject we hadn't touched on much was our experiences of the war. I told him about being aboard a destroyer escort in the South Pacific at the same time he was a prisoner-of-war in England. He recalled the riveting story of his surrender to the British.

He had been a skilled glider pilot, but when things were going bad for the Third Reich in 1944 he was reassigned to the infantry and sent to the front in northern Holland. The train in which he was traveling was savaged by a Spitfire attack and many were killed. The remainder of his unit was then sent close to the border with Belgium, where a British force was on the attack. He was in a large marshy field hiding in a foxhole as artillery shells and rifle fire crashed about. The fighting was quite fierce. His unit realized a local Flemish resident had given its position to the British and the order was given to relocate. Karl took off his helmet while digging his new foxhole and on picking it up discovered that a bullet had gone right through it. In the pre-dawn light he noticed a light tracked vehicle with soldiers was coming his way and the split-second after it had passed by his foxhole he leapt up and jumped into the vehicle, parting the rifle barrels quickly enough to avoid being shot. The British soldiers were as surprised as Karl was at this bold maneuver. He spent the next two years as a POW in England and was happy that he had never fired a shot at the British.

Karl came down with me the following day to the dock and we said our farewells. We knew we would see each other again. Karl's last comment in his brief diary was *Ich bin allein* ("I'm alone").

[Previous Spread] Karl Lugmayer signing the summit register on the Stabeler Tower, the central spire of the Vajolet group in the Dolomites, 1949.

By the time we got together again in the late 1950s, we both had married and started our families. I named my son Lee Karl Steck and he named his son Karl Allen Lugmayer. After Karl's studies were completed, he took a position with Swissair at the Vienna airport and thus traveled at reduced cost to various parts of the world. He continued climbing; two of his more important ventures were the ninth ascent of the Eiger's north face and an expedition to the mountains of Peru. He would often come to California to visit. Karl and I celebrated our eightieth birthdays at a party in Berkeley in May 2006. I had a pleasant visit in Vienna with Karl and his family in June 2012, but that would be the last time I would see him. He died in August of the following year when he fell in his living room, hitting his head on a piece of furniture.

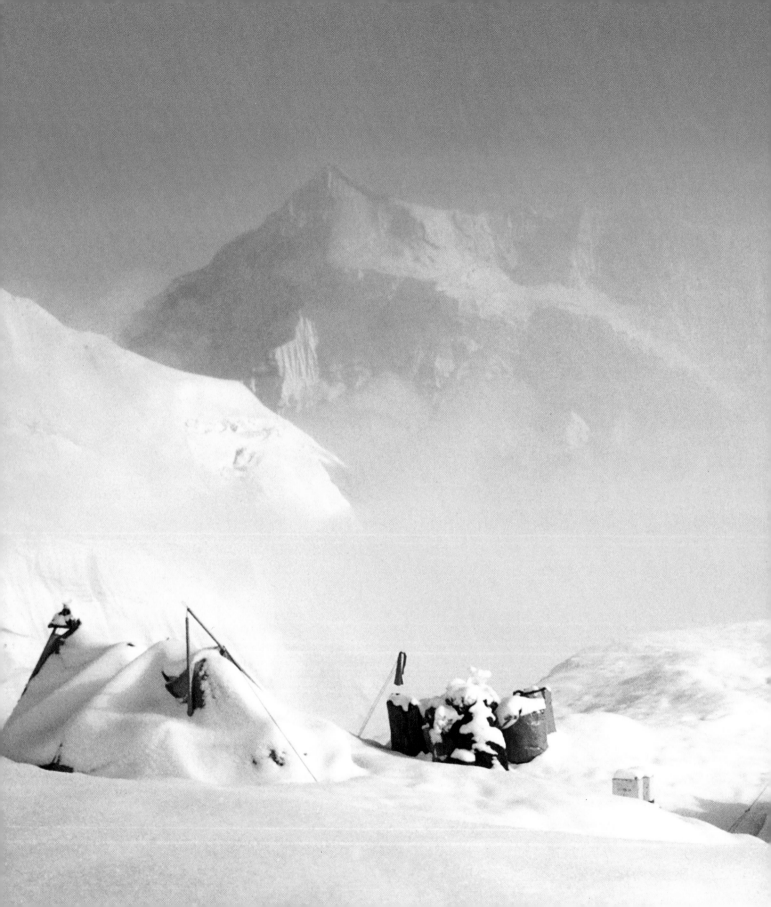

Big Climbs

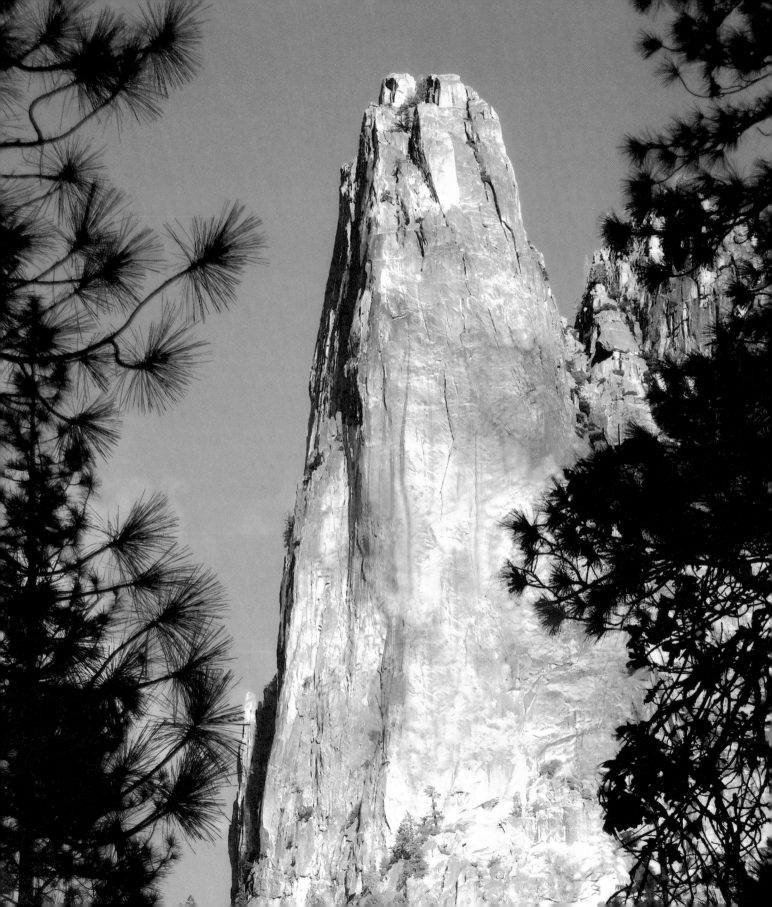

SENTINEL ROCK WITH JOHN SALATHÉ

After I returned to the Bay Area from my adventures with Karl Lugmayer, I found myself intrigued by the unclimbed 1,500-foot north face of Sentinel Rock, which loomed magnificently over Camp 4. In the soft afternoon light many crack systems, chimneys, and ceilings were visible in the multifaceted face. A prominent buttress formed the first 800 feet of a possible route. Above this was a blank section that led left to the bottom of an enormous and deep chimney system some 600 feet below the summit. We called it the Great Chimney.

Others coveted the wall, of course. As early as 1936 three climbers from the Sierra Club had found a route across the lower ledges to a sandy terrace called the Tree Ledge near the base of the wall. Robin Hansen and two friends made several attempts in the 1940s and managed to complete a single pitch above the terrace. Then, in October 1949, I made a serious attempt with my friends Phil Bettler, Bill Long, and Jim Wilson. We managed about 400 feet, including the now well-known Wilson Overhang, ably led by Jim using direct aid, before retreating after a rather miserable bivouac.

More attempts in the spring of 1950 began to fuel a sense of competition for the route. As the July Fourth weekend approached, I had an intense desire to get back to Sentinel Rock, but none of my friends were available because they were helping with a Sierra Club outing.

[Previous Spread] Camp 3, at 21,500 feet on Makalu, buried in snow after a storm. Baruntse emerges from clouds in the background. [Left] Most photos of Sentinel Rock are looking directly at the north face. This image taken farther around to the west shows the amazing verticality of the spire. The route up the north face is at the left side while the west face, first climbed by Yvon Chouinard and Tom Frost, is in full view to the right.
Photo: Richard Delong

I cast about to find a qualified partner when John Salathé came to mind. I called him and was gratified that he had so little hesitation in accepting my invitation.

Salathé was a blacksmith from Switzerland and had been climbing for only four years. I did not know him well, but we had climbed together often around the Bay Area. He was fun to be with on these weekends in spite of the fact that, being a vegetarian, he teased us unmercifully in his heavy Swiss accent for being carnivores. He had already made history with his and Ax Nelson's first ascent of the Lost Arrow Chimney in 1947. They reached the summit after five days of very difficult climbing, so he certainly knew more about nasty bivouacs than I did. Salathé's collection of pitons, which he fashioned himself, were the first hard steel pitons ever made and proved to be as essential for the Sentinel climb as they had been on the Lost Arrow.

We met in Berkeley and drove to Yosemite in his Model T Ford on June 29, spending the night in our sleeping bags at the intersection of the Four Mile Trail and Sentinel Creek. Early the following morning, after stashing our packs and sleeping bags in the woods near the trail, we made our way up to the Tree Ledge and began the climb. In addition to Salathé's pitons and some three-quarter-inch army angles, plus some bolts, we had with us my nylon climbing rope, a 300-foot hemp rappel rope, and a 120-foot hauling line (also hemp) to bring the packs up. Food was simple: Salathé had his dates and I brought dried fruit along with nuts and cans of tuna. Our water was in two one-gallon tin cans. We both had our Sierra Club cups.

I knew the route well enough (I had climbed to the top of the buttress in mid-June) and we made good time, arriving at my previous high point by midafternoon of the second day. Even though we were swinging leads, it was clear that Salathé, aid specialist that he was, should be the one to tackle the steep, almost-blank section known as the Headwall. This was difficult, unknown terrain and his progress was slow. After gaining about twenty feet Salathé decided that approaching darkness called for retreat to our bivouac at the top of the Flying Buttress.

The evening was calm and rather warm, so we slept well despite having no sleeping bags or down jackets. At first light, Salathé again went to work and struggled for seven hours to surmount the steep Headwall. The lead was maddeningly complex. His pitons were barely able to penetrate the marginal cracks and he had to place several bolts. After I prusiked up to his stance, we discussed the problem of reaching the lower portion of the Great Chimney. The solution was a tension traverse across a short blank section on the otherwise moderate face.

John Salathé on Sentinel Rock's third pitch, on the first ascent, 1950.

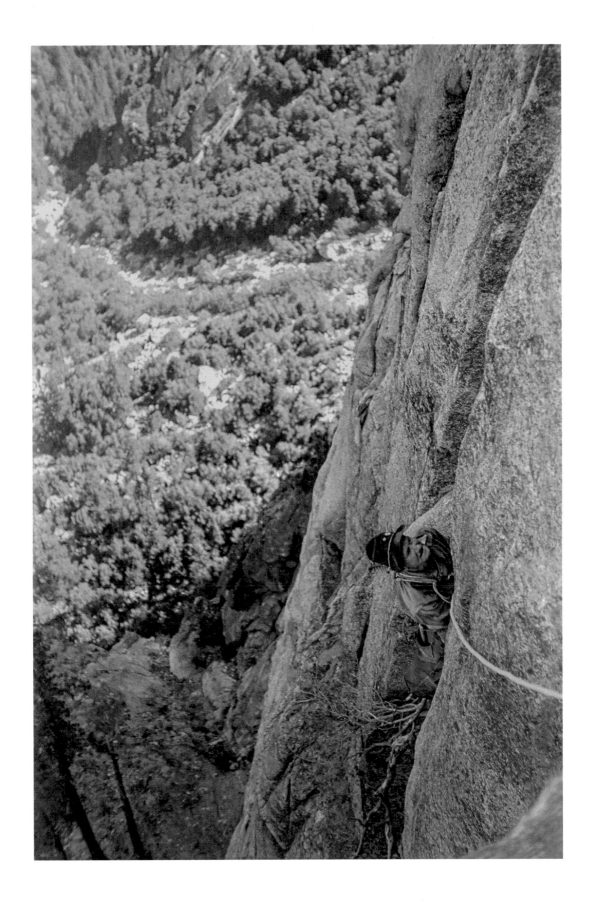

By this time, the sun was shining directly on our backs. We would learn later that the temperature in the valley approached 105 degrees. There was little wind, and thirst began to confound our enjoyment of the climbing. Our water, now rationed, was not going to last much longer. Glancing down at the valley we could see swimmers splashing around in the Merced River. This was an unexpected torment; the thought of suddenly finding myself in a cool, fragrant spring was maddening. I knew that Salathé was thirsty as well, but he didn't say much. One time, though, when he was standing near my belay with his hammer poised over the Star drill, he quietly said, "*Ja*, Al, shust I vud like a leetle glass of orange chuse." I could not have agreed more.

On reaching the beginning of the Great Chimney our spirits plummeted. A steep, flared slot soared above us, ending in a narrow section that seemed to defy further progress. I was beginning to ponder how we might escape this incredible wall. As our third day was coming to an end, we spied a bivouac site off to the right. Making our way over, we found that the sandy ledge was so narrow that we would be forced to sleep sitting up with our shoulders turned sideways.

After an unpleasant night I noticed a cave at the far end of the chimney and went to investigate. The opening was just big enough for me to enter, and I could see a possible way to wriggle upward into the darkness. After roping up, I did just this and soon, after scrambling around in the dark, found myself out in the open again, a hundred feet above Salathé, at the base of the constricted section now known as the Narrows. Because he was too bulky to manage the hidden chimney, I pulled up the rope and threw it down to him. Soon he prusiked up to my stance. He had left behind an empty water can plus some dates that he figured we wouldn't be wanting because of our intense thirst. For many years, subsequent parties would see the can, with its mantle of rust, as they entered the Great Chimney.

A menacing slot about the width of a human head rose above us. No way for us here. There seemed to be a way on the outer wall where the chimney was wider. As on the Headwall, cracks were rare, but Salathé managed to place some pitons that only someone with his skill could achieve. He eventually reached the outer face of the chimney and climbed onward, placing a few bolts, to an ample ledge where he yodeled down to tell me the good news. As I was getting ready to follow, I noticed a small mossy crack glistening in the shadows. I watched, my lips tight and drawn, as a little bead of water seeped out of the crack and slid smoothly down the rock. The trickle was barely enough to moisten my lips—a brief, wonderful sensation.

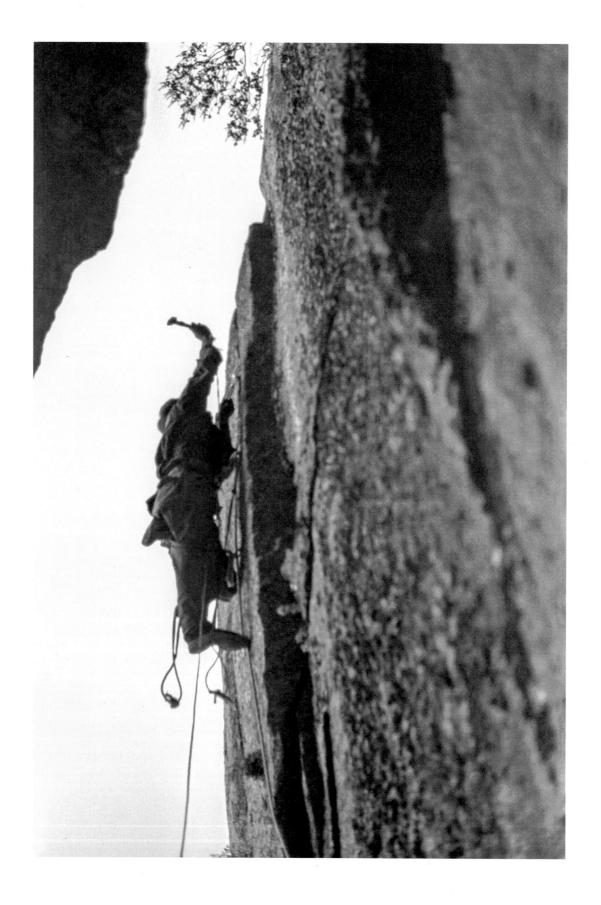

I managed the pitch without too much trouble and soon we were both looking upward at the more gentle terrain above. We could see some steep chimneys farther up the cliff. These difficult, strenuous pitches were agonizing in the hot sun. Still no wind. The packs got jammed in the chimneys, causing a great deal of wear on the nerves; bitter words were spoken and our tempers exploded. When Ax Nelson had heard of our plans, he remarked to Salathé, "If you expect to reach the top, Al will have to be every bit as stubborn as you." Salathé agreed that I was. "Al, your name, Schteck, cud be schteak, vile my name, Salathe, is salad," he commented. "So the meat-eater and the vegetarian are making the first ascent of the Sentinel north wall."

We were only two pitches from the summit when the day ended, and were forced to endure a painful bivouac hanging in a seated position from our anchors. In the morning there was one-half cup of water left and Salathé had to use his share to moisten his false teeth so they could slip into his mouth. Facing us was the last problem of the climb, a fifteen-foot vertical wall of slightly loose rock. I led this by placing several pitons for direct aid, and soon Salathé and I were lounging on the summit. It was about noon on July 4, our fifth day on the climb.

Our visit was brief, for the ordeal was not over. The awful thirst! We could see the thin, foamy line of Sentinel Creek and hurried on in desperate haste. I decided to rush down the gully leading to the stream while John traversed over to the water. I lost sight of him and in my haste missed a crucial bend in the gully. Some 200 feet lower I ended up at a steep, rocky face some thirty feet above the stream. It was steep enough that I would have to jump. I was not so far gone that I didn't realize I would break some bones, so I struggled back up through the hot, dusty brush until I reached the gully again. My judgment was numbed by the thought of water. I tripped over bushes, fell over unseen ledges, and finally collapsed fully clothed into a pool at the foot of a small waterfall, took out my cup, and poured water over my head until Salathé showed up.

We now faced the complex descent over steep, water-worn granite slabs down toward the Valley. Eventually we found our way to the Four-Mile Trail and a little farther down, our cache. We discovered that a bear had torn everything apart, including our sleeping bags. Salathé's Model T was a welcome sight. We motored on to Merced, where we stopped at a produce stand. John bought copious amounts of various fruits and I, too, ate them eagerly.

On pitch 15, the next-to-last pitch on the first ascent of the north face of Sentinel Rock. Photo: John Salathé

Three years passed before a trio of climbers from Southern California made the second ascent of the Steck-Salathé. Led by Royal Robbins, they not only managed to bypass the hidden chimney by climbing directly up the outer flared slot, but they also were the first to climb through the fifty-foot Narrows just above. And they did all this in just two days. It was a superb accomplishment. Robbins, already a force on the California climbing scene, would soon become the most prolific and gifted climber Yosemite Valley had yet seen.

The route was done another eight times in the 1950s, including the first one-day ascent by Robbins and Joe Fitschen. Then, in 1961, Robbins teamed up with Tom Frost and did the route in three hours and fourteen minutes! There would be thirty-seven ascents in the 1960s and soon the Steck-Salathé became a trade route, known above all for its strenuous chimneys and cracks. Of the route's fifteen pitches, only one involves face climbing.

The Narrows, though considered easy by most guidebook writers, became one of the most notorious pitches in Yosemite. There is nothing else quite like it anywhere in the Valley. You leave the belay stance and chimney up about six feet with perfect back and foot placements until a ceiling cuts off further progress. It's quite dark and there are no holds for your feet or hands. To proceed you must use an arm bar in the narrow constriction above and cut your feet loose, then wriggle your way up into the claustrophobic slot. The arm bar is an awkward and strenuous technique. You place your arm almost horizontally, with your hand on one side and elbow on the other, slightly higher, then jam it tightly with all the power you can find in your upper torso. You are now faced with the problem of moving upward by pressing your back, butt, knees, and feet against the smooth walls of the chimney. Once you are somewhat securely wedged into the fissure, you move your arm bar higher, and then repeat the inelegant movements of your lower body, progressing a few inches at a time until the chimney widens or better holds appear.

"Venting upward is a chute that starts as a perfect foot-to-butt span, but a roof quickly cuts it off to the width of an adult head," wrote Andy Selters of the Narrows in 2000. "I poked into it, facing right, and realized that I wouldn't be looking left for some time. I inched my neck, shoulders and then an arm into the split. When my upper body was wedged up as far as possible, I guessed I was supposed to just cut my feet loose and somehow monkey myself

upward with arm bars. I cut loose, pushed and grunted and whimpered with my feet cycling in midair and desperately came down." I was Andy's belayer, my fifth time on the route. He eventually climbed the pitch, which he protected with a large camming device, but I was so exhausted I had to bivouac at a horrible sloping stance, with Andy eighty feet above me.

With astonishing hubris I had decided to climb the route on the fiftieth anniversary of the first ascent, and Andy agreed to come with me since he had not yet done the route. At the age of seventy-five, I found the climb too strenuous for me, though I did manage to get to the top of pitch 9 on my own. Here, I ran out of energy and Andy had to haul me up the rest of the climb as best he could. At the bivouac, I wondered how I would be rescued from my terrible predicament: a helicopter, perhaps, or maybe some friends would come to help Andy get me off. Or they could just leave me there. Obviously, we did get to the summit, where I ate some food and regained enough strength to manage the descent.

Other contemporary accounts of the Narrows are equally riveting. In 1995, Dean Potter and Timmy O'Neill, two of the most talented modern Yosemite climbers, decided to climb the Steck-Salathé unroped. On arriving at the stance below the Narrows, they rested a bit. Dean would write later:

> Timmy went for it. Wedging his body right-side in, he shimmied up three or four feet and suddenly started shaking. Minutes dragged by, and he still hadn't moved more than a few feet above my perch. He thrashed back and forth, trying desperately to gain a few more inches. His legs kicked, searching blindly for footholds, then they went limp and dangled in the gaping maw in front of me.
>
> Timmy let out a moan and his body began convulsing uncontrollably. I bridged the chimney below him, feet on one side and hands on the other, just as he screamed, 'I'm coming out! Falling!' and cut loose. I caught his sliding legs and pushed up on his feet until he was through the most difficult portion of the slot.

Dean also managed the pitch, but not without incident, as he described:

> I was so nervous I thoughtlessly plunged into the roof chimney facing the same direction as Timmy (and) with quick, sporadic breaths, I wrestled for each upward inch. Timmy called out, "Grab my foot! Grab my foot!" But I was

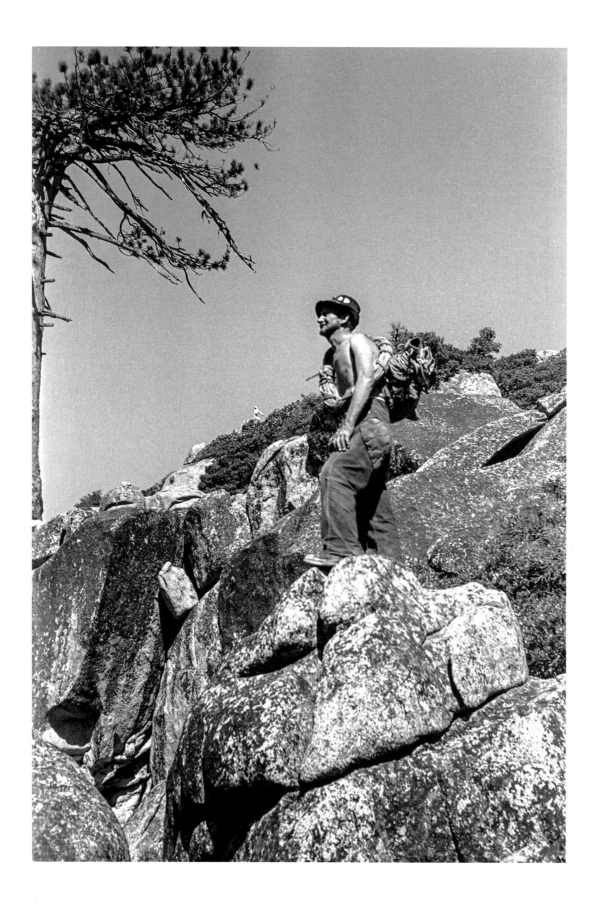

too proud and stupid.... Finally, I managed to bridge myself in the mouth of the Narrows, my body parallel to the ground 1,200 feet below. I was unable to move up, though. Timmy squirmed down closer to me and wedged himself in the slot like a human hex. I followed his orders and latched onto his little feet. Claustrophobic, nearly hyperventilating, I pulled myself from the brink of falling. We tunneled up to safety.

The north face of Sentinel still rises up in all its splendor above Camp 4 and casts a spell down upon the many climbers from a dozen different countries residing there. And the urge to climb it is as strong as ever.

John Salathé on Sentinel Rock's summit after the first ascent of the north face, 1950.

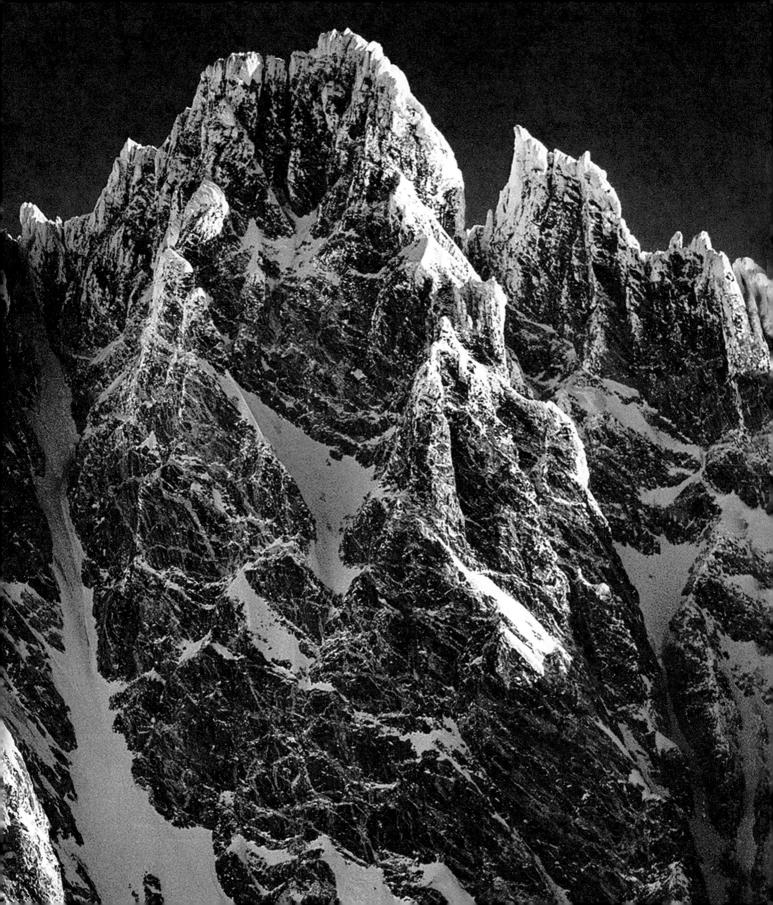

CLIMBS IN THE WADDINGTON RANGE OF BRITISH COLUMBIA

How many of us have traveled thousands of kilometers to enjoy the magnificent architecture of a distant peak? Yet one of the most impressive mountain ranges in the world lies just 280 kilometers northwest of Vancouver, British Columbia. The heavily glaciated Waddington massif consists of more than 600 square kilometers of peaks, glaciers, and valleys, culminating in the awe-inspiring cliffs and spires of Mount Waddington. At 4,019 meters, it the highest peak in Canada outside of the Yukon Territory. Some of the region's more than fifty glaciers are over twenty-four kilometers in length, originating at an elevation of 3,000 meters and descending to 300 meters above tidewater.

A group of friends had organized an expedition to Mount Waddington for the summer of 1950. We would be a party of eight. Jim Wilson, Bill Long, and Phil Bettler (who had been with me on early attempts on Sentinel), Ray de Saussure, Bill Dunmire, Oscar Cook, and Dick Houston were fellow members of the Sierra Club Rock Climbing Section. Thus, just a week after Salathé and I had finished the route on Sentinel, I joined the group on a dock in Vancouver where we awaited the ride of our lives.

Queen Charlotte Airlines would fly us to Ghost Lake just north of the Tiedemann Glacier. We were the first expedition to employ this approach to the region, a decision that saved us four or five days of thrashing along the lower Homathko River. Most of the group flew directly to Ghost Lake to begin the hike, while Houston and I came in a few days later after making an airdrop of supplies on the upper Tiedemann Glacier.

Mount Waddington summit towers, from the northeast. Photo: Barry Hagen

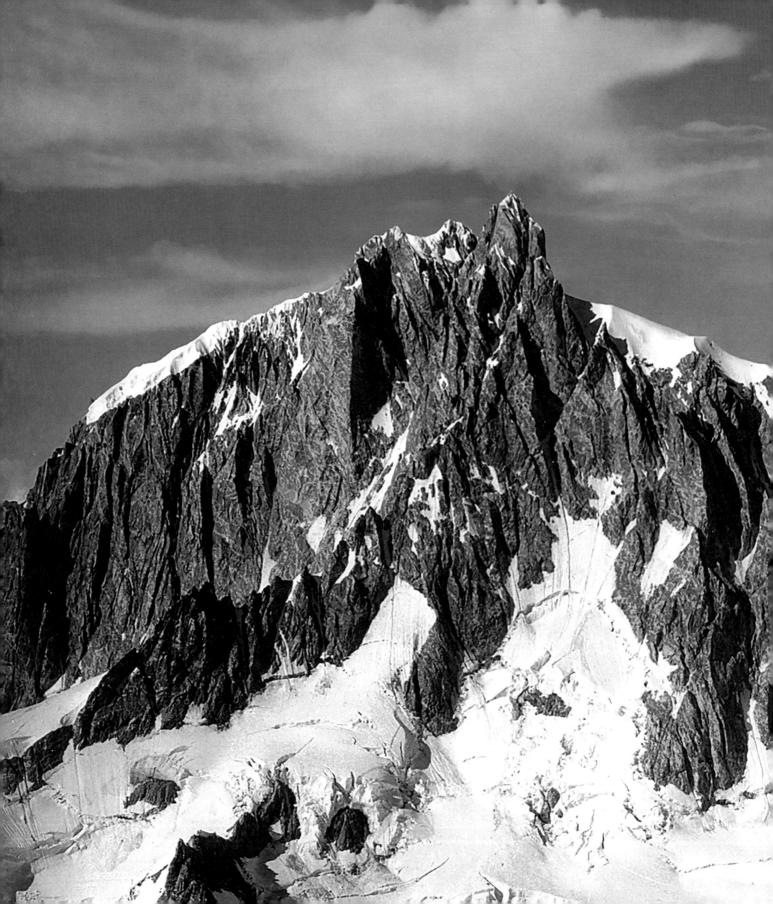

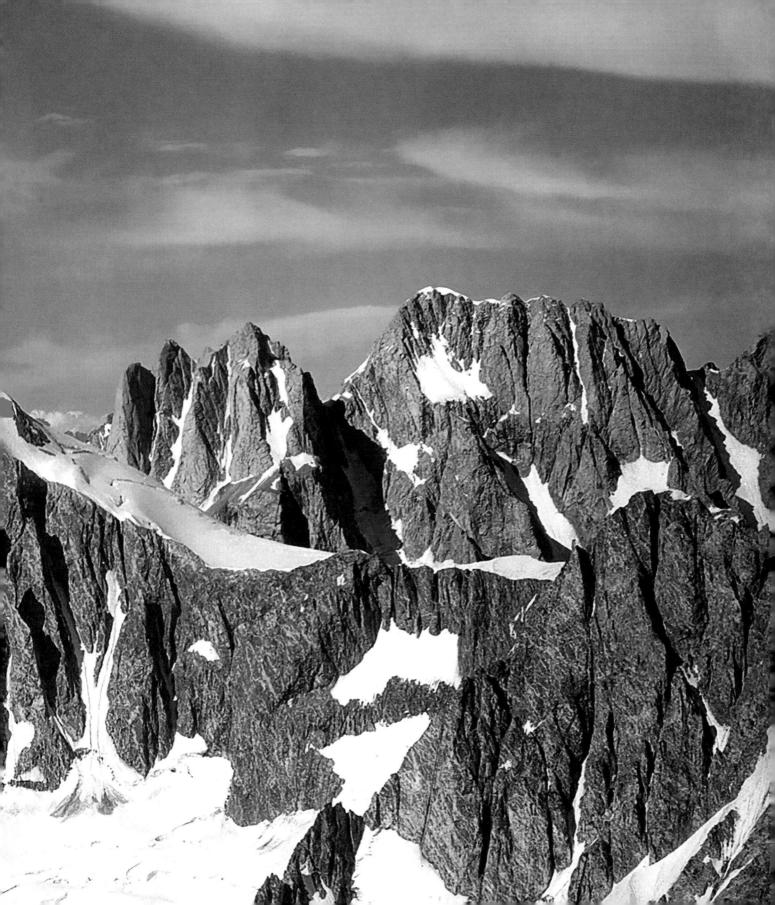

When it came time for Houston and me to take off, the rest of the team, we hoped, were already on the Tiedemann Glacier. We flew northwest and soon found ourselves above the fantastic fiord system to the east of Vancouver Island. Two of the largest inlets, Knight and Bute, end almost eight kilometers from the island. Waddington loomed in the distance. Soon we were over the glacier and saw our friends. The pilot gave us the signal, and we began shoving the boxes out of the hatch, much to the delight of the lads below. Then we veered off to the east and landed on Ghost Lake. The pilot brought his float plane to the edge of the lake, where we climbed ashore, and as we shouldered our packs he roared off on his return to Vancouver. We stood there for a moment, lost in admiration of the wilderness we had entered as the mists on the lake slowly dissolved. But soon the mosquitoes found us and we were obliged to move. Two days of marching through the forest brought us to the Tiedemann Glacier and a reunion with the rest of our team.

Our plan was to set up a base camp at the foot of the Bravo Icefall and a high camp on snowfields just below the rocky spire of the summit. The south face of Waddington had acquired an unsavory reputation for dangerous rockfall, hence our decision to approach from the Tiedemann Glacier. We hoped the rock would be more stable on the northern cliffs, which on closer examination proved to be the case. A high camp on the north side would also be over 300 meters closer to the summit than one on the south side.

Getting up the Bravo Icefall, however, was a serious undertaking owing to the intricate, dangerous collection of huge crevasses, séracs, and ice walls that we had to navigate. We split into two groups with Long, Wilson, de Saussure, and I being the first to tackle the Bravo. We managed this without mishap and in two days had established our high camp close to the final tower. All four of us made an attempt on the summit, but were stopped late in the day at the notch separating the Fang from the main tower. Bill Long described the scene in his article in the 1951 *Sierra Club Bulletin:* "Ahead of us was the impossible-looking southeast chimney, choked by three chockstones from which great icicles hung. The entire summit tower was plastered deep with rime."

The others now joined us, and we spent another day exploring possible routes on the fearsome tower above us. Luckily the weather held. There was a serious discussion in the evening while we sorted out who was going to do what during our final push. Having scouted its defenses, I thought the north face looked like a superior route and convinced Bettler, Dunmire, and Wilson to join me. Long and the others would attempt the southeast chimney. We left together in the morning of June 21 with a temperature reading of twenty degrees. Long's group arrived at the familiar notch and began work on the east chimney,

[Previous Spread] Aerial photo of great southeast aspects of the Waddington group. From left to right are Mount Waddington and, behind, Mount Combatant and Mount Tiedemann. Photo: Austin Post

[Right] Crossing a crevasse on the Tiedemann Glacier beneath Mount Waddington.

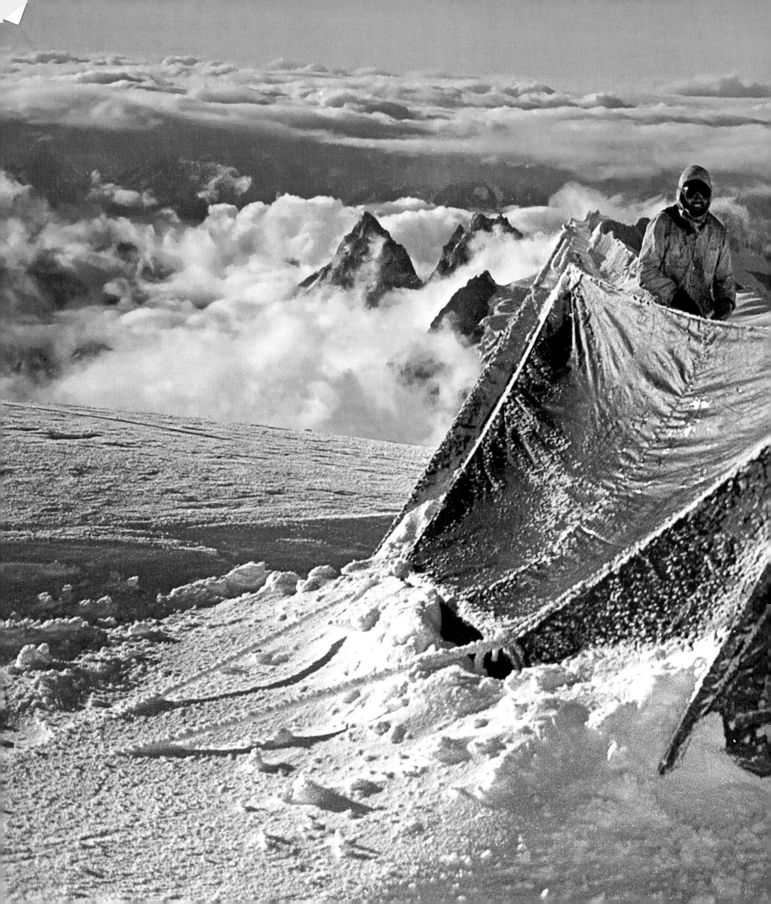

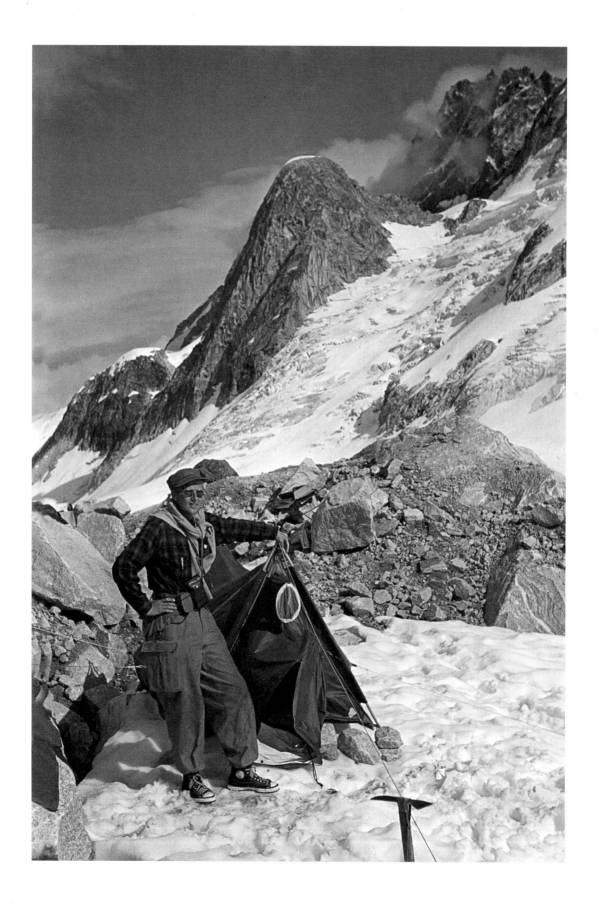

finding good piton placements and less difficult climbing around the chockstones than they had anticipated. They reached the summit at the early hour of two in the afternoon, making the first ascent of the southeast chimney route on Mount Waddington.

As for those of us on the north face, we found a way over the bergschrund and traversed until it was possible to climb directly up to the west ridge, which we reached at around three o'clock, after some precarious leads. Luckily, the weather remained stable though cold. Dunmire and Wilson decided to wait while Bettler and I traversed several pitches along unknown terrain, including a pendulum across a large gap. We could hear Long's voice when we got to the summit, so we were only about an hour behind his group. Our descent was not easy. After a few rappels, we ran out of small angles and I was forced to down climb several sections to avoid leaving any of our remaining pitons. We even bivouacked for a few hours, eventually arriving in camp at four in the morning. The others had come in at ten the night before.

The weather held and we were able to climb the Fang, the amazing eastern summit of the Waddington massif. This ascent, on the sheer south side of the tower, involved a good bit of direct aid up through the ice feathers to the top. A great contentment lay over all of us. We'd made the third ascent of Waddington by two new routes. Not surprisingly, most all future parties would use this southeast chimney route to reach the summit, as it was so much easier and less exposed to rockfall than the south face. Fritz Wiessner and Bill House made the first ascent of Waddington via the south face in 1938; Fred and Helmy Beckey repeated the same route in 1942.

So ended our adventures on Waddington, but more exciting times awaited us since we still had several weeks left before hiking out to Bluff Lake and returning to Vancouver.

On July 29, we decided to climb the north side of Mount Munday where we would begin the traverse of all the peaks on the ridge leading southeast along the Tiedemann Glacier. "Ten days later, and twenty days hungrier, we were to drag ourselves to [base camp] and thank our lucky stars that we had made it," wrote Long of our adventures. "[That] week and a half was to be the most dangerous and the most trying part of the trip." These routes would be, except for Mount Munday, all first ascents, as no one had been along this ridge before. By the third day of fine weather we had climbed seven summits, including a complete traverse of the Mount Grenelle ridge. On our descent to Echo Col, after climbing Sierra Peak and Fascination Mountain, we began to wonder how we were going to get back to the Tiedemann. Our luck dwindled as a storm system moved in and we realized that only

[Previous Spread] Jim Wilson at high camp on Waddington after a storm, before going for the summit. Note the US Army surplus tent. [Left] Oscar Cook at Tiedemann Glacier camp near Mount Waddington, 1950.

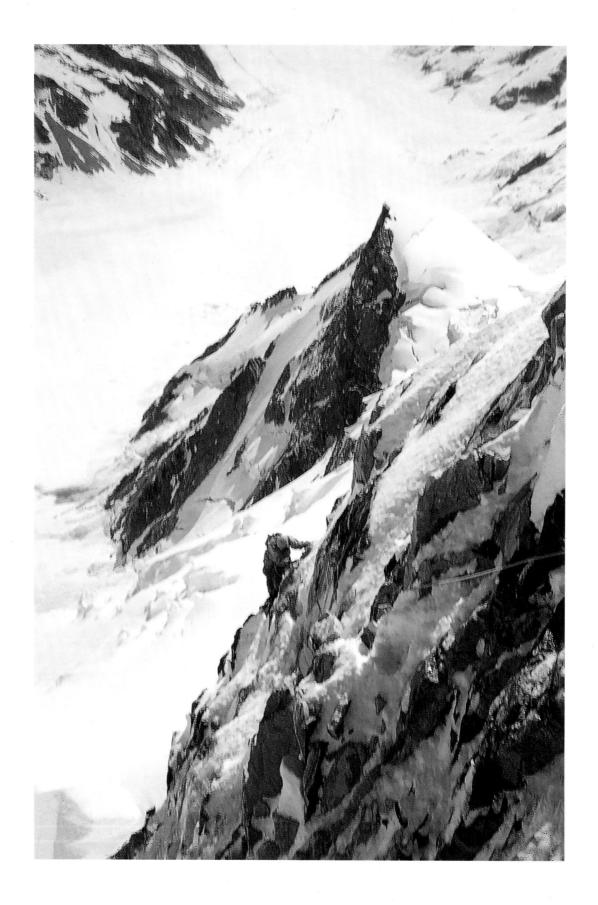

three days of food remained. Our maps were sketchy and morale sank. Waiting in the fog on half rations for three days was oppressive; finally, the sun appeared on August 7, and in a frenzy of activity we found a way back to the Tiedemann by descending from the col of Mount Marcus Smith. Back at base camp a few days of orgiastic food consumption ensued.

During these final days, parties headed out in different directions: Long, Bettler, and I went up to the Tellot Glacier; Wilson and Dunmire went to Mount Marcus Smith; and Houston and de Saussure went to Mount Jeffery. First ascents were enjoyed by all. Those of us on the Tellot enjoyed ascents of Mount Stiletto and the Serra Peaks. "The climbing was excellent and the glorious scenery from the upper Tellot unsurpassed," wrote Long of the joyous moments we shared. "In the evenings, as the sun would be stretching its last rays to tint the towering peak with delicate pastels, we would stand silent outside our tent, drinking in the beauty that was spread around us in every direction."

We all met at our camp on the Tellot and began the return to civilization by descending Cataract Glacier, crossing Scimitar Glacier, and thrashing out the Moseley Creek drainage to the roadhead. Houston and Cook had been here before during their 1947 excursion to the Tellot Glacier and knew the terrain well. But that made it no easier as we waded icy streams with our legs numb to midthigh, or struggled through, under, around, and over avalanched-felled timber with heavy packs tormenting our backs. At one river crossing I found a good-sized log and as I reached the opposite bank I pretended to lose my balance to tease those following—but the ruse failed and I plunged off the log into the river's edge. What a surprise when I actually landed on some branches and barely got wet! Those behind, thinking the crossing was too difficult, went downstream to find another log. Just before reaching Bluff Lake, Cook told us they had waded across the upper part of Middle Lake, which worked again for us three years later.

"Nothing but the best can be said for our trip," Long happily concluded. "It has been one of the grandest experiences and successes of my life."

One of my partners climbing during the first ascent of the northeast face of Mount Waddington.

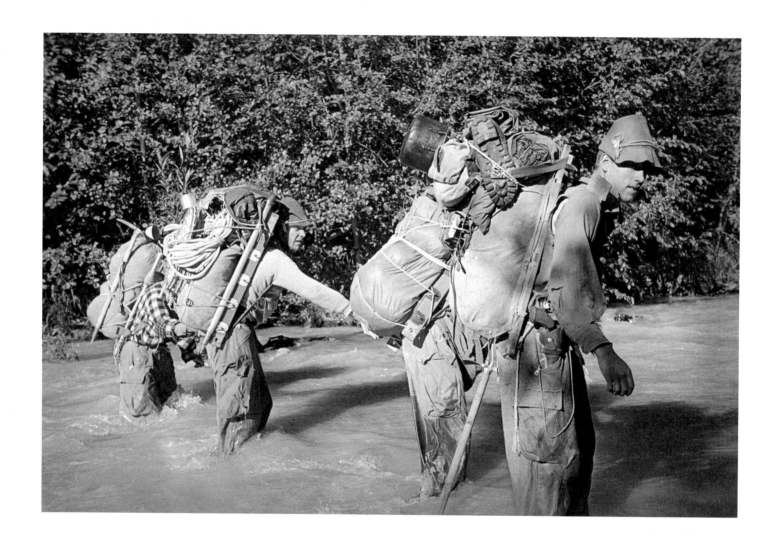

[Above] The Waddington expedition crossing Twist Creek on the return from the trek. Note the frame packs and pistol in case of grizzlies. From left to right are Phil Bettler, Glenn Dunmire, unknown, and Bill Long. [Right] The Mount Waddington 1950 team pioneered many new ascents. From left, top row: Phil Bettler, Jim Wilson, Oscar Cook, Bill Dunmire. Middle row: Dick Houston, Bill Long, myself. Front: Ray de Saussure. Photo: *The Vancouver Sun*

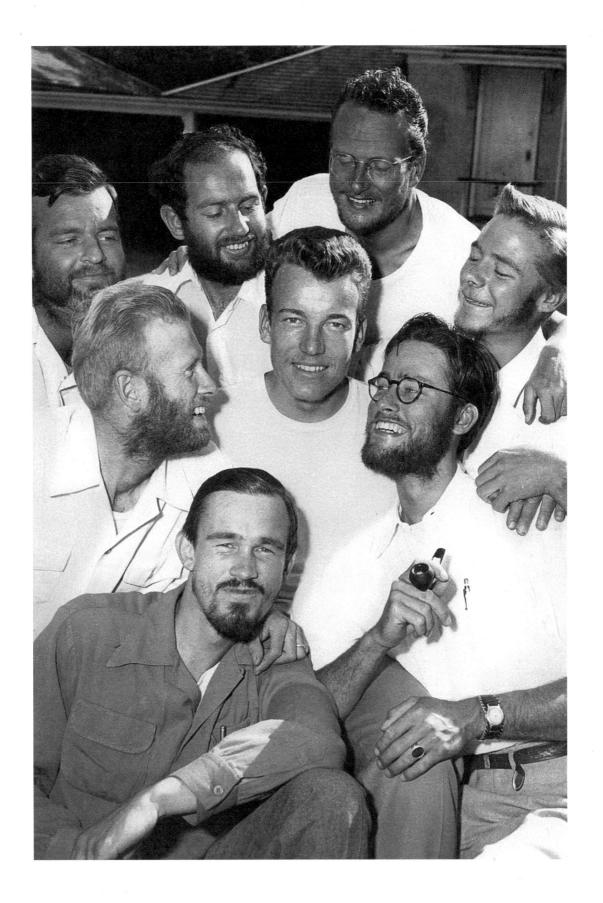

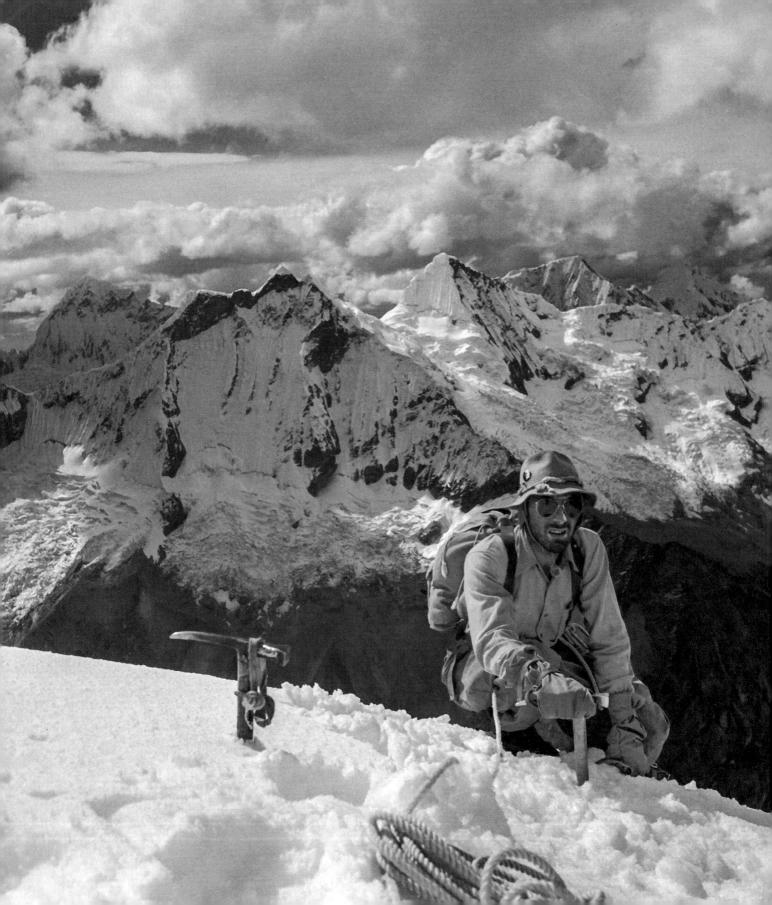

A TRAGIC ADVENTURE IN THE CORDILLERA BLANCA OF PERU

Peru's Cordillera Blanca is one of the most beautiful mountain ranges in the world. The casual observer might think that its modest length of 180 kilometers and width of 22 kilometers would contain few mountains of interest, but surprisingly there are more than 27 peaks over 6,000 meters and another 25 or so above 5,750 meters. The Himalayas may surpass this range in height but not in beauty.

The first major team to explore this tropical range was led by Dr. Hans Kinzl in 1932. During successive trips in 1936 and 1939, Kinzl and his friends from Austria made ascents of most of the major summits. In 1950, Kinzl and Erwin Schneider published a beautiful book, *Cordillera Blanca*, containing numerous photographs along with information on the many facets of this mountaineering paradise. Included in the book is an excellent map of the region prepared by Schneider. One need only look at the huge cornices on Nevado Alpamayo to realize that massive amounts of snowfall on these peaks, carried by storms from the Amazon jungle in the east during the rainy season.

Will Siri, a research physiologist at the Donner Laboratory of the U.C. Berkeley, had traveled to Peru in 1950 along with other members of the lab and its director, Dr. John Lawrence, to study high-altitude physiology. When plans were made in late 1951 to continue this research, Siri proposed including a group of climbers so the scientists could work within an actual mountaineering environment at around 5,500 meters. As the US Air Force plane

Will Siri reaching the summit of Nevado Huandoy East peak, completing the first ascent of the peak. They returned after dark with the help of a full moon and Leigh Ortenburger, who, sick, remained in camp and set a lantern to guide their way back.

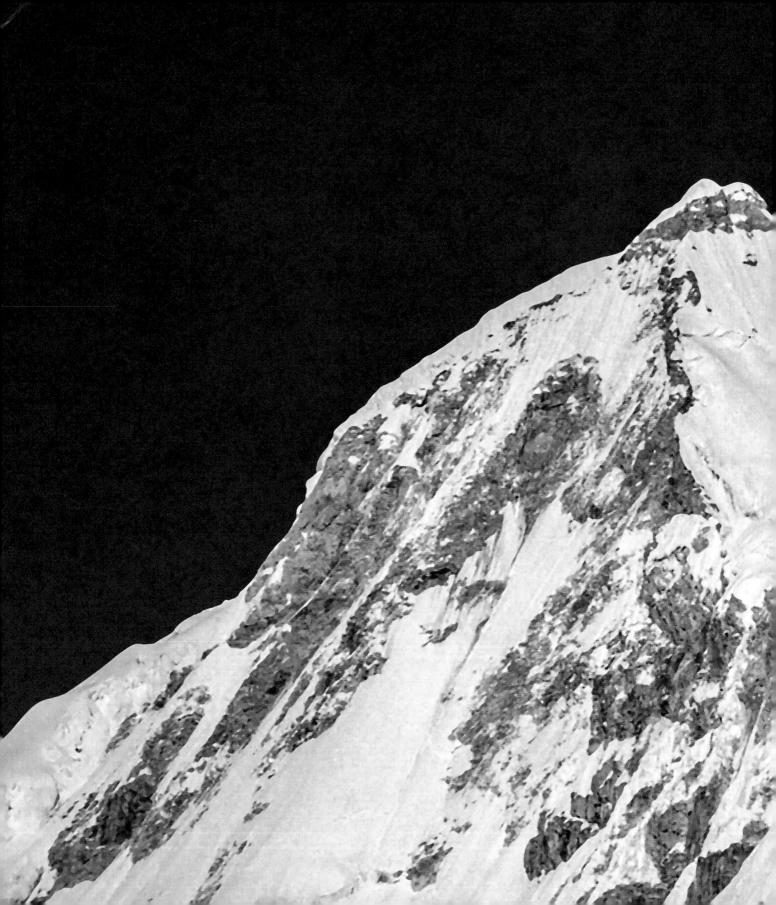

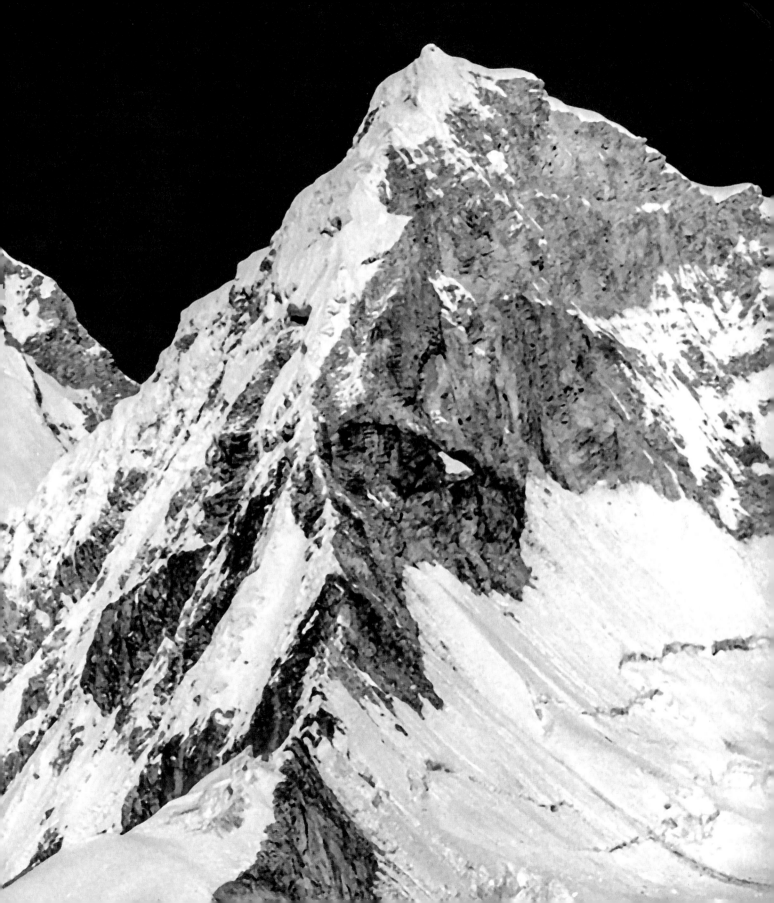

[Previous Spread] Nevado Huandoy main peak (left) and east peak (right), 1952, photo taken from Nevado Pisco. After acclimatizing on Pisco, the party later set a camp for the east peak of Huandoy. [Above] Expedition Quechua porters at Huandoy base camp.

carrying the Donner Laboratory researchers to Lima had space for the additional climbers and their equipment, Siri's proposal was accepted. The team, led by Siri, included Oscar Cook, Fletcher Hoyt, Leigh Ortenburger, Peter Hoessly, and myself. I had not climbed much with the others, but had done a number of ascents in Yosemite with Hoyt. Once a high camp was established, Siri and Hoessly, a physician, would conduct physiological studies on the team.

Not long after our arrival in Lima in July 1952 we were delighted to be invited by the pilots of our plane to make a photoreconnaissance flight around the range. Of particular interest to us was the Huandoy massif and neighboring Nevado Pisco, which Siri had decided would be desirable goals for our expedition. After some time in Lima to prepare our food and equipment, we departed on July 10 for the two-day truck ride to Huaráz, the capital of the province of Ancash, located at the foot of the Cordillera at an altitude of about 3,000 meters. Here we were welcomed by members of the Grupo Andinista of Huaráz, who helped us become better acquainted with the region.

After several days in Huaráz to acclimatize, we were off to Yungay, where we found seven porters and ten burros ready to move our loads up the Yanganuco Valley. The burros carried the loads twenty-nine kilometers to the head of the valley, where they would be relayed to higher camps by the porters. Our intention was to set up a high camp on the plateau between the three main peaks of Huandoy, but when we arrived at the glacier with its intricate web of crevasses and ice cliffs it became clear that our porters would be unable to negotiate such difficult terrain. The only alternative was to place our 5,500-meter-high camp on the saddle separating the northeast ridge of Huandoy with Nevado Pisco farther to the east. Eliseo Vargas, Marcario Angeles (the foreman), and Felipe were the most helpful of our porters. They would be our constant companions for the rest of the trip.

By July 19 we had established our 4,850-meter camp just below the saddle, and Ortenburger and I had made a carry to the high camp, Camp V. Hoyt and Siri brought some loads up the following day and returned to Camp IV. On July 22, while preparations were made for all to occupy Camp V, Siri noticed that Cook was not responding to calls for him to get ready. Cook had shown symptoms of altitude sickness and seemed to be acclimatizing slowly. Siri went to his tent and found him in a coma and unresponsive.

It was clear that Cook would have to be moved as quickly as possible to a lower elevation. Hoyt was able to fashion a litter out of a climbing rope and began the descent. Ortenburger and I came down from Camp V and we all struggled to carry Cook through the horrible

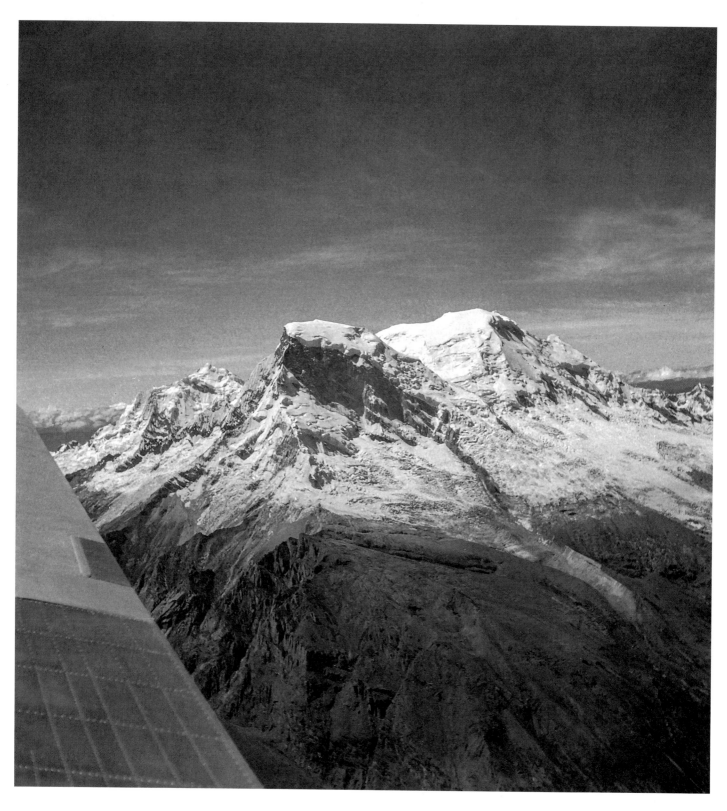

Aerial photo from 18,000 feet of Nevado Huascarán, the highest peak in Peru. The flight was courtesy of the US Air Force, and without a pressurized cabin or oxygen the climber-passengers became quite groggy.

Base camp below the main peak of Huandoy.

glacial debris and scree slopes to the first high alpine meadow. While we took a brief rest here, Cook succumbed, still comatose, to what was then thought to be pneumonia. It was July 23. Now, sixty-three years later, physiologists would most likely attribute his death to high-altitude cerebral edema.

Siri and Hoessly left immediately for Yungay, where they arranged to have Cook's body sent back to Lima and then on to the United States. They also notified Cook's parents of his death. Our four porters, along with Ortenburger, Hoyt, and me, now faced the dreadful task of carrying Cook's body, mostly during the night, down the torturous twenty-nine-kilometer trail back to Yungay.

Little time now remained. Eight days had been required to get Cook's body back to Lima and for us to return to Camp V. To further complicate matters our return flight had been advanced a week. There was only enough time to climb Nevado Pisco and the 6,000-meter East Peak of Huandoy. Our faithful porters Eliseo, Marcario, and Felipe were still with us. Nevado Pisco was an easy ascent and after a few days of rest, on August 1, Hoessly, Siri, Hoyt, and I arose before sunrise in twenty-degree temperatures and began preparing for a long day on two new routes on the East Peak of Huandoy. Hoessly and Hoyt would tackle the north ridge, Siri and I, the northeast face. Unfortunately, Ortenburger could not join us because of an intestinal disorder.

The climbing was not very difficult but the loose rock was a constant danger. All four of us reached the summit in the early afternoon after about 600 meters of climbing, and soon the laborious descent began. With only about three hours of sunlight remaining, a bivouac seemed likely but we kept going as the moon rose. Rappel anchors were difficult to arrange and loose rock slowed us considerably. During the last hours of our descent we were cheered by a tiny point of light from a Coleman lantern Ortenburger had set out to help guide us back to our tents. At around midnight we stumbled back to camp, enjoyed festive cups of tea and hot soup that Ortenburger had prepared, and happily crawled into our sleeping bags.

With the help of our hardworking porters we made rapid progress back to Yungay and Huaráz and sadly faced the imminent return to civilization. There had been time for two ascents, but none at all for Siri's carefully prepared high-altitude studies. A marvelous reception prepared by the Grupo Andinista did raise our spirits considerably as we bade farewell to Peru.

Fletcher Hoyt climbing Nevado Pisco, Cordillera Blanca. Our party used this climb as a warm-up and acclimatization ascent.

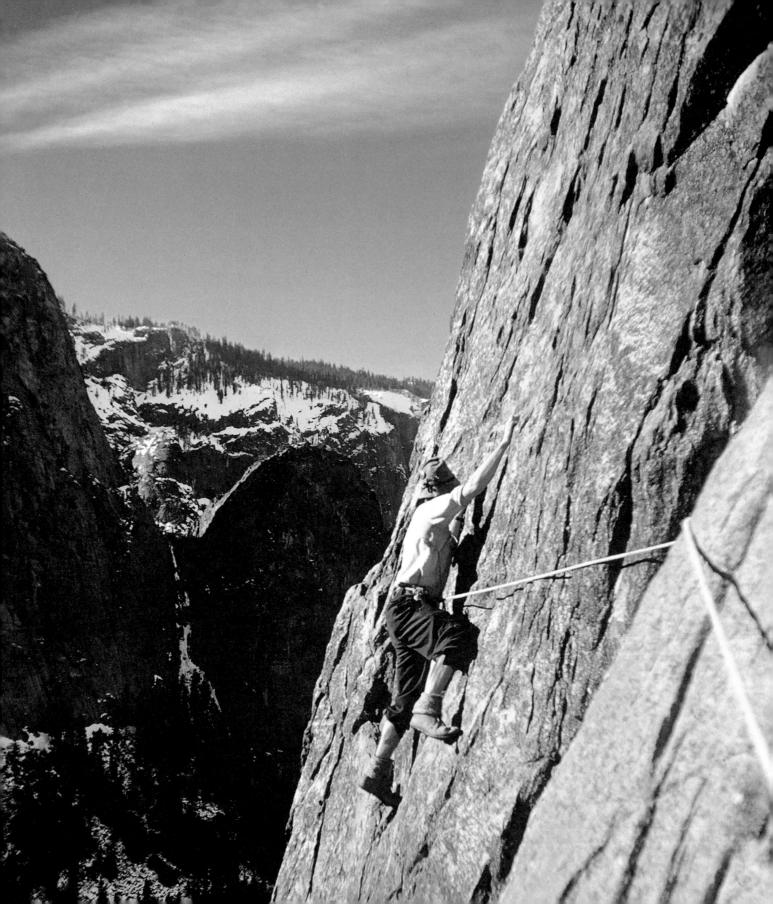

THE EAST BUTTRESS OF EL CAPITAN

I continued to be drawn to Yosemite's many unexplored routes. One was the buttress at the eastern edge of El Capitan. Unlike the steep, flawless walls farther to the west, this area seemed to have many cracks, chimneys, and fractured faces on good, solid rock. Thus began my fascination with the East Buttress of El Cap.

One attempt in October 1952 nearly ended in disaster. I hiked up to the western base of the buttress with Bill Dunmire and Bill and Dick Long, looking for a climbable line on the wall in front of us. Dunmire was leading using pitons for direct aid when he slipped. Two of his pins pulled out and the third held his fall just as his head and shoulder crashed into the rocks beside us. He was conscious but had a concussion and quickly lost a good deal of blood. I still recall him sitting up, unable to remember where he was or what he was doing. An overnight visit to the local hospital brought him back to normal. He would tell me later that he decided then to give up rock climbing.

I subsequently made several more attempts, on one of which Willi Unsoeld and I discovered the line that enabled us to get higher. The first pitch was a very strenuous chimney with complex walls that always seemed to face in the wrong direction. The next pitch involved a step-across using aid, followed by another chimney leading to the infamous ant tree. This tree provided a perfect belay except that it was populated by thousands of biting ants. We passed this point in a big hurry and belayed higher up. There was a certain stupidity about

Leading on the first day of the first ascent of the East Buttress, El Capitan, March 1952. Snow covers the valley floor while climbers enjoy sunshine on the route in early spring. Note that I am just tied directly into the rope, no harnesses in those days. Photo: Willi Unsoeld

these early attempts. Why was it that we always found ourselves on the route early in the spring? Just 200 yards to the west, Horsetail Falls came off the edge of El Cap and at 2:00 in the afternoon, predictable winds blew the water over onto the East Buttress, making climbing an unpleasant, almost impossible affair.

In March 1953, Unsoeld and I went back to the East Buttress for a serious attempt. We hoped to reach the pedestal, a prominent feature midway up the buttress. We figured out some improvements in the lower pitches, particularly the minimally protected traverse out onto the main arête, but when we reached the pedestal it was late in the day and the rock was wet. I led the next pitch and brought him up. We were on new terrain and the climbing suddenly became quite hard. Unsoeld took the lead and got thirty feet up, at which point he decided he'd had enough; darkness was approaching. I couldn't see clearly what he was doing, but eventually he called down saying he had a solid piton and asking me to lower him back to my anchors. Just as he stepped onto some good footholds at my shoulder, the entire rope suddenly came swirling down. He was safe, but the reason for the incident soon became clear. In arranging his descent, Unsoeld had run the rope through several loops of parachute cord attached to the piton in order to save a carabiner. As he lowered, the climbing rope had sawn completely through the parachute cord, which parted just as he reached the security of the holds. With his typically sly smile, Unsoeld calmly said, "I planned it that way so we wouldn't have to untie and pull the rope through." A terrible disaster was avoided.

Our troubles were not over, as we still had a complex descent to finish in the dark. We opted to rappel directly down to the talus using the many small trees growing out of cracks in the vertical wall. The first bay tree we reached was so full of pollen that we were soon coughing and sneezing out of control, hanging like bats on the twisted limbs. Setting up rappels in the dark is no easy task and when I got onto the rope for the next one, Unsoeld let out a painful howl: the rope somehow had gone over his thigh. We eventually reached the valley floor after a very thrilling day on the cliffs.

Unsoeld and I teamed up with Bill Long and Will Siri in late May with the hope of finishing the ascent. There were still several more pitches to explore above our previous high point, including two involving complex aid. We finally reached the top on June 1 after three days of climbing, some of it in the rain. Subsequent parties improved the route by finding a clever traverse that bypassed the aid pitches. The East Buttress is now one of the most popular climbs in Yosemite.

Will Siri cleaning the ninth pitch, on the second day. Willi Unsoeld is in the alcove below, and Bill Long is at the tower below that, where the trio bivouacked. Note the body rappel abrasion patch on Siri's shoulder.

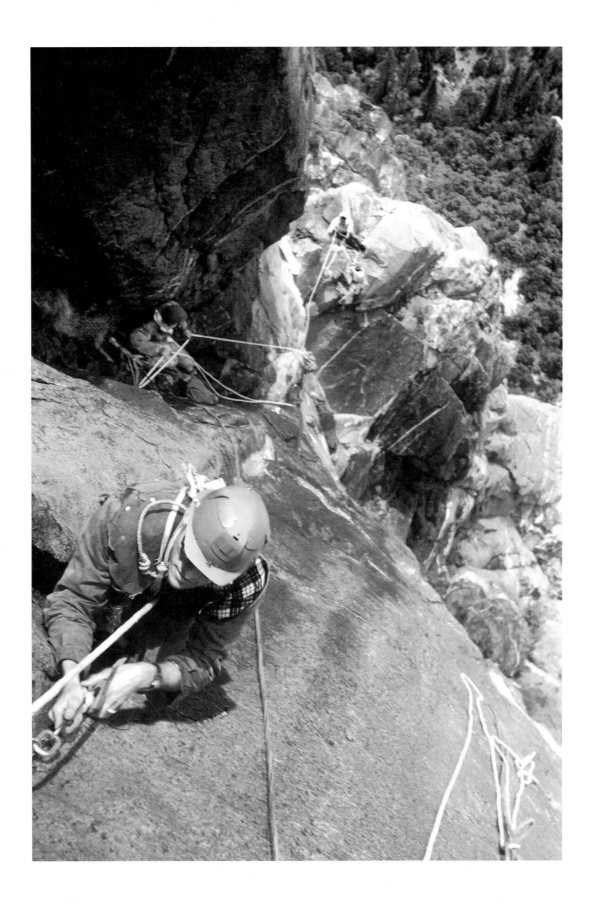

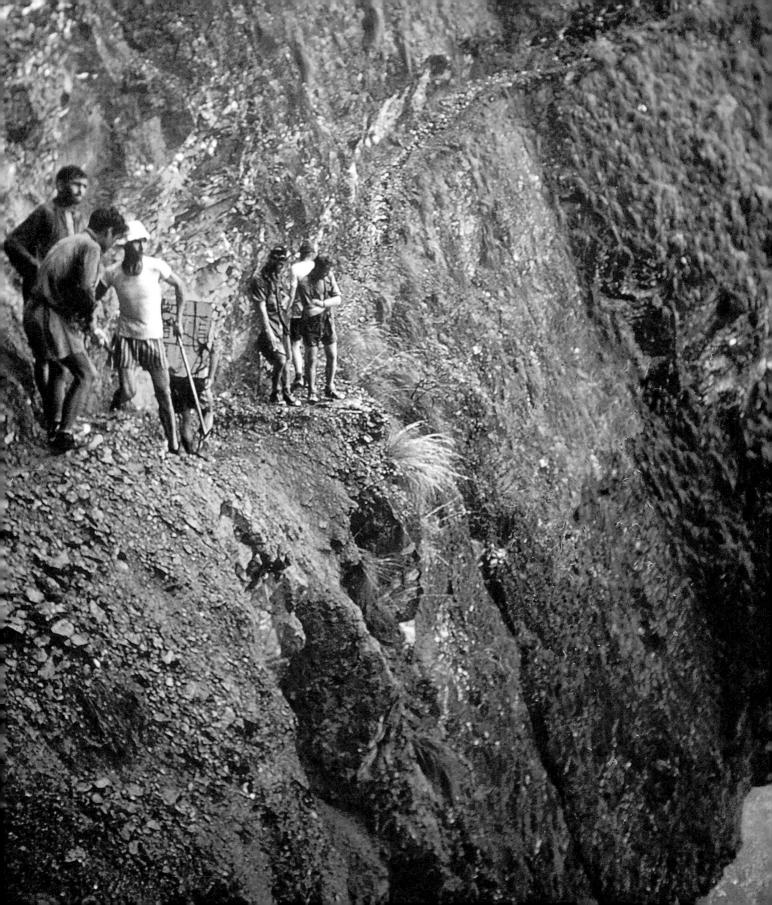

AN ATTEMPT ON MAKALU

On a rainy evening in late 1951 several local climbers gathered at the home of Alfred Baxter in Oakland, California, to discuss the possibility of doing a climb somewhere in the Nepal Himalaya. It was Baxter's idea, but the rest of us, who had also gotten our training with the Sierra Club Rock Climbing Section, were greatly excited by the possibility of venturing into the great ranges: the California Himalayan Committee was born. We were soon able to acquire much valuable advice and support from the Sierra Club Board of Directors as well as the American Alpine Club, of which several of us were members.

Will Siri became an important member of our committee and was eventually chosen as leader of a proposed expedition to Makalu, at 8,485 meters the world's fifth highest peak. He and Dr. Nello Pace, a physiologist who would undertake studies in high-altitude physiology at the Makalu base camp, were able to get the US Air Force and the National Science Foundation interested enough in the proposed research to provide funding and contributions of material and services. The Air Force offered to transport the expedition members and all our equipment from the Bay Area to Calcutta and return on a space-available basis. The other members of the expedition were myself, manager of The Ski Hut, a Berkeley climbing and backpacking equipment store; Dr. Bruce Meyer, an orthopedic surgeon living in Carmel; Dick Houston and Fritz Lippmann, both high school teachers living in San Francisco; Bill Dunmire, an enthusiastic birder as well as climber; Bill Long, who was to

Nepali porters on a cliff traverse in the Barun Canyon. The party, especially their Sherpas, had to construct parts of the trail to Makalu, including driving logs into cliffs to support a ledge trail.

become a tower of strength high on the mountain; and last but not least, Willi Unsoeld, a recent graduate of the Pacific School of Religion in Berkeley. Willi had some expedition experience gained during a 1949 climbing trip to Nilkanta in the Garhwal region of India. Dr. Lawrence Swan would travel with us to conduct research in the field of high-altitude plant and animal relationships.

Most of us were well-read in the history of the highest mountains in the world, that group of fourteen peaks above 8,000 meters. It was extremely audacious to choose one of these, for few of us had ever climbed at high altitude. Several had climbed Mount Waddington and Mount Robson in Canada, and Will Siri and I had gotten to 6,500 meters in Peru, the highest any of us had been. We had hoped to attempt Dhaulagiri, a partially explored 8,167-meter peak near Annapurna, but a Swiss team had already received permission from the Nepalese government. (In those days only a single team was usually authorized to climb each high peak.) We then asked for Makalu, and toward the end of 1953 the government gave us permission. Makalu had no climbing history; we would be faced with writing the first chapter.

In 1921, a British reconnaissance party attempting to reach the north side of Mount Everest had circled to the east of Makalu and reported that the east ridge looked quite difficult. A British aerial survey of the region in 1933 offered a new perspective on Makalu. In 1952, a party headed by Eric Shipton explored the western approaches to the peak. They stood on the floor of the Barun Khola, a deep valley that borders Makalu on the west, and looked up at the 3,600-meter wall that guards the approach to the summit. They were doubtful that the north ridge offered an easy route and found the southeast ridge even less encouraging.

Our work now began in earnest. Our budget of $51,000 was small by comparison with most European expeditions. We began to solicit contributions of funds and equipment from various organizations and individuals. A large portion of our budget came from members of the Sierra Club. We worked in a frenzy collecting all the equipment and food and packing it into 240 boxes and crates. More than anyone else, our wives deserve the highest praise. They endured over two years of planning and though they conscientiously avoided our tiresome meetings, they spent tedious hours helping us sort and pack equipment and type up lengthy inventory lists. In January 1954, we shipped the crates to Calcutta before we even had word from the Air Force that they had room for us on a flight to Asia.

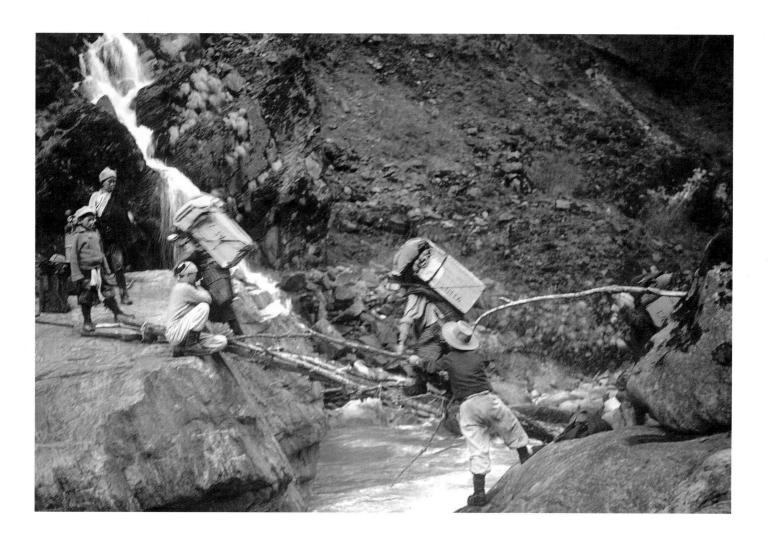

Nepali porters crossing a log bridge on the way to Makalu.

On February 27, 1954, our aircraft circled the sprawling city of Calcutta, gliding down onto Dum Dum Airport. Here, serious troubles began as we entered into a two-week struggle with Indian customs to get permission to transship our crates to Nepal free of duty.

Finally, a train carried us northward across the dry plain beyond the Ganges to Biratnagar, Nepal, where our fourteen Sherpas, who had traveled from Darjeeling, met us with broad grins of enthusiasm. From Biratnagar we traveled sixty-four kilometers by truck to Dharan, where we found 250 porters awaiting our arrival. Surprisingly, everything was ready for immediate departure owing to the organizational ability of Sirdar Angtharkay, of Everest and Annapurna fame, who was our chief Sherpa and transport officer. It was clear that he commanded the deepest respect from the Sherpas and Nepalese porters, and that our journey from Dharan to base camp would proceed without undue difficulty.

Our orange-colored boxes were distributed to the porters and we began the three-week trek through this rarely visited portion of Nepal. The first part of the journey followed the Arun River. Fires to clear the fields burned everywhere in these lower hills, and the resulting haze obscured our view of the distant, ice-clad mountains. We left the Arun at the village of Num, where we encountered one of the well-known Nepalese bamboo suspension bridges. Hanging fifteen meters above a major stream, the undulating span did not appear durable enough to sustain the wear and tear of 250 heavily laden porters crossing it. And in the stream below was a daunting sight: the remains of an older bridge that lay scattered about in the rocks and water. It was clear that a new bridge would not be built until the one in use had collapsed as well. Nevertheless, after a day of caution and effort we managed to get all the porters and loads across. It was wondrous to see the porters with their orange boxes moving along the well-traveled path. We had to climb one enormous hill in the blazing sun, and at the top I saw a small shack dispensing a beverage. To my complete surprise I found they were offering hot tea!

Climbing the steep path that day, I recalled a book about Nepal I'd found in my local library some time before and read eagerly in anticipation of the upcoming trip. The author was Percy Brown, an Englishman, and he offered a fantastic amount of information about this marvelous country. Of considerable interest to me had been Brown's description of a certain method of travel in the backcountry: "Lying full length in my palanquin, the gentle motion caused by the bearers, the soft patter of their bare feet as they shuffle along, their steady grunting chorus, the song of birds, the hum of insects, the slowly moving landscape, all combine to produce a feeling of complete rest to both mind and body, which must be experienced to be appreciated." How I wished I could travel in such a manner on the way to Makalu.

Beyond Num we began climbing steadily and eventually entered a jungle-like forest of rhododendron. Soon, the seldom-used trail was covered with snow and when a dense fog suddenly appeared, we realized that we were basically lost. We camped while two reconnaissance parties set out to locate the trail. A deep gorge lay to the east and it occurred to us that it might contain the Barun River. Bill Long and Willi Unsoeld climbed up to the crest and reported to Siri by radio that all they could see were snow-covered cliffs and ravines. Bill Dunmire and I descended into the 250-meter-deep gorge and hiked for several hours over the hard avalanche snow that bridged the torrent. Dark cliffs of disintegrating rock lurked above. Returning to camp exhausted, we told the others that we thought it was the Barun. The following morning we moved down into the canyon. It was easy going, but steep passages on the side cliffs forced the Sherpas to hammer bamboo and rhododendron limbs into cracks so a bridge could be built for the porters.

Eventually, the Barun Gorge widened and we emerged upon a rich pastureland set between massive walls of granite. At 4,000 meters, we made camp in the growing gloom of a snowstorm. Our Sherpas were in a gay mood, surprising us by performing a marriage ceremony. The newlyweds were our cook Sherpa Thandup's pot-washer and a plump, young Sherpani. In the evening when the snow had stopped Tibetan songs and dances permeated the otherwise awesome stillness of the mountains.

During the early hours of April 5, we rounded the corner of a rocky bluff and gazed along the corridor of the Barun. There, scarcely six kilometers distant, the dominant bulk of Makalu rose in icebound splendor. The mountain's fluted ice, hanging glaciers, and angular rock ridges exceeded our wildest dreams. At the foot of this giant wall a maze of glaciers plunged into the Barun valley. A falling mass of ice, accompanied by a sharp explosion, warned us of the dangers of being high on this mountain.

We set up base camp on a broad ledge, part of an old moraine above the Barun. At an elevation of 4,700 meters we were well above the timberline, though there was much juniper scrub on nearby slopes. Angtharkay paid and dismissed the porters and we began discussing our plans for the next two and a half months. Within a few days of our arrival Nello Pace established his tarpaulin-draped laboratory. The mechanism of acclimatization was not then clearly understood. In ascending to high altitudes, a heavy demand is placed upon the respiratory and circulatory systems. Unless there is oxygen at hand, a quick ascent to 8,200 meters will kill a person in seconds, but if the climb is spread out over a period of weeks the body makes adjustments to survive with lower oxygen intake. Only in this fashion is heavy

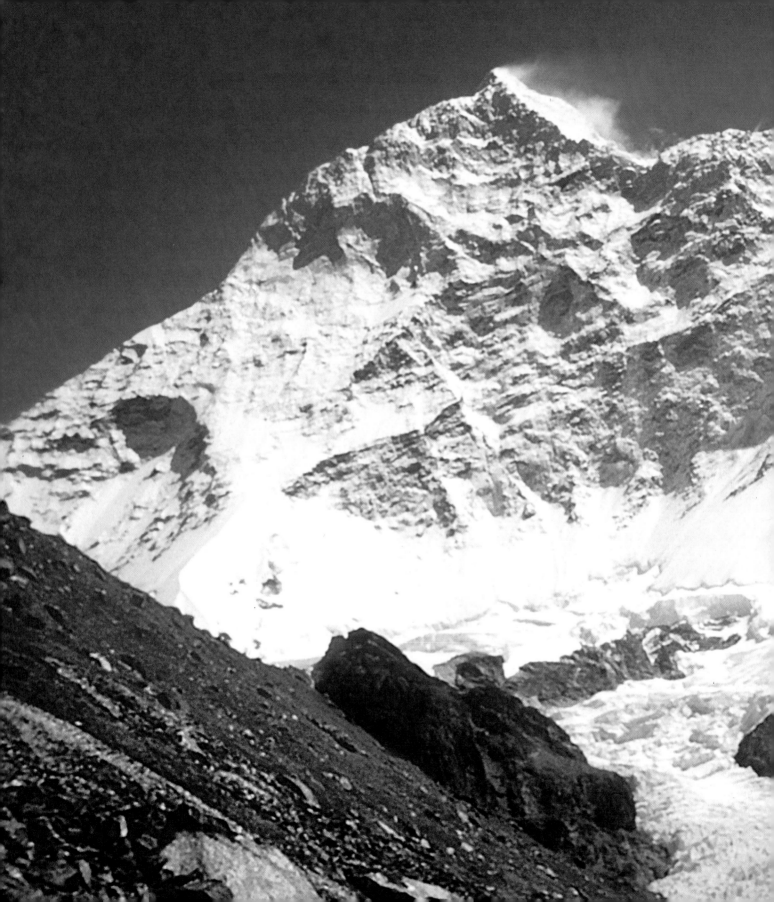

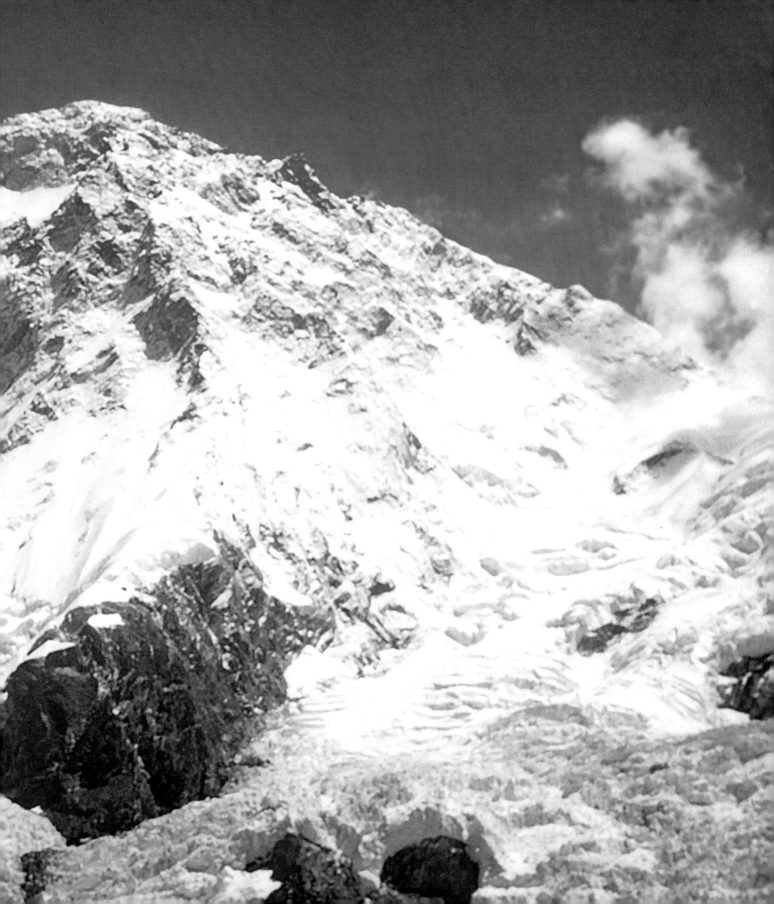

exercise, and even life, possible at high altitude. Many Everest expeditions have shown that man can climb to 8,800 meters without the benefit of bottled oxygen—provided he takes his time getting there.

To gain insight into these matters, Nello had designed several tests involving the climbers. One of them, the breath-holding test, was particularly annoying: at the end of a normal exhalation, the subject bravely fights the natural desire to inhale until the growing vacuum within the lungs becomes overwhelming and the next breath quickly follows. These tests were performed relentlessly throughout the expedition despite occasional strong protests from the reluctant subjects.

The two possible routes to the summit from the Barun were the north and southeast ridges, and we sent out reconnaissance parties to explore each. Several of us wanted to try the north ridge, which would require base camp to be moved farther up the Barun. This would involve three or four days of effort, and we did not have the funds for the extra porters. The expedition cash reserves were down to $300, which would scarcely be enough to get us back to Dharan. The southeast ridge became the obvious alternative.

Loads of food, clothing, tents, and sleeping bags were sorted at base camp and their arduous transport up the mountain began. Willi Unsoeld and I, along with seven Sherpas, made the carry to Camp I at 5,000 meters and set up our tents near a pleasant glacial pond. Houston, Lippmann, and Siri joined us and we climbed up over the shattered surface of the glacier toward a level spot where we placed Camp II at around 5,600 meters. Thin traces of ice crystals swept across dark gray sky, a sign that bad weather was approaching. The site lay on the remains of an old avalanche that had fallen from an ice wall directly above, so we moved camp several times but were never quite sure we were out of danger.

While overlapping relay teams of climbers and Sherpas flagged the route with specially prepared bamboo wands and thoroughly stocked Camp II, Siri and I, with Gombu and Tashi, explored the route to Camp III. The goal was to establish an advanced base camp on the saddle at the foot of the ridge. A late start and poor visibility forced us to drop our loads some 150 meters below the crest after putting up an excellent route over the glacier leading to the saddle. Two further attempts were made before Camp III was finally established at 6,500 meters. The long pull to this camp was a great effort for all of us, and it was heartbreaking to have to go down and bring up additional loads.

[Previous Spread] The massive southeast side of Makalu. Our Sierra Club team was the first ever to attempt the peak. The route chosen was the southeast ridge, on the right skyline. [Above] Climbers in cloud mist on the way to Camp III on Makalu.

Climbers on Makalu negotiating an extensive icefall on the way to Camp III.

We used shortwave radios to pass along vital information between camps. A special receiver was tuned to weather reports sent out by the Meteorological Institute in Calcutta. These forecasts would do little to indicate local conditions, but could warn of the advance of the monsoon. During late May and early June these moisture-laden winds move up to the Himalaya from the south and the resulting heavy snowfall puts a stop to all climbing.

Bad weather continued to delay progress toward Camp IV and gave us time to bring up more supplies to Camp III. Finally, Meyer and Long managed to climb to the new camp, but it was clear that the tents would not survive long on the slope, which was continually covered with shifting snowslides. At 6,800 meters it was extremely hard work to excavate a snow cave, but the pair managed to construct a reasonable shelter. As they returned to Camp III a series of storms put a stop to all climbing for four days. It was good to get back to base camp, where we enjoyed excellent cooking by Thondup. The lads had managed to shoot a few *rum chukor*, a local bird similar to a partridge. Nello worked furiously inflicting the infamous breath test and miscellaneous injections on the captive climbers.

By May 23 conditions had improved enough to permit the team to again occupy Camp III and climb to Camp IV where Long and I, with two Sherpas, Mingma and Gombu, enlarged the snow cave. It was impossible to stand erect; the floor slanted toward the opening and once we were all inside, it was difficult to move. A new storm settled over the mountain and there was little hope of placing Camp V, though we made a valiant attempt.

We crossed the slope above Camp IV toward a nearly vertical rock chimney plastered with ice and snow. Long led this pitch, placing several pitons for protection as it began to snow lightly. Soon he came up to an impassable rock rib and we decided to return to camp. We had given the Sherpas considerable instruction in rope handling during the first weeks at base camp. They would now put their training to work. I placed a large aluminum piton solidly into a crack and passed the rope through the eye. Mingma watched in horror as Long and Gombu rappelled to the base of the gully, but he resolutely mustered his courage and followed them down the cliff. Our Sherpas were brave men; it was the first time they had rappelled on a mountain.

We spent another grim night in the cave. I was tormented by bad dreams and felt as if I were suffocating. I awoke with a start and found my throat clogged with heavy mucus. In the subzero temperature I crawled from my sleeping bag, took off my down jacket, and on my hands and knees, fearing death, put all my strength into breathing. The following morning I was able to get back to Camp III and after a rest day went all the way down to basecamp. Meyer suggested later that I had probably suffered a severe case of tracheobronchitis.

Meanwhile, on May 29, Dunmire, Unsoeld, and two Sherpas managed to almost reach a site for Camp V, somehow getting past a fifteen-meter rocky rib where they left a rope ladder. Two days later, Long and Unsoeld, with Gombu and Mingma, reached the crest and set up Camp V at about 7,000 meters. The weather was terrible, and though there seemed to be few problems for another 250 meters or so, any further advance was impossible. The climbers returned to Camp III in a blinding snowstorm.

The weather report indicated that monsoon rains were drenching Assam and would reach Makalu in twenty-four hours, two weeks ahead of schedule. We lost little time in evacuating the mountain. When the monsoon did arrive it didn't appear to be much worse than the weather we had already experienced. It was just a bad season in this part of the Himalaya.

While I was recuperating in base camp, word arrived indicating that our wives and many friends, realizing how broke we were, had managed to transfer $3,000 to a Calcutta bank. Siri suggested that Houston and I, along with one of the Sherpas, Tashi, go quickly back to Dharan and on to India to collect these funds.

Tashi was a fine companion during the five days it took us to reach Dharan. Each afternoon he would collect food for our evening meal, usually a chicken and potatoes roasted over our fire. We learned much about Sherpa culture and what life was like in his home village near Namche Bazaar. Tashi usually found lodging in the village while we weathered the continuous monsoon rain in a comfortable tent. We were still able to cross the now-swollen rivers that had been so small on our way in, and the swinging bridge at Num remained intact. From Dharan we managed a truck ride to the Indian railhead and boarded a train for Purnea, a city some 320 kilometers north of Calcutta that we knew had a branch of the bank holding our funds.

It was a delight to walk into this small, rural city and see how different life was here than in poverty-stricken Calcutta. We found our way to the bank, met the manager, and explained to him our urgent need for the funds. The heat was oppressive, particularly inside the building. During our discussion, I noticed several rugs hanging from the ceiling that were moving slowly back and forth to provide some movement of the air inside. I wondered how they were powered, then noticed way up in the back of the room a young boy pedaling a bicycle attached to the rugs. The bank manager said it would take several days to arrange the transfer and offered us a place to stay in his home not far away. We spent a lovely time with this intelligent man and his family. One evening he recited Persian poetry and the mellifluous cadence of that beautiful language enthralled us.

Camp III on Makalu, at about 22,000 feet. Note the special tents supplied to the trip through Eddie Bauer.

Finally, we had the cash and took the train back to the border with Nepal and reached Dharan about the same time our expedition arrived. The porters and Sherpas were paid and sufficient cash was left to bring us all back to Calcutta and our flight home courtesy of the US Air Force.

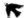

A French expedition made the first ascent of Makalu via the northwest ridge in 1955, a year after our attempt. The French Mountaineering Federation had organized a reconnaissance trip to Makalu in the post-monsoon season of 1954, during which they climbed 7,678-meter Makalu II, which afforded excellent views of the northwest ridge. A French team had been successful on Annapurna I in 1950, the first time an 8,000-meter peak had been climbed. With many famous mountaineers and the French Mountaineering Federation providing ample funds, there was no problem in financing these large expeditions.

The first ascent of the southeast ridge did not occur until 1970 when a huge Japanese expedition, following our line, succeeded in working their way through all the obstacles that lay above our high point. They had twice as many Sherpas as we did and also an ample supply of oxygen, which helped immensely. Obviously, their budget was far greater than ours had been.

Willi Unsoeld filming at Makalu base camp. The footage was never publicly shown, and ended up in the possession of Will Siri.

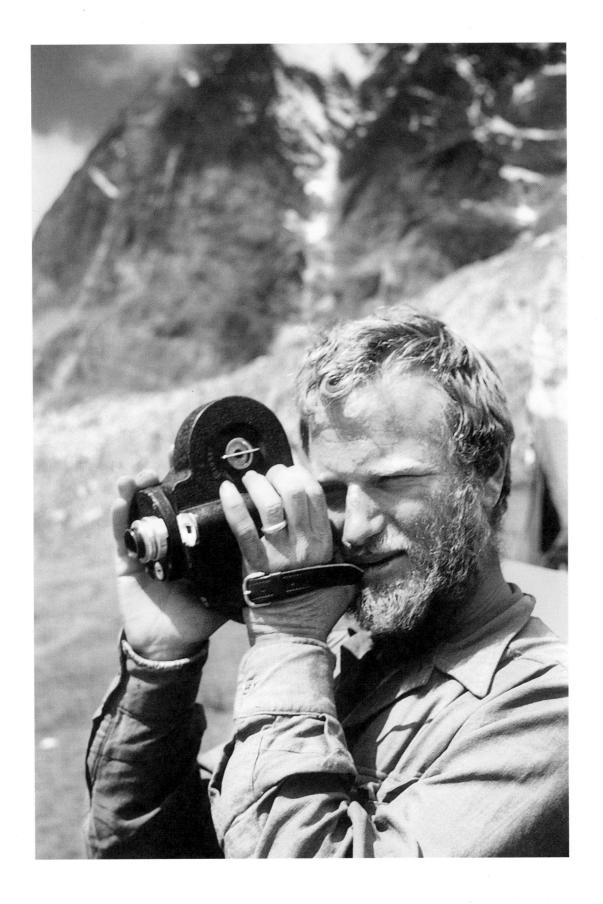

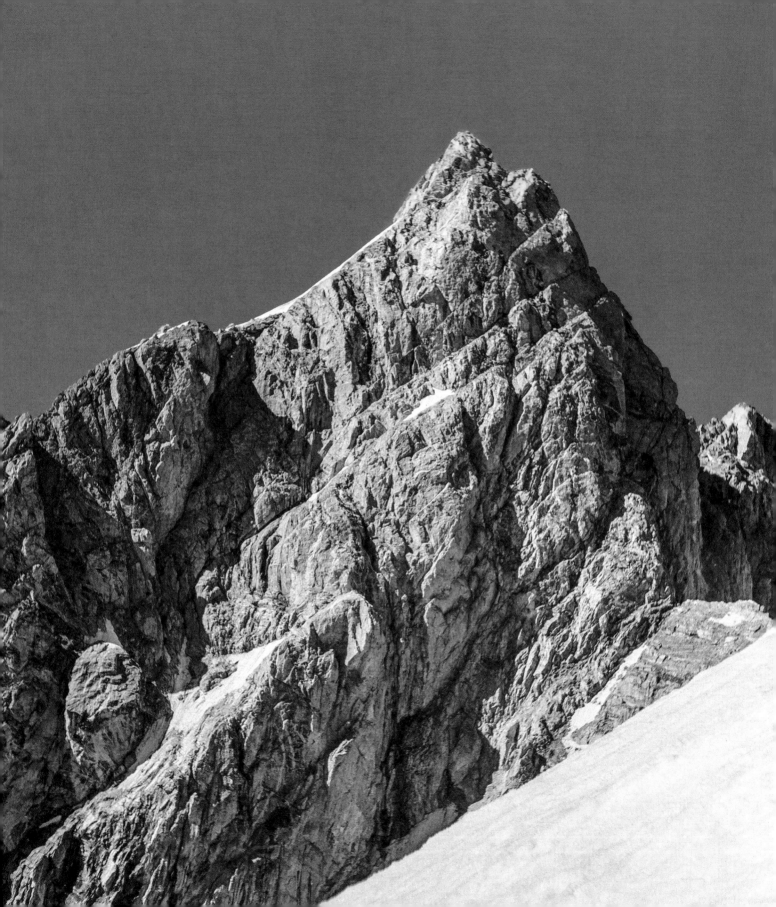

A TRAVERSE OF THE TETONS

I t is not so strange to suggest that the failure of a complex mountaineering venture can be a prerequisite to its subsequent success. The peculiar nature of the Grand Tetons traverse perhaps validates this statement. Not all mountaineering objectives are brilliantly conceived (and surely the purists will call this no exception), but the Traverse is bizarre and difficult enough to merit special attention. I am not aware of the origins of the insidious schedule, though I do detect a certain Unsoeldian flavor in its composition: from the Jenny Lake parking lot ascend Teewinot, then traverse, in order, Mount Owen, the Grand Teton, Middle Teton, South Teton, Cloudveil Dome, and Nez Perce. Last, struggle as best you can back to the car. Any route or time of day is acceptable; however, you must finish within twenty-four hours.

These summits rise dramatically above Jackson Hole, Wyoming, forming one of the most famous mountain ranges in America. Thus is revealed the delight of the Grand Traverse: an improbable time schedule, a fair number of objective dangers, a more-than-adequate supply of the subjective ones, and the normal "lemming-like" pursuit of the summit common to all mountaineering.

One attempt was made within this arbitrary framework in the early 1960s by Willi Unsoeld, Pete Schoening, and Dick Pownall. Unsoeld confided that they had gone astray, of all places, on the east slopes of Teewinot, and had enjoyed some energetic bushwhacking on

Sun striking the magnificent North Face of the Grand Teton.

forty-five-degree grass slopes in the dark. Upon reaching the summit of Teewinot after five hours of effort, they traversed over to Mount Owen. Pownall was in such good form that he pushed on ahead down the south ridge of Owen with their only rope and so they were all obliged to climb this rather frightening section without belay. The north ridge of the Grand took more time than planned, and by the time they had reached the lower saddle, Nez Perce seemed a little too far away to justify continuing.

From this attempt came the advice to reverse the order and start with Nez Perce. There were two main advantages to this approach: the trail approaching Nez Perce could be negotiated easily at night, and the joyous rappel down the north face of the Grand would be less complex than the ascent of the nearby north ridge. Or so everyone thought.

Though I am the author of this story, it was unlikely that the Traverse and I should ever have met. Upon reflection, I can say this about a number of climbs accomplished during the 1963 season, as I only became involved in them through an unfortunate association with Dick Long, a climbing companion whose motivation, ability, and powers of persuasion can best be described as excessive. The third member of our posse was John Evans. During our climbs together that summer I came to know Evans as having a gentleness that belied his immense strength. He was quiet, generous, good natured, and always hungry; in addition, he was a fair alligator wrestler. In contrast to Long's consuming desire for the nobility and glory that would come from doing the Traverse for the first time, Evans had said, in an offhand way, "Sure, it's all right with me, I guess. Sounds like a good tour."

As for me, I saw the inevitability of a struggle. And a good struggle now and then is a tonic, for while it taxes the leg and arm muscles, it tends to relax those in the cranial cavity.

We left our campsite after saying goodbye to Long's family and reached the trailhead at Jenny Lake shortly after midnight on August 6. A thick cloud cover had spread out over the Tetons and Jackson Hole and a soft rain was falling. Lightning shattered the otherwise gloomy landscape across the valley to the east. In complete darkness we ascended the trail toward Nez Perce, a depressing start although a proper part of the struggle. We made good time while Evans, owing to his vastly superior lung power, described the intricacies of rattlesnake handling.

The rain stopped and the clouds opened slightly to reveal a full moon and a sky of brilliant clarity. How beautiful the mountains are at such times—for out of the glare of the sun so much is left for the imagination. The sound of running water filled our ears; off to our right a bivouac fire flickered in the darkness of Garnet Canyon. This momentary rapport with the nocturnal

beauty of the Tetons was broken upon contemplation of the dark shape of Nez Perce looming before us. When we left the trail and began to ascend the loose talus, the footing instantly became more troublesome. Eventually we reached the summit of Nez Perce. First light glimmered off in the east while to the west a black wall of clouds inspired anxiety.

Wet lichen caused all sorts of anguish as we began the traverse to Cloudveil Dome, and we soon made our first error in finding the route around a rocky pillar. Once past this obstacle, I was following the others when I noticed Long had slipped: a large slab had slid out from under his feet and as he jumped down to a lower ledge, it had followed him and clipped him at the ankles. He was about to pitch off onto steep rock and snow when at the last moment Evans reached out and grabbed his outstretched hand. Our first disaster was avoided.

We climbed over and around the towers beyond Cloudveil Dome, past the skeletal remains of an unusually large animal, and reached the summit of South Teton. The weather was now beautiful. I saw old friends to the south: Buck Mountain, Death Canyon Bench, and the limestone cliffs of Jedediah Smith and Bannon. I settled into my usual "long duration" rest position only to hear a voice behind me. "Ah, old man, this is no time for sloth," said Long. "John will sign the register. Let's go!" We stopped just short of the slope leading up the Middle Teton for a fifteen-minute lunch of candy, sweet rolls, and meat bars. A small stream ran along beside us, a place to linger and enjoy some other day. We reached Middle Teton in good time, but lost the route on the other side and took more than four hours to gain the summit of the Grand. It was now 2:00 p.m. and the thunderheads were sailing by.

Being unacquainted with the north ridge route, we decided to climb down a short way from the summit and then rappel the north face to its base, the Grandstand. Using two 150-foot lines, we made the first rappel to Fourth Ledge, and the second, like ants on the end of a thread, to Second Ledge. I came down last and found myself alone with a jammed line, the others having continued without a belay over rather difficult rock to scout the next rappel point. The rope cleared eventually and I joined the others on a small ledge where we were unable to place a piton. Ten minutes of anguished searching revealed a shallow crack. In desperation, Long took an army angle and drove it no more than an inch into the fissure, bending it over flat against the rock. And there it was, somewhat flexible but possibly sound.

Having constructed the anchor, Long was obliged to go first and he did so, undoubtedly with a good deal of deep inner turmoil, while Evans and I amused ourselves watching the storm move in. Soon Long was down and as I got into the rope, I noticed Evans' ashen expression. "Evans, since you are heaviest, it seems only fitting that you go last," I unhelpfully

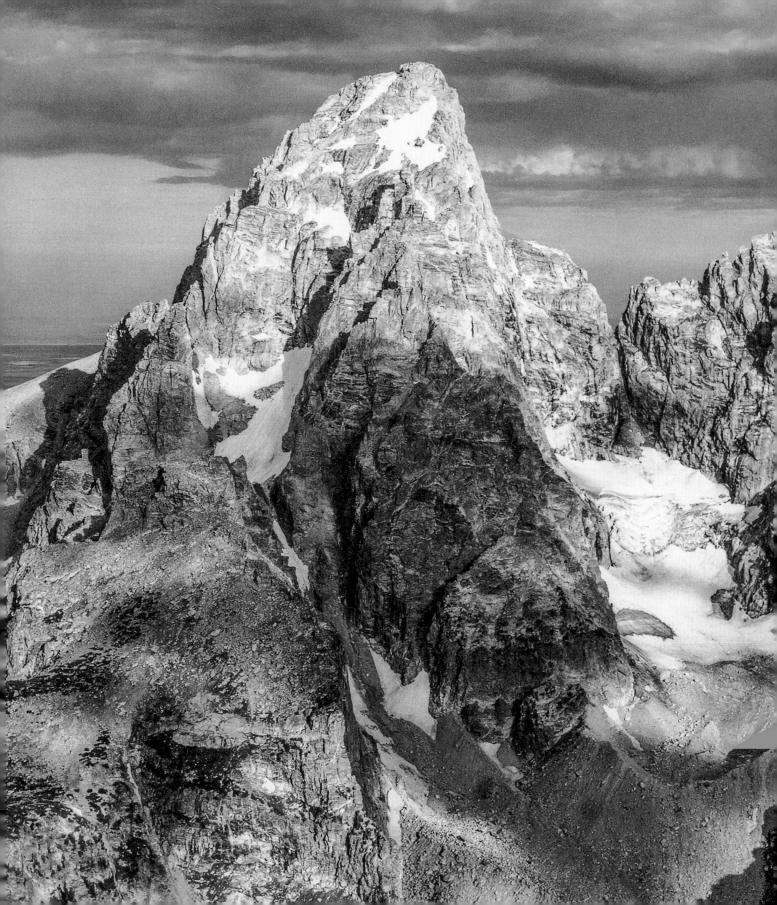

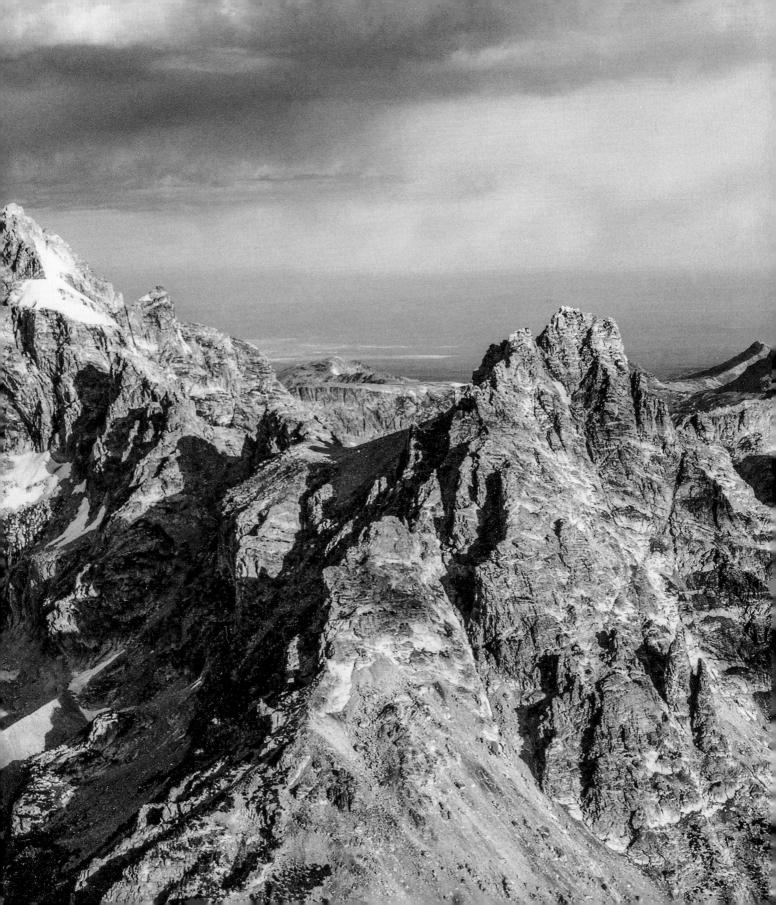

remarked. "If the piton pulls, we might at least be able to retrieve the rope as you go by and salvage two-thirds of the expedition." Having thus consoled him, I went over the edge, involved with my own thoughts of survival, and reached the next ledge. A short time later Evans came into view, his face a hemisphere of joyful expression. "*Madre,* I live."

We'd reached the Grandstand at last! We scrambled a couple hundred feet and discovered an excellent route up the west couloirs of Mount Owen. But it was now 5:15 p.m. and raining, with the usual electrical display so famous in the Tetons, and we were still 200 feet shy of the summit. It was obvious that the game was over. We had been out for eighteen hours and the descent, the most exhausting part of the trip, was now before us. We declined to make the final ascent and pulled out the rope to belay across the snowfield leading to the east ridge. It was dark by the time we reached the col below the East Prong and none of us could recall the route down the couloir to the glacier. I took no part in the navigation since it was difficult enough to follow Long and Evans at the speed they were going. I marveled at their endurance, for mine seemed about gone.

As we gained the glacier, the storm weakened and the moon cast a silvery light over the ice and the east face of Mount Owen. You mountains! By yourselves you are nothing. Only in our imagination do you become something mysterious that enriches our lives. And so we come to you in the pursuit of beauty and kinesthetic pleasure; seeking to penetrate your mystery do we somehow understand our own fragile existence a little more.

We now lay there, exhausted beyond belief, with our retreat still unfinished. Somehow Long found the trail over to Amphitheater Lake and we started the twenty-five-mile (or so it seemed) hike back to the car, occasionally falling asleep and stumbling off the trail into the bushes. Rest came at last at 2:45 a.m.—and none too soon.

Long was insufferable! "If we had at least climbed Owen, I would feel better." He continually reproached himself for this oversight. I nourished a feeling of elation that the Traverse and I had parted for good, for the physical punishment of those twenty-six hours was still fresh in my mind. For the inscrutable Evans, the tour was over. "Let's move on to Colorado." We had planned to climb Long's Peak and were to meet the fourth member of our party in Boulder for final preparations. Long got his family together and we started down the highway to Jackson Hole and points south.

[Previous Spread] The northern end of the Grand Traverse of the Tetons: Grand Teton at left, Mount Owen at center, and Teewinot at right. Photo: Leigh Ortenburger

As we neared the Jackson Airport, a moment of inspiration caused us to phone our friend in Boulder to see if he indeed was there. We received the startling news that storms had been centered there for over a week and that it might be best to delay our departure for another three days and enjoy the sunny Tetons. And so the weather again became the arbiter of our alpine intentions. The forces of destiny were at work. We returned to the climbers' campground and unpacked the car. Long's children were overjoyed to have moved camps so quickly. The weather was beautiful. What with the hot springs and the nearby practice cliffs we passed the time admirably without undue exertion.

As we sat in camp debating possible objectives for our last day, Long casually cast his line. "Think it'll go in twenty-four hours?" he inquired, his voice soft and probing.

"I'm sure it will someday," I replied. Silence. I could see that Evans was amused at the drift of the conversation.

Long then set the hook. "You know, we're in top shape with two days of rest. The weather's great. We know most of the route…" His voice trailed off.

The hook was well baited with the logic of his words and we rose at once to take it, all of us perhaps sensing that we were in the best possible position for success. Pete Sinclair and Sterling Neale were in the rangers' shack when we went to sign out, and I believe they pretty well relegated us to the ranks of the demented as we again outlined our program for the Traverse. We downed sleeping pills at 8:00 p.m.

We were up at 10:30 p.m., and Betty Long served us a nutritious plate of hash browns and eggs before our departure an hour later. The full moon was nearly hidden by an even thicker layer of clouds than on our previous attempt and the chances of rain seemed about 90 percent. Uncertainty again, but we agreed to go on until beaten by the weather.

We were indeed in excellent shape, for we reached the summit of the Grand Teton by 10:30 a.m. We met a large group just beginning the Owen Chimney and to avoid congestion we climbed out to the Catwalk, circled around the party, and proceeded to the top. On our return, the last member of the aforementioned party, a woman, was in the middle of the chimney. She was carrying a new ice hammer, which we sorely needed because it would serve much better than the cumbersome ice ax I was carrying. A few minutes later I heard a clatter above me and saw that the hammer had fallen from her pack. Evans was safely around the corner, but Long was in stemming position with no hope of making a quick move to get out of the way. The hammer spun down, smashed in the rock over my head, shot by Long, and disappeared down the west face. The Great Belayer had looked after us today!

At this point we were able to traverse out to the Second Ledge, thus avoiding two long rappels. Moving fast, we reached the bent piton, reinforced it with a special piton brought along for the purpose, and finished the descent of the north face without incident. We waited out a thunderstorm near the summit of Mount Owen, reaching the summit eventually, though there was a great deal of electricity about. Lightning has a way of provoking haste and we literally raced off the summit to relatively safe ground below. It was a credit to Evans' nerve that he stayed behind to sign the register.

Descending again to the col, a 175-foot lead on good snow brought us close to the top of the East Prong, where we circled around to the south to gain the summit. It took us four hours more to reach Teewinot, the major difficulty being the traverse of the prominent buttress on the north side that bars easy access to the west shoulder of the peak. A portion of this traverse was over mixed ice, snow, and steep mud at the head of a twisting, dirty couloir that offered a speedy ride for the unwary to Cascade Canyon 4,000 feet below.

It was precisely 6:00 p.m. when we reached the summit of Teewinot and peered over the edge down to Jenny Lake more than a mile below. It did not seem possible that we would reach the car before dark, so once past the difficult climbing we moved into top gear. We were impressed with the consistently high-angle slopes below tree line and our descent was at times rather like high-speed skiing at the limit of control. Our route was well chosen; we reached the car at 8:00 p.m. with a little twilight to spare.

As we made our way finally to Colorado we gave little thought to our adventure on the Grand Traverse, except to rejoice that our torment there was only a distant memory. We would never have guessed that this route would eventually become one of the more interesting three-day guided tours offered by Exum Mountain Guides. Before this happened, however, there were those in Jackson Hole who became interested in doing the Grand Traverse in a faster time than the twenty-one hours we managed. The late Alex Lowe did it in less than nine hours in 1988, and in 2000 Rolando Garibotti (whose exploits on Cerro Torre and nearby peaks in Patagonia defy belief) cruised it in six hours and forty-five minutes.

This is an extraordinary achievement when you consider that the Grand Traverse is well over ten miles long with more than 12,000 feet of cumulative vertical gain and interminable

route-finding problems. All parties now tackle the Grand Traverse from north to south (from Teewinot to Nez Perce, as we'd originally conceived the route), climbing the 5.8 cracks on the North Ridge rather than having to haul extra ropes for the descent off the Grand Teton. We sit in our armchairs now thinking wistfully about our participation in the history of the Grand Traverse.

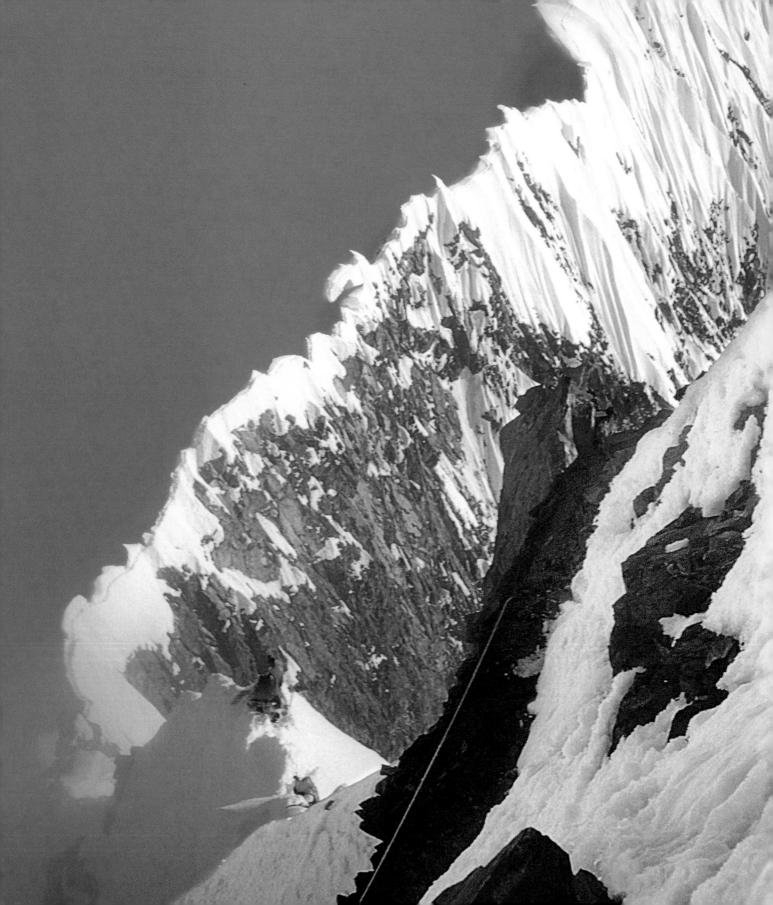

FIRST ASCENT OF THE HUMMINGBIRD RIDGE

"It is not the role of grand alpinisme to face peril, but it is one of the tests one must undergo to deserve the joy of rising for an instant above the state of crawling grubs."

—Lionel Terray, 1965

The first ascent of the south ridge of Mount Logan in the Yukon Territory was completed by a six-man party on August 7, 1965. Starting from the Seward Glacier at an elevation of 7,200 feet, the group gained the ridge by climbing its western flank and then followed the crest the remaining three and a half miles to the 19,800-foot summit. The climb required thirty-seven days and the placing of eleven camps, or more accurately, the moving of one camp eleven times. After traversing the east, central, and west summits, the party descended via the west ridge to a cache left at the head of the Quintuno Sella Glacier below King Peak.

The name of the ridge commemorates a momentary chance confrontation of man and hummingbird at 9,000 feet—a good omen, perhaps. The following story recapitulates in tranquility the personal experiences of one member of the expedition.

A view looking back over the 900-meter-long corniced "Shovel Traverse" section of Mount Logan's Hummingbird Ridge from about 170 meters above.

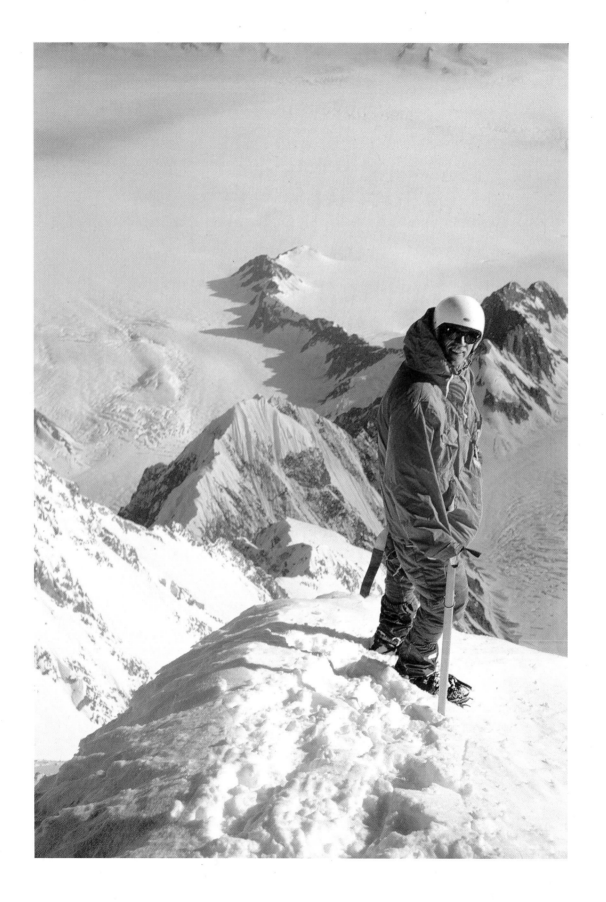

Much time has passed since our team climbed the Hummingbird Ridge, and even as I write, I am acutely aware of the feelings of disbelief and despair that we shared for a good part of the ascent, along with other related certainties, such as incomparable effort, hunger, disordered beauty, and, at times, quiet companionship.

Since his first visit to the Seward Glacier in 1953, it had been Dick Long's consuming desire to climb this absurd ridge. Jim Wilson and I were drawn into the enterprise early on, little realizing how intense an experience it would be. I recall that we wrote John Evans while he was still in the Antarctic, advising him that he was drafted for the expedition because we needed an alligator-wrestling Übermensch, heavily muscled yet sound of mind, to drag us relentlessly to the summit. Frank Coale and Paul Bacon joined us later, both of them excellent men of proper spirit and humor—good sufferers all.

The only photos of the ridge were aerials taken by Boyd Everett in 1964 and they were so dramatic that we simply could not cope with them. The terrain eventually proved to be less horrendous than these pictorial nightmares indicated; still, a mood of defeat developed early in the planning stages and persisted right through to Camp IV.

On July 7, 1965, our bush pilot, Jack Wilson, brought Long and me in from Kluane Lake on the first flight and we took a few passes across the ridge to obtain some idea of the scale and difficulties we would encounter. As we flew toward the mountain, a huge avalanche dropped from the crest under the east summit and we followed its course down the southeast flank as it grew to a massive cloud in the glacial basin two miles below. So overwhelming was the magnitude of this mountain that we could scarcely concentrate on the complexities of the ridge itself.

We landed at the base of the ridge late in the afternoon and suddenly found ourselves alone as we watched the tiny airplane disappear over the vast glacial sea of the Seward Plateau. This was my first visit to the Yukon and the land of the evening sun. I was entranced at once with the spaciousness and compelling beauty of the place. For the longest time we just sat and watched Mount Augusta and Mount Saint Elias in the fading light, but it was Mount Logan, of course, that dominated the scene because of its proximity. The southern escarpment is more than 14,000 feet high, and the south ridge gains this amount of elevation over a distance of some six miles.

Dick Long at the summit of Mount Logan. Behind him you can see the "Shovel Traverse" section of the Hummingbird Ridge running down to the Seward Glacier.

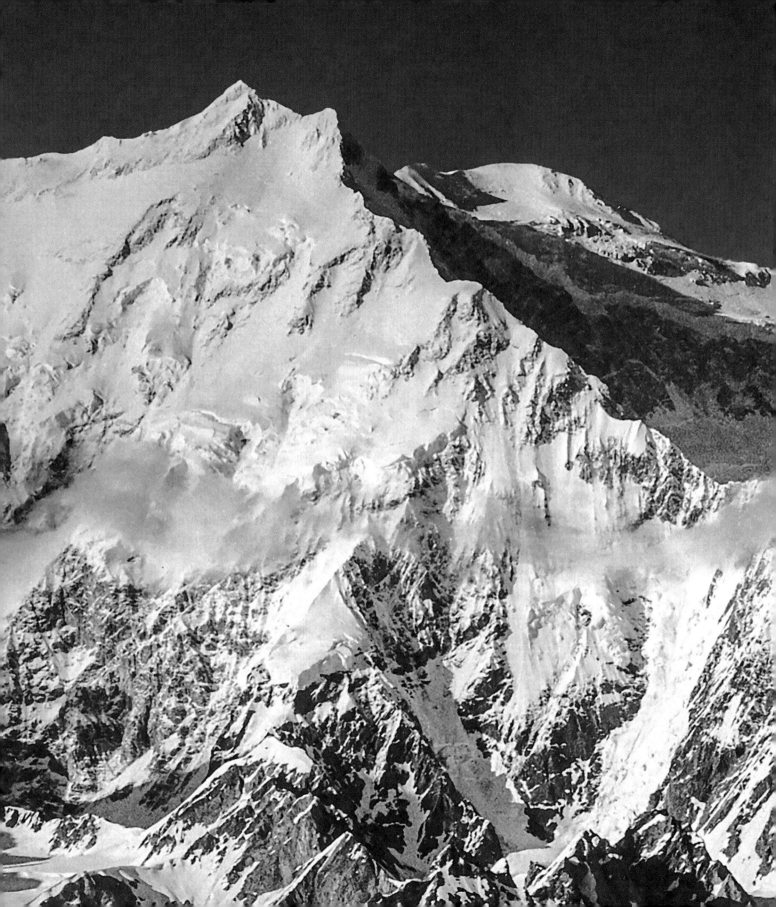

The others arrived the following day and we were very soon occupied with the task of hauling our equipment up the glacier closer to the mountain. The weather had turned warm and in the days to come, the cliffs lining the five-mile perimeter of our glacial cirque were alive with avalanches, some of which cascaded down over the rock with all the grace and vigor of Yosemite Falls. For several days we were undecided about the best way to gain the crest of the ridge some 3,000 feet above us. Avalanches gave a sense of urgency to the problem, but we minimized the danger somewhat by doing our exploratory work during the colder hours of midnight to 11:00 a.m.

There were anguished discussions at base camp about our chances of getting to the crest. We had to do something, however, and eventually decided the western buttress would be the most realistic approach. We began to haul food and equipment up the monstrous thing. We named it Osod, an indigenous Tlingit Indian word that signifies an intense hysteria and adrenal stimulation that produces a chill in the back of the neck. A ten-day effort brought forth sufficient excitement for all, even if we had simply stopped here. The Shooting Gallery in the couloir was bad enough, but the 200-foot Prow was the locus of agony as far as Osod Buttress was concerned. I shall not dwell on my own problems there, which were extreme, but refer to Evans' diary for the sheer drama of his solitary rappel off that eminence, some 2,000 feet above base camp:

It again struck me as pretty damned ultimate to start off without belay on a single strand of quarter-inch line on a 200-foot rappel, the top 100 feet of which were free. I used a brake bar with two carabiners and fastened a Jumar to my seat sling for safety. About a third of the way down, my thumb slipped off the Jumar and it caught me and held tight. I could barely graze the wall with one foot and could not raise my weight off the Jumar. Fortunately, I had my trusty Swiss army knife in my parka pocket, so I wrapped the lower rappel rope around my body to jam it and cut the tie-off loop connecting the Jumar to my Swami. This, of course, bounced me down on my rappel brake, but I was able to grab the Jumar and release it and finish the rappel.

One can imagine Evans' moments of careful thought as he chose which of the two quarter-inch lines to cut—his rappel rope or the connecting sling. He is a remarkable person, a man of great energy and endurance with qualities of kindness and compassion that make

[Previous Spread] This distant view of the Hummingbird Ridge shows the immensity of the climb, starting at the rocky cliffs at lower right to the summit three and a half miles away and some 13,000 feet higher. Photo: Roy Johnson Jr. [Above] Jim Wilson ferrying a load up the rock cliffs on the crest of the Hummingbird Ridge, between Camps I and II.

for a good companion. Both he and Long had "big-wall" capability: they could operate with equanimity when faced with intense exposure and really impossible situations, where peace of mind hangs by a fine thread. We all acquired a level of composure to handle these situations as the expedition went on.

Osod Buttress was a taste of things to come. I doubt that we realized we would be living for thirty days on a ridge where, 90 percent of the time, anything dropped outside of the tents would immediately be gone. It is still a mystery to me why we lost only a few minor items—a few gloves, an ice ax, and some first-aid equipment—instead of something more substantial like a tent or even Dr. Long, whose medical talents surely would have been missed. Speaking of Long in this manner is indicative of the good relationship that we had formed over the many years we had climbed together. Long was very ambitious. Perhaps his greatest creation, as far as mountaineering is concerned, was having designed and promoted this particular adventure.

Camp I was eventually carved out of the ice near the top of the Osod Buttress, at which point we became aware of the ghostly configuration of the ridge beyond. Bad weather hit us there, but we moved out anyway, feeling a compelling sense of urgency now that we were committed to the ridge. There was no time for wasted motion, no time for rest. Long and I fixed the lines up an immense cliff above Camp I. Even before we reached the top, his creative mind had already envisioned the aerial tramway we'd employ to haul our loads across the gulf between this pinnacle and the ridge above Camp I. The following day Bacon, Coale, Wilson, and Long exhausted themselves ferrying freight over the tramway and beyond the gendarme, while Evans and I laid the lines up toward Camp II, mostly in bad weather. The decision to dismantle Camp I in favor of an unknown site above was unquestionably aggressive. Long, in a moment of incisive thought, considered it too rash and shouted to us to come back, but we were already too far up to hear him.

Evans reported that there was a cornice above where we might place the camp. Viewed from some distance in the fading light, with the tents still neatly tucked in our packs, the cornice was exciting beyond belief; we had a vague perception that an intimate association with it was both imminent and unavoidable. Evans' diary brings the scene to life:

> [Steck] went on another forty feet (it was now 7 p.m.) and called for me to come with the shovel. The cornice was incredibly airy and the drop-off amounted to several thousand feet on both sides. I shoveled furiously as it was quite

> cold, and [Coale] soon came up to help... later the platform was complete, although quite marginal in space and most precarious looking... Steck seemed strangely subdued these last few hours.

"Subdued" in this context was a euphemism of the worst sort. I stared aghast at Coale as he plunged the shovel ever closer to the heart of the cornice. With each blow I settled deeper and deeper into a psychological morass. "In the name of Osod," I asked Wilson, "what is happening here?" The sparkle in his eye dulled. "This ridge is sheer madness," came his pronouncement. The rest of us could not disagree.

Camp II was a desperate and fearful place. We spent seven days there in severe weather. We could not leave the tents without going onto the fixed lines; the weakened cornice behind us was unpleasant to contemplate. We were not much closer to the summit than we had been at base camp, and our thoughts vacillated between advance and retreat. As the storm engulfed us we became more and more despondent. One evening Long lay in the back of the tent, his face reflecting a deep sadness. "What will it take to climb this ridge?" he muttered quietly.

Some wanted to start the retreat right away, but we eventually agreed to continue to the Snow Dome with the proviso that we would return to base camp if we weren't across the traverse beyond it by August 2. This part of the climb, which came to be called the Shovel Traverse, was a forbidding 3,200-foot horizontal ridge, capped by an unbelievable array of double cornices, which led out from the Snow Dome toward the summit.

Our pessimism was such that each of us was imagining how to arrange the retreat. Coale had a wild scheme to tie all our ropes, belts, and shoelaces into one huge rappel, should the need for escape arise. This was just the sort of fantasy one would expect of his vigorous engineering mind. He displayed a beautifully positive, fearless spirit at Camp II, which the rest of us felt was surely fraudulent but nevertheless endured.

Bacon also performed well considering his rather recent recovery from a fall he'd taken in Eldorado Canyon near Boulder, Colorado. He was new to the expedition game. One day he, Evans, and I were engaged in a ten-hour load-hauling session when I heard what sounded like a falling rock and instinctively hugged the wall. But no rock came down. I looked around and there hovering over my red pack was a hummingbird, obviously hoping for a bit of nourishment. In a moment it flew away, consuming its fuel supply at a rate perhaps thirty times my own. My little friend, you and I are both intruders on this lifeless ridge, I thought. We are now both engaged in a struggle with our environment, though mine appears

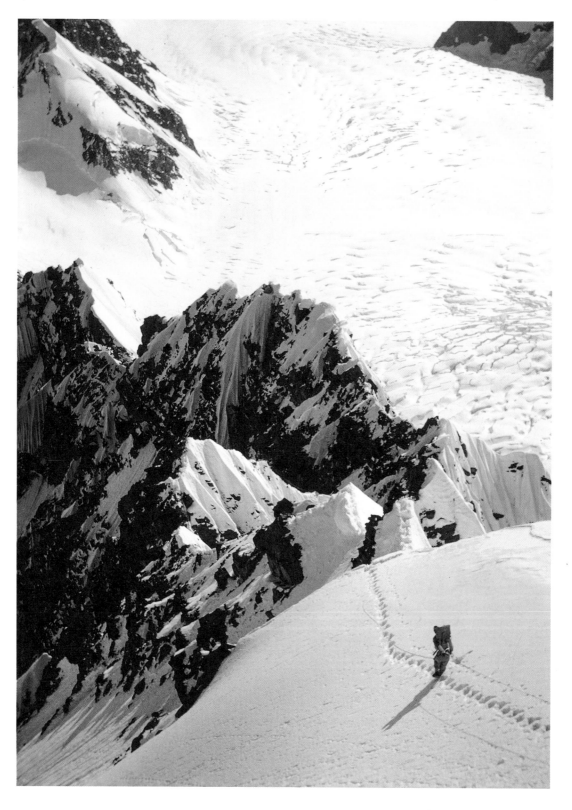

One of my partners descends from Camp III. The precarious perch of Camp II, where the team excavated a small ledge from a cornice, can be discerned at the high point of the serrated ridge below. You can make out much of the trail of climbing along the jagged ridgecrest.

Looking down the lower Hummingbird Ridge from Camp III. Camp II is discernible on the high point of the serrated ridge.

the more absurd. Or is it really? Maybe it's the city that's absurd and life here is more real. I wonder which of us is the better prepared to meet the trials to come. I shall be thinking of you. Thanks to you we have a name for our route. The mind struggles now to comprehend the meaning of all this.

Wilson, expedition philosopher and cook, pronounced Camp II safe by postulating that the cornice, should it collapse, would not take the tents and its occupants with it. He was a proponent of the value of "suffering" to be found in mountaineering, the enjoyment of the sport being in direct proportion to this ingredient. Another certainty that came to mind was that of the unwashed body. Shortly after our return I recall that my aunt, a psychologist, asked me in astonishment, "You mean to say that you went thirty-three days without washing?" The great mental forces that lead inexorably to mountaineering were well known to her, but going unwashed was a concept she could not quite understand.

I heartily recommend a week at Camp II for anyone desirous of experiencing the deep excitement of living. The view from Camp II was most peaceful as long your eyes were closed. You could then evoke such pacifying images as lush, expansive green meadows, tropical ferns, soft leaves pressed into moss. Open your eyes and there you have it—great contrast and the cult of danger. As Wilfred Noyce once wrote: "See that vast glacial expanse: no living thing … the only forces at work being the wind, the caress of the sun and the terrible crushing power of moving ice." Wilson, his eyes happily closed, merely noted, "I would rather be back in Livermore fighting for fluoridation."

Through the ritual of democratic discourse we arrived at a temporary solution to the problems of Camp II by abandoning them for those to be found at Camp III. The Snow Dome became our primary objective. The main concern now was our dwindling supplies. By the time we arrived at Camp III we had been out twenty-one days and while our loads were getting lighter, visions of food were becoming more intense. Our cache on the glacier below King Peak intruded more and more into my thoughts. There was no more disturbing idea than not being able to find it on the great expanse of that icy plateau.

Camp II was precarious. Camp III was even more exposed, although without the excitement of the cornice, which had collapsed on the day of our departure. The weather turned really bad during the carry to Camp IV on the Snow Dome. Long and I contemplated going down to collect the fixed lines below Camp IV that evening, but decided not to since we were certain that retreat would begin the following day. You may imagine our joy when the storm miraculously dissipated and we looked out onto the incredible traverse in brilliant sunshine on the following morning. It was July 31 and suddenly the summit seemed possible.

John Evans deploys the perforated steel shovel, leading out from Camp V at about 14,000 feet to finish the "Shovel Traverse" section of the Hummingbird Ridge. Evans refered this day as their "forward retreat"; at this point it seemed clear that they had to reach the summit as their best way to return home. Note the airplane above and to the right of Evans.

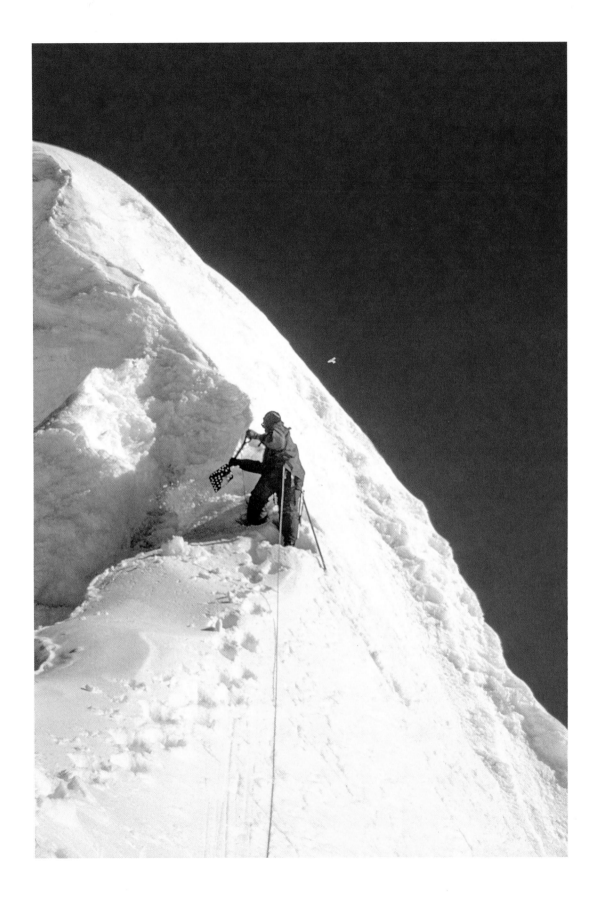

A shovel and an ice hammer were the only tools needed to carve the trail across the elegantly corniced ridge, the ice axes being used simply to hold up the tents back at Camp IV. During the next two days it seemed as though we were suspended in mists between the sky and the glacier 7,000 feet below, so thin was the crest at times. Coale and Long fixed the lines on the first day. The technique used was novel in the extreme: the first man would forge ahead tied into the fixed rope, resulting in leads that amounted to 600 feet at a time. It was exhausting work and what had taken some ten hours to carve could be traversed after completion in thirty minutes. Small cornices were simply removed from the crest by shoveling them away, a rather fearsome task because they made such disturbing noises as they collapsed. The rest of us carried loads out onto the traverse and set Camp V on the first level platform we had found on the ridge. Camp V carried the affectionate name of "Yukon Flats" for it was indeed expansive in contrast to the others.

On August 2, Evans and I set out to finish the last part of the Shovel Traverse. It was a lovely day. The time-consuming 600-foot leads kept us separated most of the time. In what was very nearly a disaster for Evans, we sat together at lunch with our feet dangling over the edge. Evans had taken off his outer boot, and while occupied with clearing ice from the insole he dropped it. He lunged forward to catch his outer boot; I was unaware of the unfolding drama until then and, fearing that he was falling, I grabbed the rope tied around his waist at the same instant his fingers caught the shoelace. Thus he was spared the joy of completing the ascent in his inner boot—a task, I might add, that Evans was well qualified for.

I drew the last lead, took the shovel, and bade farewell to Evans. The air was still. The cornices and ice towers were balanced on a slender spine of rock, the culmination of this giant ridge that formed a 7,000-foot barrier between two huge glacial cirques. A soft mist rose to the east, though it did not quite reach over the top. I turned for a moment and was completely lost in silent appraisal of the beautifully sensuous simplicity of windblown snow. Equating beauty with audacity has many connotations in our lives; the concept seems particularly meaningful as I think back on this moment. Such a capricious interaction of wind, sun, and snow, the result of which is made even more exquisitely delicate by gravitational forces. Snow is one of the more lovely manifestations of nature.

Each of us had moments of rather personal involvement with the ridge, and this seemed to be mine. The last 600 feet unlocked the trail to the summit. Moving deliberately and without hesitation I began to excavate a path across the remaining cornices and ice towers. The quarter-inch line tied to my waist led back to Evans, who was now some 300 feet distant. I was

entirely alone and deeply absorbed in this work when a small cornice broke with a strange squeaking sound. The sensation of falling was not new to me, though here it was more unpleasant than usual. I cannot explain why my left arm happened to be extended, unless it was some sort of futile reflex action directed toward flight, for which I had the wrong equipment. In any case, I found that I had stopped with my arm draped over the ridge crest formerly hidden by the cornice. The shovel hung below me on the cord we had tied to it for just this purpose. I watched the broken cornice disappear into the depths and began to reassemble the pieces of my shattered composure. Rather unnerved, I finished the remaining 300 feet of the traverse engaged in a one-way conversation with the mountain, the first that I can ever recall. I explained forcefully, without restraint, that one of us was going to win, and because of my shovel and uncontrollable desire, it would be me. Thus mentally fortified, I reached the end and called for Evans to come over. Together we surveyed the route up toward the summit before going back to Camp V. The Shovel Traverse was complete.

Hunger was our companion now as we worked our way up through Camp VI, Camp VII, and finally Camp VIII just below the summit. We were on reduced rations as we wished above all to be able to endure a week of bad weather should it come higher up on the mountain as it had below. Working on the route up to twenty hours at a stretch, we were burning 2,000 more calories a day than we were ingesting. Emotional release was abundant when we finally fixed the lines to the summit plateau. The ridge was finished, the exposure gone. A four-foot picket, sunk to the hilt in the ice, still held 2,400 feet of fixed line leading down to Camp VIII.

As we neared the summit the sun shone on us, beautifully diffused through thinning clouds in the upper sky. Words are such useless things at times, the mind preferring simply to be absorbent, drawing up impressions from all it senses. My eyes told me that Evans' tattered pants were in urgent need of repair, and that Wilson's parka could use several trips to the dry cleaner's.

I saw too that my friends shared my great inner joy at the simplicity of the moment.

Many have reached the summit of Logan with visibility down to less than fifty feet, while others, like us, were blessed with unlimited views in all directions, the most lovely being a glimpse of the Malaspina Glacier and Pacific Ocean beyond the summit of Mount Augusta to the west. We faced this magnificent panorama with emotions reminiscent of similar occasions on other mountains. At one point near one of our upper camps I lay on the snow while a Mozart symphony raced through my mind. Such delight!

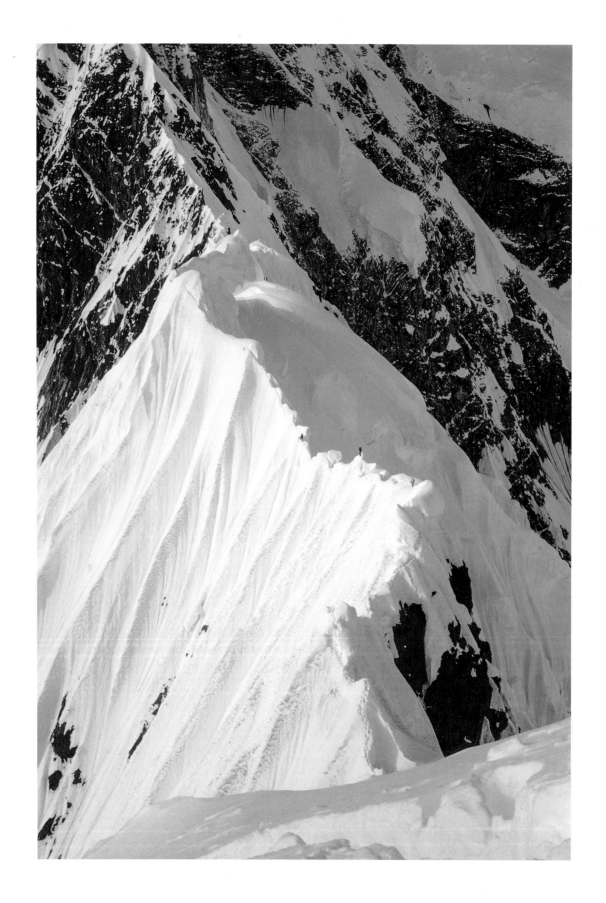

The trip was far from over, however. We spent another three days getting down to our glacier cache, whence our flight out to the civilized culinary smells of the 202 Club in Whitehorse was undertaken. Surely the most exciting moment of the expedition came as the tiny aircraft groaned down the glacier at full throttle, while Jack Wilson desperately tried to get the thing into the air before reaching the icefall that lay directly before us in paralyzing proximity. The venture was not without substantial emotional and physical impact. We did not deceive ourselves that we were engaged in an activity that was anything but debilitating, dangerous, euphoric, kinesthetic, expensive, frivolously essential, economically useless, and totally without redeeming social significance. One should not probe for deeper meanings.

We returned from Mount Logan to our families and continued with our lives in the regular world. Most of us lost 10 percent of our body weight and ate compulsively for several weeks. The ascent generated a good deal of interest, since the Hummingbird Ridge was not just a new climb but also the first route to be done on the south side of Mount Logan. We were also the first to climb all three major summits and to traverse the mountain. We were lucky that the early weeks of warm weather in July had allowed the snow slopes and cornices to settle, which facilitated our passage across the Shovel Traverse. Of the thirty days it took to get to the summit, twenty-two were needed simply to get to the Snow Dome, which at 13,500 feet was situated about halfway to the summit both in elevation and distance from our base camp. The terrain from the end of the Shovel Traverse to the summit was much easier than we had expected.

Some years later I was invited to England to give a series of lectures on the Hummingbird Ridge ascent. The one at the London offices of the venerable Alpine Club was not well attended; however, after the presentation a fellow came up to thank me for the talk. He handed me a card, encased in plastic, and said, "This might explain how you managed the ascent." It read:

Nothing in the world can take the place of persistence. Talent will not; nothing is more common than unsuccessful men with talent. Genius will not; unrewarded genius is almost a proverb. Education will not; the world is full of educated derelicts. Persistence and Determination alone are omnipotent. —Calvin Coolidge

Looking up-route across the "Shovel Traverse," you can discern all five of my partners. The team was moving from Camp IV to Camp V, and two partners are gathered at Camp V, while three others are negotiating the corniced ridge.

Our ascent generated interest in other new route possibilities on the southern escarpment of Logan, but of more interest to our team was who would try the second ascent of the Hummingbird. More than a decade passed before another serious attempt was made. In 1978, Jim Logan, Barry Sparks, Terry 'Mugs' Stump, and Randy Trover decided not only to try the Hummingbird, but also to start their route at the toe of the ridge, very much farther away from the summit than our original ascent. The arête was steep and technical, requiring the four climbers to use up most of their food and fuel in ten days of considerable effort. They reached a point only slightly higher than where our original route reached the crest and gave up the attempt when they realized they didn't have the resources to continue. "The route-finding was really complex," Stump wrote. "Up pillars, down and around." His overriding image of the Hummingbird was its sheer size: "It's like one of those enchainment problems in Europe, linking several peaks together in one climb … It's similar to the Peuterey Ridge on Mont Blanc, except ten times longer."

In May 1980, Dave Jones, Jim Allen, Steve Fuller, Blair Griffiths, and Ross Nicol attempted to reach the Snow Dome by climbing mixed slopes on the east side of the Hummingbird Ridge; they eventually gave up in the face of loose rock and dangerous snow conditions. Jones was quite familiar with this side of the Hummingbird because in 1977 he, Jay Page, Frank Baumann, Fred Thiessen, and René Bucher had made the first ascent of the Warbler Ridge leading up to the east peak of Logan.

Four Canadians (Camirand, Chalifour, Raynauld, and Whitehead, as noted in the 1984 *Canadian Alpine Journal*) very nearly achieved the second ascent of the Hummingbird in 1983. When they reached the Snow Dome it became clear they did not have enough food and fuel to continue, so they were forced to return to their base camp.

In 1987, David Cheesmond and Catherine Freer, two of the most experienced mountaineers in all of North America, disappeared on the Hummingbird. It was the greatest catastrophe in Canadian mountaineering history. The pair had quickly reached the Snow Dome sometime around May 20 by a snow couloir that bypassed all of the rock climbing on the route. They then started out on the Shovel Traverse and for some inexplicable reason, chose to place a camp a couple rope-lengths out from the Snow Dome, in the most fragile area of the ridge. When they did not contact their pilot on June 7, the Kluane National Park Service attempted to locate them. Due to poor weather, the search flight did not happen until June 15. Searchers found a tent hanging over an area where a cornice had fallen. Two packs were visible nearby, and most strange, a fixed line was still in place spanning the area

of a possible fallen cornice. It was assumed that Cheesmond and Freer had fallen off the ridge along with the cornice.

Whatever happened, it's clear they had let their guard down by arranging that fragile campsite, particularly early in the season when snow structures are more unstable due to the severe cold. In 2001, a pilot flying near the Snow Dome discovered what turned out to be Cheesmond's body slumped over a snow mushroom at the start of the Shovel Traverse with a rope leading from him down into the snow below, presumably to Freer. They didn't fall off the ridge after all, and the mystery deepens as to what actually happened to the pair.

Owing to these tragic deaths, few parties have attempted to climb the route and so the original Hummingbird Ridge remains unrepeated.

[Previous Spread] Summit party at the top of Mount Logan after the first ascent of the Hummingbird Ridge. From left to right: John Evans, Dick Long (wearing white helmet), Frank Coale (in front), Jim Wilson, and Paul Bacon.

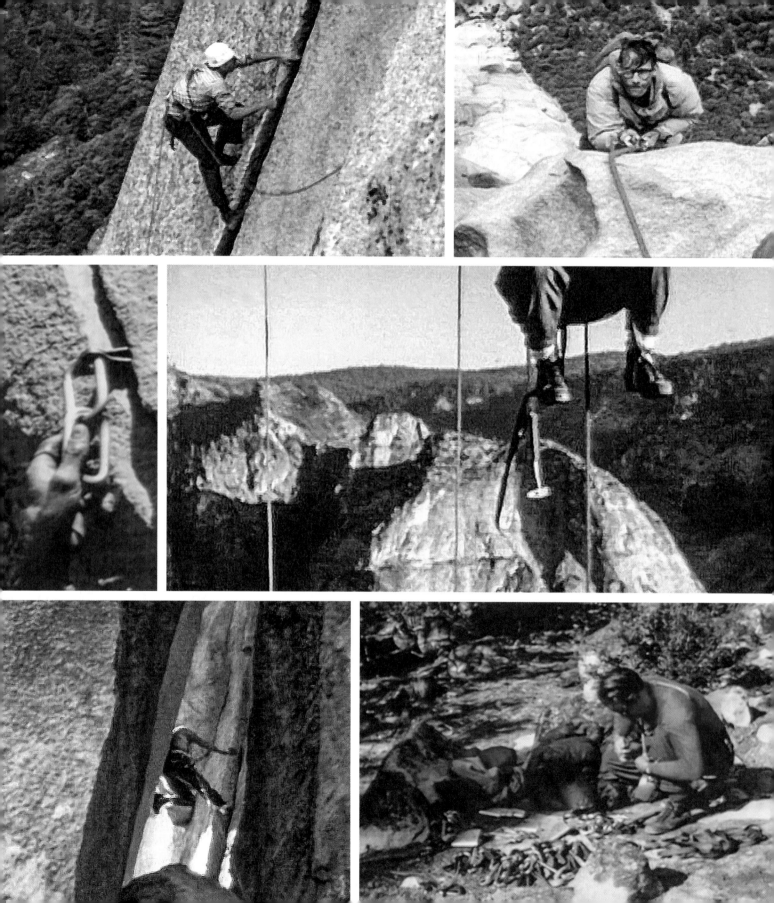

FILMING THE THIRD ASCENT OF THE SALATHÉ WALL

One day in the early spring of 1966, my friend Steve Roper came to me with the absurd suggestion that he, Dick Long, and I climb El Capitan's Salathé Wall. This was a major multi-day route that had seen only two previous ascents by the most talented climbers in Yosemite Valley at the time: Royal Robbins, Tom Frost, and Chuck Pratt in 1961, and Robbins and Frost in 1962. And the Salathé hadn't been climbed in four years! Long and I were only weekend warriors, but Roper's insistence that we were equal to the task convinced us that perhaps we could make the third ascent of this beautiful climb. Many were calling it one of the greatest routes ever done. Roper would later say it was among the boldest adventures he had ever undertaken.

We did several training climbs together, including the west face of Sentinel Rock, and Roper had just made a remarkable one-day ascent of the Northwest Face of Half Dome. Obviously, he was in great shape. We gathered at the foot of El Cap the evening before the climb. To our surprise, Long brought with him a Super 8 movie camera he had just bought, along with many film cartridges. Now it seemed we were to make a film of the climb! So we dutifully read the instructions for this machine by headlamp, eventually drifting off to sleep.

It wasn't long before we realized that climbing and shooting the climb were two operations that had to be carefully meshed. Getting to the optimum filming angles was essential, as was the exposure. We dare not waste film.

The complexity of climbing the face: huge chimneys, cracks, and severe overhangs.

During the climb, two of us would lead and the third man had the job of not only hauling the loads up at the end of each pitch but also doing all the filming that day. The first day we learned a lot and got some good footage. The second day I was hauling and was able to get in good position to film Roper leading the pendulum into the Hollow Flake. Long was belaying but was far from the action, so I had to tell him each time Roper needed more rope. He tried several times and finally got himself into the crack just as Long gave him more slack, so he slid three feet down in the crack without falling out. What happened next was beautiful: Roper liebacked the crack for some thirty feet before it got too steep and he had to get inside it.

Roper had consulted earlier with Robbins about the route and knew about many of the pitches. He wanted to lead the Hollow Flake pitch as well as the Roof, a famously exposed pitch much higher on the wall. The Roof pitch was actually a double overhang, which Roper climbed elegantly. It was late in the day and as he got to the end of the pitch, there was no ledge there, so he hammered many pins into a crack from which we hung like bats during the ensuing bivouac. The wall above overhung some eight degrees, consisting of two pitches that we would climb the next day. It was a bivouac from hell—lacking harnesses, we hung with our knees against the wall.

We planned to do the route in four and a half days but took an extra day because of filming priorities. We had a lot of footage to deal with, so there was much editing to be done. After assembling all the equipment we needed, Roper and I spliced together a lovely sixty-minute silent film showing all the exciting action during the ascent. We screened it on numerous occasions for several years using our small Super 8 projector—so many times that scratches began to mar the film. At the suggestion of a filmmaker friend, we decided to have the film converted to video format. This was done in 1984 at a cost of $950. It was the only way to save the film.

The video languished on my office shelf for several years as film technology changed. In 2006, a climbing gym companion, Linda McMillan, introduced us to a young climber, Owen Bissell, who generously offered to convert the video to a DVD. This was not easy and took a couple of years to work out. Just before we were ready to have the DVDs made, he surprised us by suggesting that we add voiceover to the film! Roper and I assembled at my home early one morning and while Bissell was setting up his equipment, which included a small DVD player so we could follow the action, Roper opened a bottle of red wine, which helped smooth the flow of our voices. If one listens carefully, the removal of another cork can be heard toward the end of our narration.

Roper and I arranged for 300 copies of the film, *The Salathé Wall of El Capitan*, to be made in the fall of 2011, most of which have since been distributed to friends in the United States and Europe. It was shown at the 2015 Kendal Film Festival in Britain to great acclaim. John Cleare, the renowned British climbing photographer, later wrote me that he had never seen such a great film of a major route, adding that there was an immediacy to the action. "You were right there where the hard climbing was happening," he wrote.

We have many people to thank for bringing this film to fruition, but the greatest appreciation has to go to Dick Long, who made the brilliant decision to purchase the camera in the first place.

SOVIET INTERNATIONAL MOUNTAINEERING CAMP IN THE PAMIRS

In the summer of 1974, the Soviet Mountaineering Federation organized an international climbing camp in the Pamir range under the overall leadership of the legendary Russian climber Vitale Abalakov. Alpine clubs of many the developed nations were invited, including the United States, the Netherlands, England, Italy, Japan, Austria, Germany, Switzerland, France, and Scotland. The Pamirs, located between Kyrgyzstan and Tajikistan, contain the highest peaks in the Soviet Union, Peak Lenin (7,134 meters) and Peak Kommunizma (7,495 meters). I was lucky to be among the nineteen American climbers chosen by the American Alpine Club to represent the United States. Pete Schoening was the leader, with Bob Craig as his deputy.

Base camp was set at the side of a lovely meadow at 3,600 meters known as the Glade of Edelweiss, right at the foot of Peak 19 and the northeast ridge and north face of Peak Lenin. We all reached the camp around midnight on July 14, but none of our equipment had arrived so we had to wait to get our tents set up. We were greeted by Michael Monastyrski, the Russian in charge of camp operations, who offered us tea and then entertained us by playing his guitar and singing. I loved his music, especially the gypsy songs, and during our time together Michael and I became good friends.

At the opening ceremonies 170 climbers from the ten developed nations plus Estonia, Siberia, and other parts of the Soviet Union assembled at the Glade of Edelweiss to hear

Frank Sarnquist relaxing at international base camp below Peak 19.

music and speeches. Finally, the time had come to plan our climbing objectives. Bob Craig would lead a small group to Peak 19; Jock Glidden's team would head for Peak 6892; and Pete Schoening and his team would go to a peak southwest of Peak Lenin. I was a member of John Evans' team, which included Fred Stanley, Jeff Lowe, Bruce Carson, and Pete Lev; we aimed to climb the forbidding east face of Peak Lenin. To reach our objective we had to ascend the 1,000-meter Krylenko face, cross the northeast ridge, and descend to the foot of the east face. It would take two days to get up the Krylenko, so on July 21 we placed a camp high on the face on a flat area just below a sérac. At this point two things converged to prevent us from continuing. Lev, an avalanche expert from Jackson Hole, Wyoming, was worried about the stability of the slope above us: windblown snow lay over an ice layer with depth hoar below. The other matter concerned a defective stove. It was decided that Evans, Stanley, Carson, and I would return to base camp and bring back a new one.

At around noon on July 23 we donned our slick outer garments and slid, occasionally out of control, down the Krylenko face. I was slightly behind my companions but close to the bottom of the massive face when a muffled roar caused me to look up and see snow falling from all the slopes above. If I'd given that brief moment enough thought I would have realized it would be better to move left. But I didn't. I threw myself on the snow and waited for the avalanche to hit. Heavy torrents of snow tumbled me right and then left. I swam furiously with the grinding monster and it kept pulling me under, but I thrashed about enough for my head and hands to reach the surface when the avalanche finally stopped.

With most of my body under the snow, the pressure slowly increased on my chest until the simple act of breathing became extremely difficult. I looked at the drops of water falling from my fingers for several minutes and realized that I was going to die. I wondered how long it would take.

Then I heard a shout. I tried to call back but only a croaking sound escaped my throat. Stanley had found me and he and the others soon dug me out. It was snowing lightly and a heavy fog had settled over the glacier. Carson later wrote, "Al was buried up to his neck, with his left hand sticking out and blood on the snow around him, and on his face. My first reaction was that his lungs were punctured by his ribs in the fall. We started to dig him out … he was moaning … when we got the snow off his back it was curved backwards and obviously painful for him."

When they got to my lower body, my legs were so twisted and out of place that they couldn't believe they weren't broken. I slowly recovered and was able to walk back down to

International base camp where the flags of many climbers' nations fly. Behind the flags stands Peak 19, and to the right is the Krylenko Face. Photo: Gary Ullin (Gary died in an avalanche during this expedition.)

a lower camp just above base camp. Our thoughts turned to our friends at the sérac camp, who we were sure we would never see again. To our amazement they appeared at the lower camp not long after we arrived. It was a joyous reunion as we shared all the terrible moments of the last few hours.

We returned to base camp on July 24 and learned of the other disasters that had occurred during our absence. An earthquake centered in the Hindu Kush had caused avalanches all across the Pamirs on July 23. The party attempting Peak 19 got into heavy snowfall and Gary Ullin suffocated when his tent was buried by a large snowslide. Three Estonians attempting the east face of Peak Lenin also died in avalanches. The mood at base camp was gloomy indeed and we welcomed a few days of inactivity so we could recover from our ordeal and decide on a future course of action.

The weather now seemed reasonable, but in light of the four deaths that had already occurred, Abalakov and Monastyrski were not eager to see any of the teams take on undue risks. After much discussion, Jeff Lowe, John Marts, and John Roskelley decided to return to Peak 19 to complete their route and to bury Gary Ullin's body at the site of the avalanche; we would later learn that Marts turned back early due to illness while Lowe and Roskelley continued. Two other groups of Americans along with teams of several other nationalities— including the Russian women's team, composed of eight of the top female climbers in the Soviet Union—would go to Peak Lenin. Jock Glidden, Chris Wren, and I would retrieve the buried gear on the Krylenko and then climb the Lipkin route on Peak Lenin a few days behind the Russian women, who planned to sleep on the summit during their traverse of the mountain.

Little did we know the tragedy that would unfold over the next several days.

I have taken the information that appears in the italicized portion of the following diary entries from later conversations with friends who were at base camp. We had no direct communication with base camp during our climb because of a malfunctioning radio.

August 2. Now that my back is feeling much better, I decide to go with Jock Glidden and Chris Wren to climb the eastern, Lipkin route on Peak Lenin, which is entirely visible from base camp. Jock is a professor of philosophy from Ogden, Utah. Chris, who speaks fluent

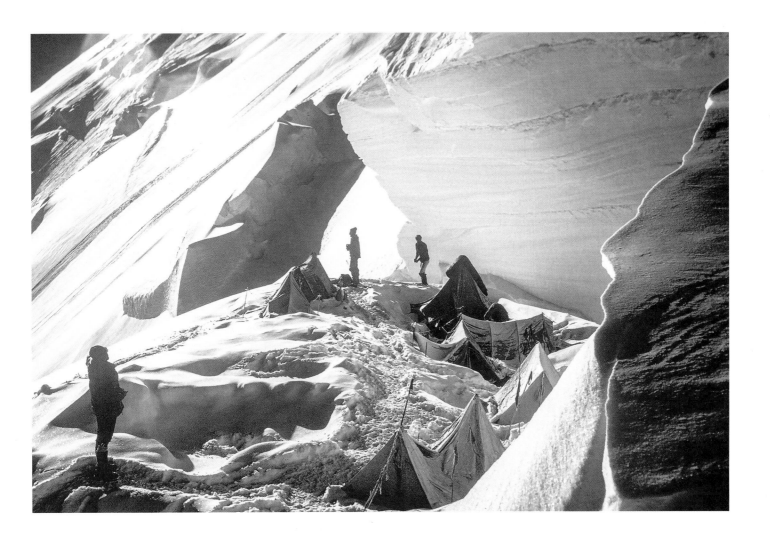

Crevasse camp on the Krylenko Face near Peak Lenin. Early on the day this photo was taken, Evans, Bruce Carson, Fred Stanley, and I returned to base camp to get some supplies and parts for a failing stove. A huge earthquake hit, triggering many avalanches, including one that poured over this camp. The four of us had glissaded swiftly down the face. Three of my companions were unscathed, but I was buried with only my head and hands showing. Luckily they found me and dug me from my grave. The attempt to cross the Krylenko saddle was abandoned. Photo: John Evans

My partners negotiate high winds on their way up to Camp III at 6,700 meters before the infamous storm on Peak Lenin.

Chris Wren and Jock Glidden at Camp III on Peak Lenin. The following day they would climb to the summit
and discover the bodies of the Russian
female climbers.

Russian, is chief correspondent with the New York Times bureau in Moscow. We arrive at Camp II around midday in beautiful weather. It is so warm that we take snow baths, jumping naked from our tent platform and crawling rapidly back up to the tent.

The Soviet Meteorological Center in Osh, a large city some 160 kilometers to the north, has sent a weather report stating, "unsettled conditions over the Pamirs, with no definite signs of frontal formation."

August 3. Cloudy weather today and we have route-finding problems getting over to Camp III in whiteout conditions. Our altimeter tells us that we are at about 5,800 meters.

August 4. We decide to take a layover day at Camp III. Weather is quite stormy with snow and rain at base camp. Alan North, a member of the Scottish team, comes by after his ascent of Peak Lenin and stays for a cup of tea. He was ahead of us on the Lipkin along with some of his mates from Scotland, but they were moving so slowly he decided to go on alone. He dug a snow cave and spent last night a hundred meters below Lenin's 7,000-meter summit, the second highest in the Soviet Union. He tells us he'd seen the Russian women just as he was descending from the top. They had appeared cheerful and were looking forward to camping on the summit. Another group of French and British climbers appear on their way back to base camp so another round of tea is prepared. The French, bless them, produce their last pop-top can of wine, which they share.

Osh reports this morning that a major storm front is moving in from the southwest, one of the largest they've seen in years. It's already snowing at base camp in the Valley of Edelweiss at around 4,000 meters. Abalakov radios all teams on the mountain, including the Russian women, and advises them to descend as quickly as possible.

August 5. Clear in the morning. Still with our useless radio, we gather our belongings and start the laborious hike up to about 6,750 meters where we set up Camp IV. A storm is now upon us with strong winds. We're right on the ridge, fully exposed to the increasing fury of the weather. Jock prepares a fine dinner using our freeze-dried packets in conjunction with nourishing Russian food supplied by the commissary at base camp. The stove works flawlessly. Our four-man tent is being severely battered, so much so that I suggest to my mates that we wear our boots and all our outer clothes to bed in case the tent blows apart during the night.

A lot is happening on Peak Lenin this day. Many from the international camp are climbing Lenin along the west ridge above Razdelny Pass, including several of our American team. It is crowded on the route, and some climbers are confused.

A group of Scots and Japanese reach the summit around 4:30 p.m. in the worsening storm at about the same time that the Russian women get there. Ronnie Richards, one of the Scots, urges the women to descend as the storm is a fierce one. "No, we will place our camp here on the summit," Elvira Shatayev, the leader, replies. "We are strong, we are Russian women." When they radio that they are trying to establish their camp on the summit, Abalakov, the supreme master of sports for mountaineering in the entire Soviet Union, orders them a second time to get off the summit and retreat down the Lipkin route as quickly as possible. But they refuse again. It's snowing hard at base camp and the temperature is dropping fast.

August 6. The storm rages on but we seem in control of the situation. We do our chores and occasionally step outside to face the elements. Sometime in the night the top section of our aluminum tent pole snaps and while one person holds the tent up in the terrible windstorm two of us are able to splint the broken pieces and reset the tent. All is well. Early in the morning something happens that I'd never seen before: I awake briefly, perhaps startled by the increased force of the wind, and watch as static electricity from the tent fabric discharges to the tent pole. It is an eerie scene.

There is five inches of snow on the ground at base camp. The Meteorological Center is forecasting winds of hurricane force—it's the biggest storm Osh has seen in twenty-five years. The tents at base camp are sagging under their covering of snow and the closure system of toggles allows the wind to blow snow inside. These are the same tents the Russian women have on the summit and they are blowing apart in the ferocious 145-kilometer-an-hour winds up there. The women radio from the summit that the night was bad for them. Two tents have been destroyed.

Abalakov again urges retreat down the Lipkin, telling them to dig snow caves, and Shatayev says they will try. At 5:00 p.m., the women report that one has died and two others are doing poorly. At 8:30 p.m. Shatayev reports that two more have died and the remaining five are in a collapsed military tent with broken poles. They are unable to dig snow caves because the terrain is too rocky. Shatayev feels a great responsibility toward her companions and does not want to abandon them, thus the retreat is agonizingly slow.

August 7. We lie in our stormbound tent waiting for better weather to appear. The wind seems to become less intense in the late afternoon. Chris tells us what he knows about Elvira Shatayev and the young women on her team. Abalakov himself had encouraged the group to undertake the traverse of the Lenin summit. He felt it was time that female mountaineers in the Soviet Union try a major ascent on their own without male companions. The women were the top female climbers in the country; several had already climbed Lenin, and Shatayev was the first female climber to ascend the highest peak in the Soviet Union, Peak Kommunizma. In an earlier interview with Chris Wren, Vladimir Shatayev, Elvira's thirty-seven-year-old husband, described his wife as a temperamental, artistic woman who had worked her way up through the various grades of difficulty to become a Master of Sports in mountaineering.

At the 8:00 a.m. transmission, all the women are weak and only two are functioning. They will stay and die together. At noon, one more dead, two dying. Shatayev seems almost delirious when she says, "We will go down now, there is nothing left for us here. When will we see flowers again?" She sobs into the radio at 3:30 p.m., "How can this be happening to us? We are sorry, we have failed you. We tried so hard. Now we are so cold."

At base camp, Abalakov, Craig, and others in the communication tent are stunned with the growing realization that all the women are lost. At 6:30 p.m., we hear several clicks of the transmitter key and then above the roar of the wind the very faint voice of Shatayev: "Another has died. We cannot go through another night. I do not have the strength to hold down the transmitter button." At this, the female Russian interpreter bursts into tears. People look at one another in embarrassed silence. At 8:30 p.m., the receiver registers a few of the clicks heard earlier and Shatayev comes on in a voice almost drained of life: "Now we are two. And now we will all die. We are very sorry, we tried, but we could not … please forgive us. We love you. Goodbye."

The radio clicks off, and everyone in that storm-lashed meadow knows the cheerful Soviet "girls" are gone forever. All weep unashamedly as the finality is driven home by the utter silence of the radio and the unforgiving wind. The Soviet men and women weep the hardest as they, even though several generations removed from the church, make the sign of the cross and with that almost-forbidden gesture signify the end has come.

And then there is only the wind.

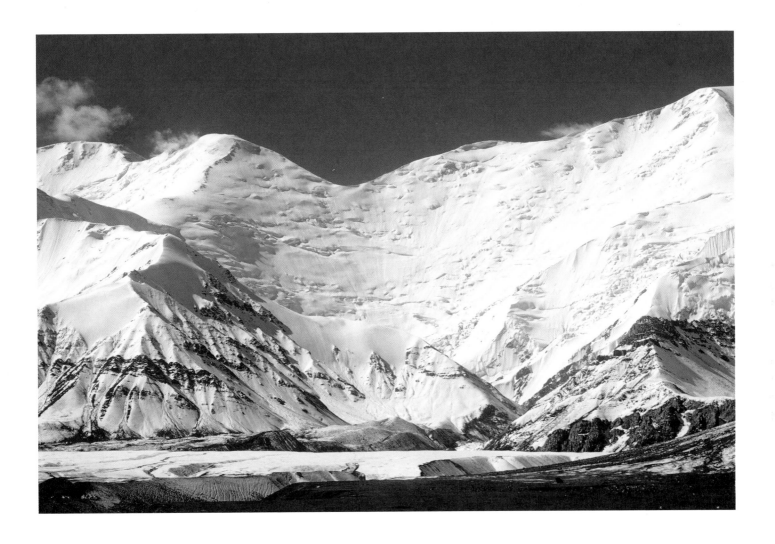

The Krylenko Face on the left and Peak Lenin on the right, Pamirs.

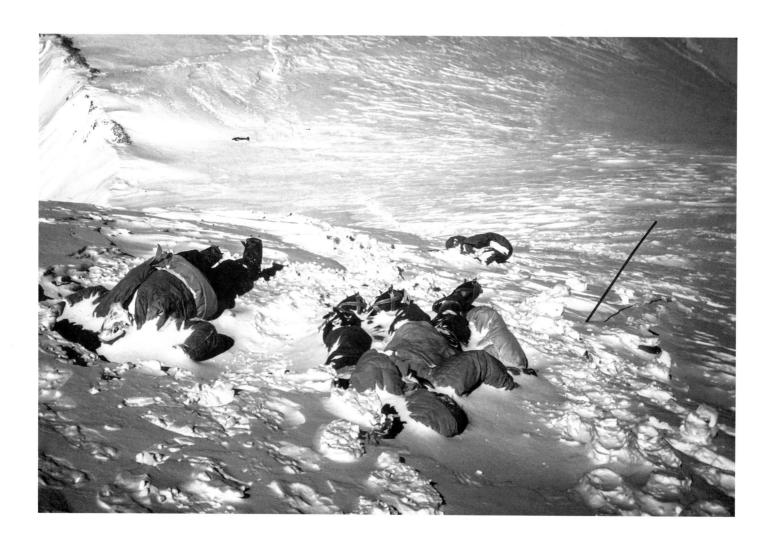

The frozen bodies of Russian female climbers a hundred meters below the summit of Peak Lenin. The women had been determined to camp on the 7,134-meter summit despite a forecasted storm. On their way to the summit after the storm, my partners and I were the first to discover the bodies.

August 8. The storm has finally ended, and there is not a cloud in the sky though a strong wind is still blowing. The cold is intense as we stumble around in the tent getting our gear together after such prolonged inactivity. Our tent site is about a half kilometer from the summit and 400 meters lower. I'm the last to step outside and as I close the zipper and attempt to follow the others, I find myself unable to move. I stand there in rising panic as the figures of Chris and Jock get smaller and smaller. *What on earth is wrong?* I ask myself. Finally, I come out of whatever lethargy has taken over my body and follow the others. I eventually reach them on the snow-covered slope about 120 meters below the top. Luckily, the wind has subsided. Incredibly, four Japanese appear. I have no idea where they weathered the storm and we can't find out since they speak little English. They are holding out a radio to us saying, "*Basa, basacamp.*"

We call base camp and are stunned to hear of the tragic demise of the Russian women just above us during the last two nights. There is a body close by; Chris recognizes Elvira Shatayev. We tell base camp we'll call when we get to the top. We find the bodies of the women climbers, in various positions, just below the summit. Tears form as I walk among them and I cry openly. Shreds of tent fabric and pieces of broken tent poles appear here and there. One woman lies on top of a shredded tent right at the edge of the north face. Her eyes stare back at me with stark intensity.

We call base camp again and tell them what we are seeing. They inform us that a group will come up to the site in a few days and give the women a proper burial. With heavy hearts and great sadness we return to our tent and begin preparing for the descent to base camp.

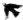

A lengthy inquiry by Soviet government officials into the tragedy determined that the deaths of the Russian women had resulted not from mistakes but from a natural disaster. Chris, Jock, and I along with many other members of the American team disagreed with this official declaration. As early as August 4, when the national weather service had warned of the approaching major storm, Abalakov had requested that all climbing teams return to base. We did not openly share our disagreement with either Abalakov or the camp director Monastyrsky, assuming that they surely understood why the women died. The loss of these eight women was the worst tragedy ever to occur in the history of Soviet mountaineering.

On the summit of Peak Lenin, from left to right: Chris Wren, Jock Glidden, and myself.

The Glade of Edelweiss was bustling with activity as the date of departure approached. On the morning of August 10 another earthquake tossed us about in our sleeping bags. We made our farewells to our Russian friends. Monastyrski and I sang one of his gypsy songs. Another strong earthquake occurred on August 12 and snow and ice roared down from all the peaks in front of us. Surprisingly, Gary Ullin's parents arrived at the glade in an Aeroflot helicopter and we had a final ceremony at the big memorial stone on which were inscribed the names of all the mountaineers who had perished doing what they loved. Finally, on August 13 we boarded trucks and began our homeward travels.

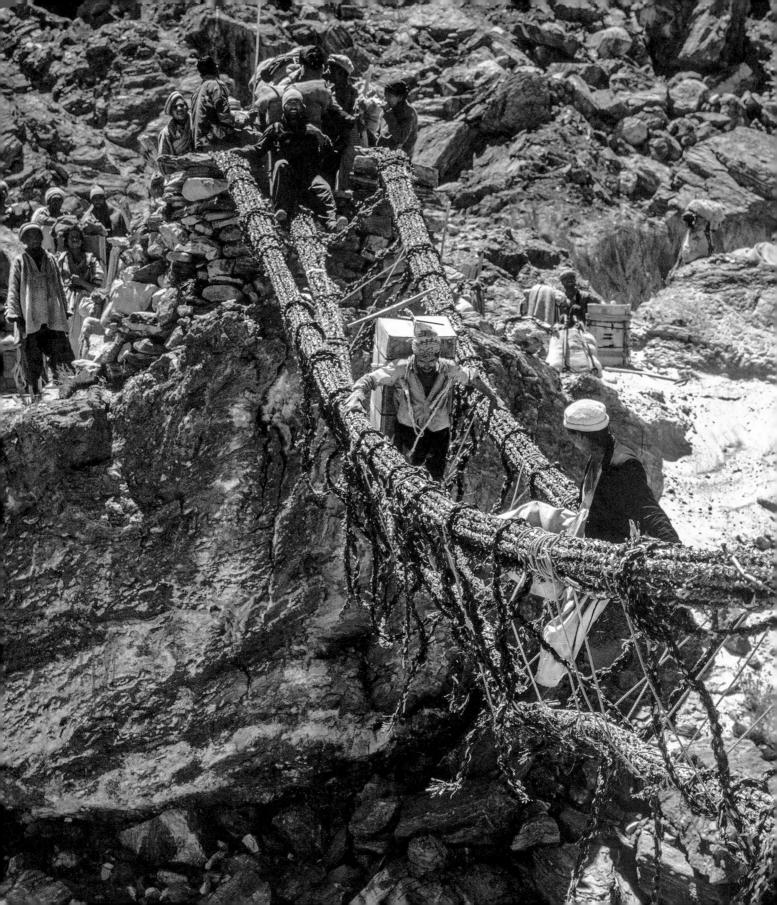

FIRST ASCENT OF PAKISTAN'S PAYU PEAK

I was sitting by the fire enjoying a glass of sherry on a cold, rainy evening in January 1976, when the phone rang. It was Nick Clinch, that venerable mountaineer who had led successful first ascents of Hidden Peak and Masherbrum in Pakistan and Mount Vinson in Antarctica. Clinch began by telling me about his experiences with the Alpine Club of Pakistan and their efforts in 1974 to climb the 6,600-meter Payu, a spectacular unclimbed peak he was familiar with from his previous expeditions on the Baltoro Glacier. The Alpine Club of Pakistan consisted mainly of officers from the military, and its secretary, General Safdar Butt, had arranged for Clinch and two other American climbers, Tom Hornbein and Dick Emerson, to join the attempt on Payu.

The team had established base camp in a lovely meadow a day's hike up a small side valley from the Braldu River and, after a few days of training in basic mountaineering techniques, had begun the climb. Unfortunately, the attempt was abandoned when Momin Hamid, one of the Pakistani climbers, fell to his death while crossing an ice slope low on the route. It was a sad ending for so noble an enterprise, and Clinch, in his usual generous manner, offered to return in the spring of 1976 for another summit try.

He now startled me by asking if I would be interested in taking his place for the coming attempt only a few months away. He had just taken on the job of executive director of the

A Balti bridge of woven roots crosses the Dumordu River on the way to Payu. The party worked to reinforce this swinging bridge.

Sierra Club Foundation in San Francisco and would not be free to return to Pakistan. He knew I was familiar with the trek along the Braldu River and up to the Baltoro Glacier, as I'd been there in 1975 with a Mountain Travel group. I brought to mind an image of Payu, which I had passed with my trekking companions; even then I wondered what it would be like to attempt such a beautiful mountain. Payu lies just downstream from the terminus of the Baltoro Glacier and its glistening summit rises majestically above the valley, seemingly supported by giant, snow-plastered pillars of golden-colored granite so characteristic of this part of the Karakoram. I told Clinch that I was interested but would need time to study the ramifications of such an endeavor. I would give him a decision within two weeks.

What was there to consider? All my expenses in-country would be covered by the Alpine Club of Pakistan. I could get time off from work, and my wife, Cyla, and our children were by now used to my absences on various Mountain Travel trips. My one major concern was the composition of the team. What would it be like to climb with inexperienced mountaineers from another country whom I had never even met? Many climbers would have said no at the start, for part of the joy of climbing is to go with trusted friends. I knew that going to Pakistan would be a risk, but in the end the pull of Payu was irresistible. I called Clinch and told him I would be glad to take his place. I hoped to convince another American, preferably a doctor, to accompany me, but all declined for various reasons.

Clinch and I were soon hard at work accumulating equipment for Payu. General Butt had connections in various parts of the world and made available the funds necessary to purchase and ship most of the gear required to Pakistan. My ticket to Rawalpindi was inexpensive due to the travel agency discounts available in the 1970s. Finally, I was ready to leave San Francisco with six heavy duffle bags. After landing in New York, Seema Saeed, the special services superintendent for Pakistan International Airlines, helped me load everything onto Flight 324 and I took off for Rawalpindi, arriving there midmorning on June 3. Major Manzoor Hussain, leader of the expedition, met me at the airport and soon introduced me to the other members of the team. To my amazement, everything was already packed and loaded onto a military C-130. We would leave for Skardu, the last town on the Indus River with an airport suitable for such a large airplane, at 6:00 a.m. the next day.

We assembled at 5:00 a.m. on June 4 and took off at 6:15 a.m. The flight up the Indus valley to Skardu usually takes an hour, but after thirty minutes, as we neared the icy slopes and cliffs of Nanga Parbat, the cloud and fog became quite dense, so we returned to Rawalpindi. Now there was time to become better acquainted with my new climbing friends, who all

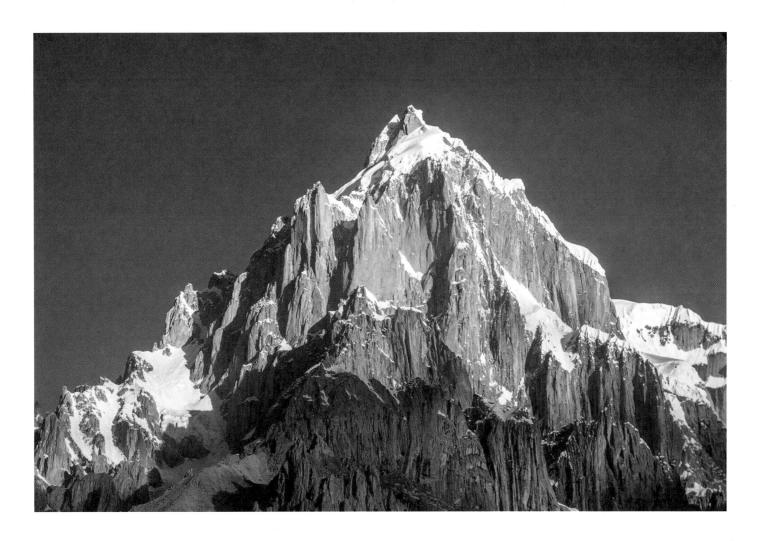

Payu Peak, the route of the first ascent party was around to the left, out of view.

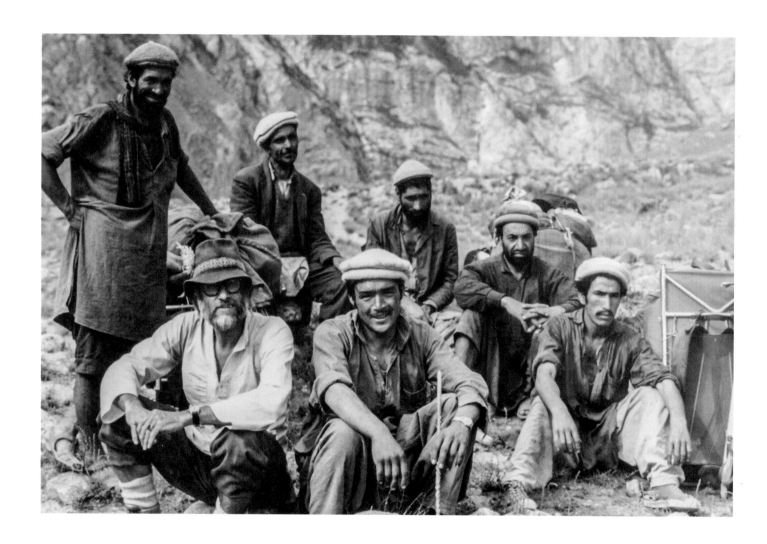

With Balti porters.

spoke excellent English. The team consisted of Major Manzoor Hussain, leader, and Squadron Leader Javaid Iqbal, deputy leader; Major Bashir Ahmed; Captains Mohammad Ayaz, Amjad Kamal Butt, and Saeed Ahmed; Flight Lieutenant Z.H.K. Yousafzai; Captain Tahir Ahmed, trip doctor; and Nazir Ahmed Sabir, a native of Hunza and the only non-military member besides me. Except for the doctor, the Pakistanis were all young; several had at least some climbing experience but the others were absolute beginners.

The weather was doubtful but we took off anyway at 8:30 a.m. on June 5. Visibility improved as we passed Nanga Parbat, and we landed in Skardu at 9:30 a.m. in clear weather. What a joy it was to travel with this group absent any worries about transport or logistics. Manzoor found enough jeeps to take us in two groups to the end of the road at Dasso, some fifty kilometers upriver from Skardu, although the going was not easy. Our team was reunited and to our delight, the porters—all 103 of them—had already arrived. The loads were made ready for an early departure on June 8.

We left ahead of the porters and arrived at Chagpo late in the afternoon. I thought I'd get away with carrying only camera gear but ended up with a forty-five-pound pack. This was probably for the best; I needed to acclimatize. The trail to Chongo, the next village, led over a huge hill, which we had to hike during the hottest time of the day. Five sheep traveled with us and would end up in the base camp pot. Due to rockfall, there were several dangerous passages along the route. But the weather was lovely, with scattered clouds. As Saeed and I entered Chongo, one of the locals asked him, "Who is the white infidel traveling with you?" Saeed told him I was an American liaison officer, specially hired for this trip!

The next day we passed through a couple of small settlements, Tongal and Sungu, on our way to Askole, the last village before base camp. There were some hot springs on the way, and we enjoyed these pools immensely. It was an easy day. As we went through Sungu, we noticed a pretty girl in the window of a small stone cottage. To see us better she leaned forward, putting her arm on the sill: it was black with gangrene well past her elbow. Her fingers glistened as though they were carved out of polished ebony, a ghastly sight. She stayed in her little room, dying slowly. Captain Tahir, our doctor, asked a male relative about her and learned she had fallen into a fire pit nine days previously and been severely burned.

"How did you treat her?" Tahir asked. "Local solutions and herbs," he replied. "The Askole clinic is only an hour away, but she has a better chance if you take her to Skardu," Tahir told him. "Too far, five days. She can't walk. Allah will take care of her," was the man's final response.

Stratocumulus clouds were with us through the day. A soft rain fell as evening approached. The clouds were with us still as we left Askole on June 11. We crossed the Biafo Glacier and wandered over easy terrain near the Braldu River to our camp at Korophon. As we walked along, I learned more about a few members of the team. I discovered that Captain Saeed felt lucky to have been chosen for this expedition, as both his parents and his base commander considered mountaineering a worthless pursuit. Captain Ayaz had been supervising a road crew working on the Chinese-funded road that would link Pakistan with China over the Khunjerab Pass. Major Manzoor had been the liaison officer for the 1975 American K2 team. It continued to rain that evening.

After traversing a few tricky cliffs the next morning, we arrived at the Jola, a twenty-meter rope bridge made of three woven strands derived from the roots of a local bush and spanning the Dumordu River. Crossing this fast-moving glacial torrent was a serious matter since the bridge was in disrepair. Two hand lines were situated about a meter above a larger-diameter strand on which one walked, and all three strands were laced together with smaller cords. Many of the smaller cords were missing, so we reinforced the structure by adding pieces of our spare nylon rope. Once the repairs were finished, it took about three hours for all the porters to cross. You had to be careful not to induce any swinging motion, and it was essential to focus on your feet and to avoid looking at the rushing river below. Nazir volunteered to carry the sheep across. The afternoon was quite hot, and as we set up our camp at Bardumal a frightful wind came up, blowing sand into everything. Finally, the gale subsided and a beautiful full moon bathed our tents in silver light.

An easy day brought us to the Payu nullah, the gully that led up to our base camp some 600 meters above. The carry up the nullah would be tricky and a bit dangerous, and we decided to camp so we'd have a full day to undertake it. The year before I'd met a French group here that was returning from an attempt on Payu after an accident involving one of their party. The injured climber, who was caught in an avalanche in one of the lower gullies on the mountain, sat by the trail with his right leg covered in a plaster cast all the way to his thigh.

The route up to base camp was as complicated as we had thought, and it took about five hours for all the porters to reach the site at 4,550 meters. It was a wonderful place with flowing water and lovely small flowers and grasses, named Momin's Meadow after the Pakistani climber who was killed on the 1974 expedition. We were quite close to the major gully leading up to the lower snowfields of Payu. The time had come to pay the porters, but they asked

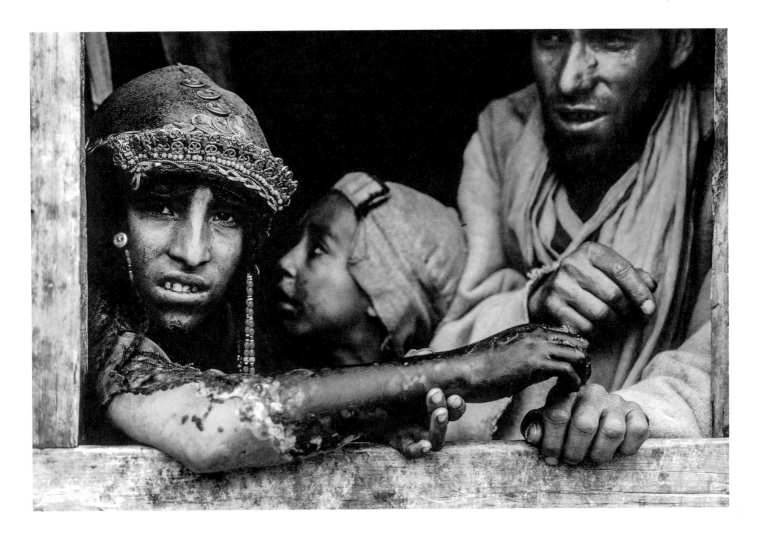

This Balti woman fell into a fire and her arm had been wrapped using dirty bandages and became gangrenous and necrotic. The party recommended that she be taken to a doctor in Skardu, but her relatives said, "Too many days. Allah will take care of her." When the climbing party returned after climbing Payu, she had died.

for more money than we'd agreed to. The year before, I had to deal with a similar problem myself, but now I sat quietly and watched the proceedings. Manzoor handled the situation with aplomb and soon the porters headed down to the valley floor with a few extra rupees in their pockets. They'd had an easy time because they did not have to go up onto the snow of the upper Baltoro Glacier where most expeditions were headed.

In the late afternoon of June 15 we set up our tents and began sorting our equipment. The plan was to begin a weeklong training session the following morning in which I would teach the Pakistanis everything I knew about climbing on rock, snow, and ice. The sky was clear by evening, and the lower buttresses of Payu loomed above us in the spectacular sunset. The first sheep went into the pot.

Our training began in light snowfall. It soon became obvious that the team had less mountain experience than I'd anticipated, so we spent the day reviewing the basics of knots, belaying, and rappelling. I thought that only three or four of the Pakistanis would go high, which meant we'd have a manageable summit party of four or five, an ideal number. The following morning, snow still covered the camp and the weather was mixed. The sheep were unable to forage, so their days were numbered. We worked on setting anchors with pitons and chocks, holding falls, rigging fixed lines, using Jumars, and more belaying and rappelling.

At his suggestion, Manzoor and I shared a tent, making it easier to discuss important matters. He was twenty-seven and had been in the army since the age of sixteen. Like Captain Ayaz, he had been working with the Chinese on building the road through Hunza to the Chinese border. As we sat in his tent, we could hear the dull roar of many avalanches coming off the peak, not a pleasant sound. The snow load up there had to be tremendous.

After a few days of training at base camp we moved up onto the glacier for extensive crampon and ice-ax work. I showed the lads how to place ice screws and rig a pulley system for crevasse rescues, and we spent a lot of time practicing self-arrests. We practiced direct aid climbing for several hours. With each day of training I was getting a clearer picture of individual abilities. Manzoor and I agreed that Saeed, Bashir, and Nazir were skilled enough to go up high on the peak with us.

The snow continued. For most of the week the slopes just above us had been in cloud. The snow there was quite unstable and it became clear that avalanches were going to be a serious problem for us. Saeed, Bashir, and I tried to get to Camp I on June 23 in poor weather. We decided to go up a smaller gully to the right of the main gully on the assumption that the

snow slopes above were less dangerous. We climbed a hundred meters in light snowfall and found some fixed lines that the French had left the previous year. At the top of the lines I asked Saeed to lead the next rope-length. The only anchor I could find was a tiny crack into which I hammered a knifeblade piton; it went in well, though not very deep.

Saeed had climbed out around the corner about ten meters when we heard a horrible sound, like that of a jet taking off. A small avalanche swept Saeed down the gully. The rope came tight onto my belay and I watched in astonishment as the piton bent ninety degrees yet still held the fall. Saeed was pinned under the snow and crying out in pain. The rope was jammed in the carabiners but I quickly figured out a way to release it and then all was well. Saeed suffered only slight injuries and we managed to get back to base camp without further problems. Later I recalled the Frenchman I'd seen the previous year; he must have been avalanched in the same place, but he'd paid a much heavier price.

We listened to the wireless radio that evening for the Skardu weather forecast. The news was not encouraging: clouds, thunderstorms, and snow were expected for the next several days. We'd have to put off establishing Camp I until we had at least two days of good weather. June 26 dawned clear and the following morning was beautiful as well, but we needed to let the upper slopes set up more firmly before carrying loads to Camp I. We practiced direct aid again while we waited.

Finally, Manzoor, Nazir, Amjad, Ayas, Javeed, and I set off early on June 28. The bottom of the gully was narrow and we crossed a large amount of avalanche debris before beginning the ascent. We fixed ropes over a few delicate sections and soon reached the level of Camp I, which would be placed thirty meters to our right, across an extremely active avalanche path at an altitude of around 5,200 meters. It was quiet since the sun had not yet reached the slopes above. The avalanches had carved out an undulating, icy trench that looked like moguls at a ski resort. We belayed each other carefully across this dangerous area. After six hours of climbing we carved Camp I out of a tiny ridge that led to a large pinnacle. Here we were protected from the avalanches that began to roar past us in late afternoon, often throwing plumes of snow five meters into the air. We set up the tents, stashed our loads, and waited until early evening to start the descent, well after the sun had left the slopes and the snow had stabilized.

The next day we brought more loads up to Camp I in the record time of four hours. Saeed, Bashir, and I spent the night there, and the next day we set out early for Camp II in poor weather with light snow flurries. Saeed and Bashir moved well enough, but they were slow.

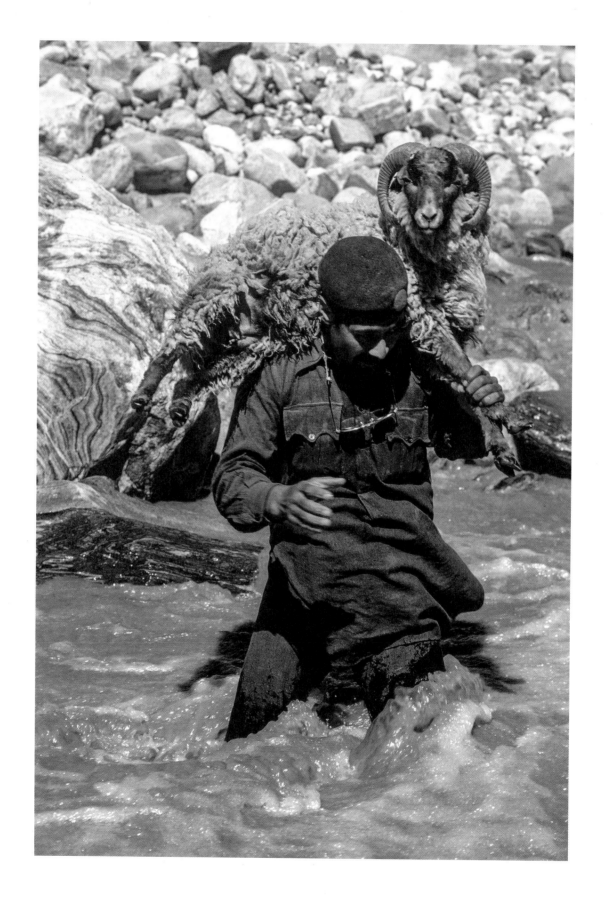

We got to within one rope-length of Camp II on the crest, but the worsening weather forced a retreat. At one point I suggested that Bashir take the lead on an easy snowfield. When he reached a short, rocky section, he asked, "If I go up on the rock, shall I take the carabiners off my feet?" What a surprise to hear that! He'd confused the names, but carabiner and crampon both start with "c." Climbing with the Pakistanis was often agonizing because they had so little experience and knowledge of mountaineering. Still, I felt comfortable because they had learned much since we began the ascent.

We set 200 meters of fixed lines and returned to Camp I. Snow fell intermittently all night. I slept poorly. We awoke quite late to cloudy weather with snow flurries and short intervals of sun. When we made radio contact with base camp late that afternoon we learned that the forecast called for three days of stormy weather. We started down at 5:00 a.m. on June 30, reaching the base of the couloir at 6:40 a.m. I hated this place with a passion; every few minutes I relived avalanches I'd been caught in previously. I could not bear to go up more than one more time! We soon reached base camp. The weather remained cloudy with some sunny periods for a few more hours, but it started snowing in earnest at noon.

We had learned that a Mountain Travel group led by Jack Turner had mail for us and would be camped along the Braldu below our base camp on July 4. I went down to meet them. Turner had brought along a Balti porter, too old to carry loads, who danced and sang beautifully. The steps were simple; it was the flute and the singing that made the evening special. We enjoyed a superb evening dining and dancing with the Baltis. Turner also told me about the meetings he'd had with tourism officials in Rawalpindi, which would be helpful in promoting Mountain Travel's trekking ambitions in Pakistan. I returned to base camp on July 5 with the mail and discovered that seven loads had been carried to Camp I that day.

The weather was perfect and Saeed, Bashir, and I set out on July 6 to establish Camp II, taking about an hour for the final lead. Under Manzoor's direction, six of the team would carry loads up to Camps I and II for a few days. I would stay with Bashir and Saeed at Camp II so we could start working on the route to Camp III, which looked rather complex. A gully led to a snow saddle some 250 meters above but we could not see much beyond that.

Camp II was at about 5,600 meters on a nice, flat area overlooking the Baltoro. We spent much time enjoying the fantastic views of K2 and the other giants of the Karakoram. I suffered from gut problems, but Bashir and Saeed were climbing well and together we set 350 meters of fixed line toward a corniced crest at about 5,800 meters, in spite of a few

Nazir Sabir fording a stream carrying a sheep for dinner at base camp. Porters wouldn't cross this stream, and Sabir volunteered to lead the way. He would later become the first Pakistani to summit K2.

avalanches set off by the intense sun. I climbed five meters of direct aid to avoid an active avalanche gully, which slowed us down considerably as Saeed and Bashir did not have aid slings. This was the hardest climbing I had ever done at that altitude.

We got an early start on July 9 and reached the top of the fixed lines by 7:00 a.m. An easy ice pitch took over an hour and I realized we should have followed a ramp, which we hadn't noticed earlier, over to the corniced crest. We moved so slowly that we gained only forty meters. Reluctantly, we returned to Camp II and collapsed in the tents after a thirteen-hour day. We took a rest day on July 10, lounging about enjoying our fabulous location and generally doing nothing. Nazir, Amjad, and Ayaz arrived around noon with extra rope and other supplies. Nazir stayed and Bashir went down with the others for a well-deserved rest. The altimeter had gone up 100 meters, signaling a change in the weather. It snowed about twenty centimeters during the night and in the morning a light cloud cover obscured the sun. It was so warm that I could take a sponge bath in the snow. Nazir and Saeed were good company and there was much for us to talk about. Saeed, who was twenty-four, came from Jhelum just south of Rawalpindi and had six brothers and sisters. Before joining this expedition he was stationed in Kashmir near the border with India. He had been the liaison officer for a Polish women's expedition in 1975; they'd invited him to come to Poland with all expenses paid, but he couldn't go because of commitments in Pakistan.

I slept poorly that evening owing to a respiratory problem known as Cheyne-Stokes breathing. Several normal breaths were followed by a gap of seven or eight seconds, at which point I woke up in a panic before returning to a normal breathing pattern. Manzoor arrived in camp on July 12. It was a beautiful day and we were able to fix the route to within fifty meters of the crest. Two good-sized avalanches came down, one of which swept the length of the initial gully and caught the edge of Camp I.

I was getting tired of dealing with the fixed lines although we needed them to ferry loads and secure our descent. Nazir, Saeed, Manzoor, and I finally established Camp III at about 6,000 meters on July 13. It was still some distance from camp to where the route steepened into the final 250-meter gully below the summit. Saeed and I felt well and had good appetites; we thought the time was right for a summit attempt. Manzoor was surprised at our audacity. He told us he'd make an attempt with Bashir and Nazir a day or two later. We were working well together, Manzoor and I. He was a gentle, youthful person, but could speak with authority when the situation required. He was a good leader.

Payu Peak showing a small segment of the route of first ascent. Many avalanches came down this couloir, and the route trended right across the lower portion of the photo frame and out of the picture.

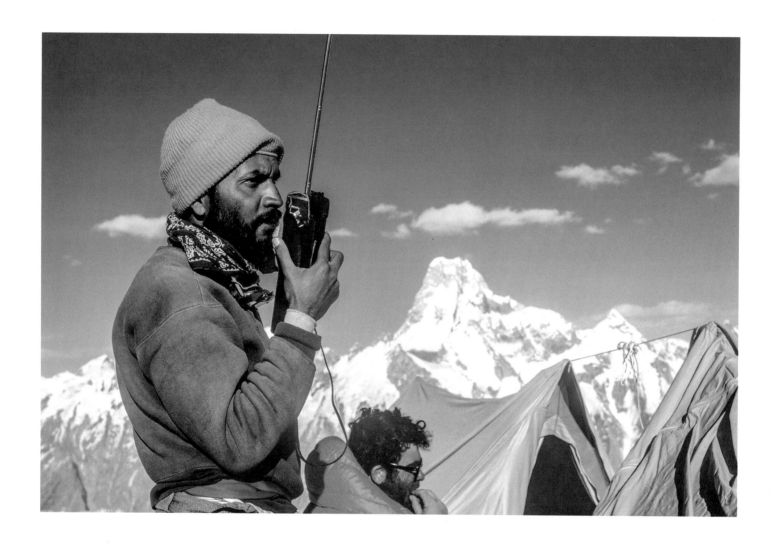

Manzoor Hussain, Pakistani leader of the Payu expedition, making a radio call from Camp III on Payu. Masherbrum is behind on the skyline.

K2 from Camp III on Payu Peak. In the foreground are the tops of the Lesser Trango, the Cathedral Group, and Lobsang Spire.

Saeed and I got away early on the morning of July 14, but the going was slow across the soft, lower-angled snow slopes. The heat was intense. We climbed a few steep ice pitches in the final gully at 6,300 meters leading to the summit but time ran out and we headed down. An avalanche scoured the gully and gave me quite a fright; we were lucky we stopped where we did. On our return to Camp III, Saeed complained of frostbite on his toes and numbness in his fingers, so we continued down to Camp II. Amjad and Ayas accompanied Saeed back to base camp, and he was evacuated a few days later by helicopter.

Meanwhile the weather continued to hold. Bashir and Javeed joined us in Camp II after making an eight-hour ascent from base camp on July 16. That afternoon a cornice collapsed and wrecked the traverse lines leading over to the crest. The hot days were causing havoc on the route. I was depressed and wanted to forget about Payu. Manzoor and I agreed that we needed to set a higher camp. He, Bashir, Nazir, and I climbed up past Camp III on July 17 and established Camp IV at 6,100 meters, below the ice pitches Saeed and I had climbed a few days before. We spent the next day packing for our summit attempt. Our group was working well together and I was feeling good about the climb.

We left Camp IV at 3:30 a.m. on July 19 and made good time on the ice pitches that Saeed and I had previously climbed. We had a clear view of the route ahead after we climbed around a monstrous boulder, and I soon realized that most of the gully was an active avalanche chute. To avoid this I climbed sixty meters of direct aid on the rock to the right, which took quite a bit of time since I didn't remove my crampons and my slings were not the correct length. A sizeable avalanche came down the gully while I was on this lead. On the last easy pitch below the summit plateau I suggested that Nazir take the lead; partway up, his rope came untied and slithered down the slope. There he stood alone on the snow facing a 2,000-meter fall. I got a belay and brought the rope up to him, urging him to tie-in properly the next time. Nazir finished the pitch. It was now 7:00 p.m. and we'd been on the go for seventeen hours, so we decided to dig a snow cave here at 6,500 meters, just below the summit. We spent a cold, miserable night without sleeping bags or food.

Late on the morning of July 20, Nazir led the way up the complex snow structures defending the summit. By 2 p.m. Bashir and Manzoor had joined him on top. I remained on the tiny terrace just below in dazzling sunshine. The view was stupendous, an infinity of peaks arrayed in a wide arc. K2 rose above them all, basking in its glory as the second highest peak in the world. For some weeks I had been thinking of this moment; I'd already decided that I wouldn't go to the summit. Just my Pakistani friends would make the first

ascent of Payu. It was my gift to the entire team and the Pakistan Alpine Club. I relented momentarily when I asked Manzoor to bring me up, but the rope did not reach. Just as well.

It was now almost 5 p.m. We began the descent immediately, making two rappels before dark. We were very tired. There was not much room at the stances while pulling the ropes and we were still above 6,000 meters. We struggled into Camp IV at midnight. I was impressed with how well all three Pakistanis managed, especially Nazir. Only twenty-three years old, Nazir came from Aliabad in Hunza. He had two brothers and four sisters and was enrolled in a German language program at Islamabad University. He had been on expeditions to Passu Peak in 1974 and Nanga Parbat in 1975 but had not previously visited this part of the Karakoram.

Nazir now had a severe headache, but more seriously, Manzoor had developed snow blindness. Bashir and I were fine. Never before had I felt so good climbing at altitude. We decided a rest day was in order. It began to snow at 4:00 p.m. By the next morning Manzoor felt better and we began the descent to Camp III early on July 22. Birds had gotten into our cache there, but enough food remained for everyone. We spent the night at Camp III. Manzoor and I started down to Camp II in the morning but didn't reach the tents until after 8 p.m. Bashir and Nazir followed, collecting as many of the lines as possible, and did not arrive at Camp II until well after dark.

Much melting was happening now, and there were waterfalls everywhere. Bashir and Nazir, along with Amjad, Ayaz, and Yousufzai, our support crew in Camp II, worked hard at dismantling the fixed lines between Camps II and III. They carried enormous loads back down to base camp, obviously with great care and attention to safety. Meanwhile Manzoor and I descended to base camp and made preparations for our return to Skardu. The weather was a mixture of sun and clouds with occasional precipitation. The snow line rose to 5,500 meters and the streams were running high. Finally, after much furious activity, all the loads were down and the entire team had returned to base camp.

We'd arranged for forty porters to arrive from Askole on July 29. Miraculously, they showed up at 8:30 a.m. and the loading began. We said our fond farewells to Payu, still engulfed in cloud, and began our descent to the Braldu River, now running at flood stage, at 11:30 a.m. Over the next few days it continued to rain and we experienced some difficulties on steep terrain because of the high water. But we reached Askole without much trouble. In spite of their poor living conditions, the villagers were very hospitable and welcomed us warmly with a great dinner of chicken and greens.

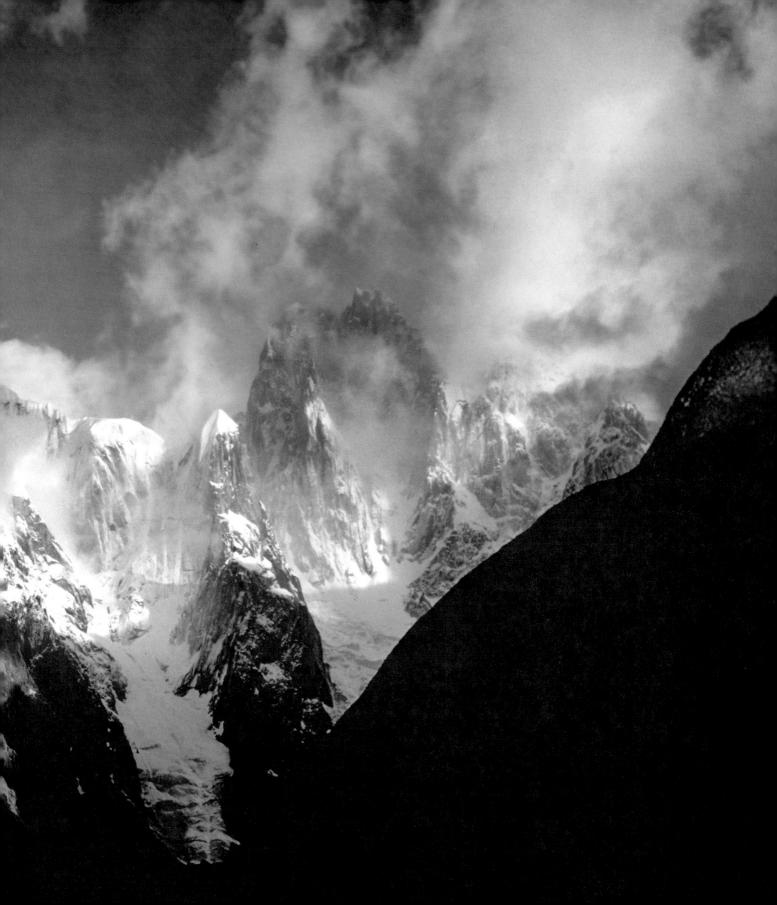

The trek back to the jeeps at Dasso was a nightmare of rain and mud. As we passed through Sungu we learned that the girl we'd met on our way in had died. I got quite sick from a lunch we were invited to by Ali, one of our favorite porters, who lived in Tongal. We camped in a quagmire at Chongo and listened to the rocks falling on the other side of the canyon across the Braldu. The sound was like a jet engine, as boulders the size of VW buses crashed down the hillside all the way to the river. The trail to Chagpo was extremely dangerous. On one big hill, the track was gone for 100 meters and we were forced to cross a series of mud and gravel slides, some of which had gone 200 meters to the river. It was a miracle that we all survived this chaotic section. Finally, we arrived in Dasso, where we met the same disreputable group of jeeps that had originally brought us in. Manzoor and Nazir had already left for Skardu to get funds to pay the porters and to finalize arrangements for our flight to Rawalpindi.

The jeeps were worse than before. The rain continued unabated and we often had to work on the roadbed to make any progress. Somehow we survived this grueling adventure and arrived in Skardu, where we indulged in the first of many victory celebrations. Manzoor arranged for some jeeps and a tractor to get us to the airport, but the tractor toppled over on the way to pick us up. After this was sorted out, we flew to Rawalpindi at last on August 7.

Saeed, who had recovered completely from his frostbite, was at the airport to meet us. The generals in charge of the Alpine Club of Pakistan were pleased that Payu had become a Pakistani mountain. I was invited, along with the other members of the expedition, to a dinner at Murree, a military hill station, where I gave a brief talk. A major in the audience asked about my age. He was surprised when I told him I was fifty. "How were you able to accomplish such a climb at that age?" he replied. I said, simply, "You just have to want to do it."

[Previous Spread] The cathedral-like Payu Peak from Urdukas camp above the Baltoro Glacier. [Right] Pakistani climber Captain Saeed Malik on Payu, who later had to descend with frostbitten feet.

Childhood, Family, and Business

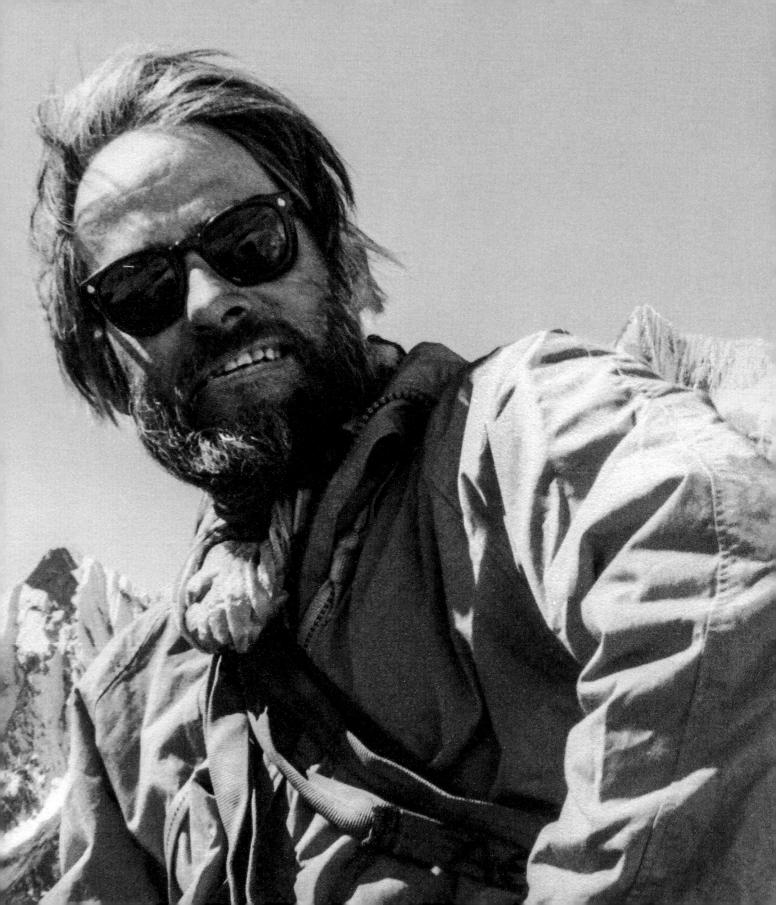

CHILDHOOD AND FIRST CLIMBS

My parents, Leo and Eleanor, divorced only a few years after my birth in 1926. It's still strange to me that I never really tried to find out why. I was the youngest and went with my mother to her new home in Sausalito in the San Francisco Bay Area, while my older brother, George, remained with my father in Oakland. My mother soon remarried and in 1935 we moved to a lovely hillside home in the center of town with a beautiful view of San Francisco and the bay. My stepfather, Frank Lee, a public accountant working in San Francisco, had to take the ferry to and from work, since the Golden Gate Bridge was still under construction. I used the ferries as well to travel alone to Oakland to visit my father, who had recently married Frances Johnson, a schoolteacher he met while on a business trip to Boston. And it was always fun to visit my uncles Homer and Parker and to see my brother George and get to know him better.

In Sausalito I did the usual boyish things. I often went down to the ferry pier to spearfish around the pilings, but most of all, I loved traversing the rocky cliffs at the tidal zone that led from town out toward Fort Baker. Such was my introduction to rock climbing, though I had no idea that it would become my passion later in life. Sausalito started to change in 1933 as work began on the Golden Gate Bridge and the new highway that was to carry traffic through the hills behind town. I loved hiking up to the roadbed to watch the construction of Highway 101. Finally, on May 27, 1937, my family and I joined the huge crowd

[Previous] Image from *Ascent* 1970, a photomontage by Tom Frost showing Royal Robbins displaying various chimney-climbing movements. Photo: Tom Frost [Left] In Peru, 1952.

that walked out onto the span before it was opened to traffic. A fabulous change in the way people would move around the Bay Area had occurred.

In the fall of 1939 I enrolled as a freshman at Tamalpais High School in Mill Valley. I took the train that in those days ran from the Sausalito pier to Mill Valley. I enjoyed the new experience of high school and a growing sense of freedom. I now had a bicycle and often took weekend trips with my new friends to Muir Beach. These were adventurous occasions, as we had to traverse several hilly sections to find a place to camp on the nearby headlands and otherwise fend for our young selves.

The tragedy of Pearl Harbor came partway through my junior year, and I watched from our porch as the Navy began installation of an anti-submarine net across the Golden Gate. The military built a small hut on the hillcrest above Sausalito, and I often went up there with friends to monitor air traffic coming in from the west. We had been trained in the sounds of various aircraft, and when we heard one we'd use the phone to relay the information to headquarters. There was no such thing as radar in those days, except in the United Kingdom.

I enjoyed our house in Sausalito and I was fond of my stepfather, but I don't recall any vacations we took together. My mother and Frank had a daughter, Lillian, about the time I started high school. I do not have many memories of my mother, which bothers me greatly even today. She was a troubled person, and I didn't learn until later from Uncle Homer's wife, Nina, that Eleanor didn't really like young children. It wasn't long before her second marriage ended in divorce, at which time she and Lillian moved to Carmel, where her life slowly unraveled, ending in her suicide in 1960 at age sixty-one. My brother and I had encouraged her to seek psychiatric help, but she did not want to go in that direction. An artistic person, Eleanor worked in her studio in a variety of crafts, but these efforts did not exorcise her demons. I went to Carmel to help with funeral arrangements and remember going down to the beach, where I cried uncontrollably, thinking I was somehow responsible for her sad exit.

I loved my father in spite of our many differences. Basically, he wanted me to become a person like himself. Leo had a Ph.D. in chemical engineering and began his career at Shell Development in Berkeley. This eventually led him to Shell Chemical in San Francisco and then on to the parent company in New York, where he became vice president in marketing, the highest position a non-Dutch person could achieve. My brother George, in contrast to my wayward path in life, would get his Ph.D. in theoretical statistics and

This photograph, "Sons of the Sea," was on display during the 1939 International Fair on Treasure Island, San Francisco. The photographer found us at the Sausalito pier painting this trawler. He arranged the photo with me on the left, holding the brush, and my friend John Hooper at right. I was thirteen.
Photo: W.D.A. Jorgenson

move to Albuquerque, New Mexico, where he worked for Sandia Corporation, much to the approval of Leo and Frances. George also had an adventurous streak, particularly when it came to the Grand Canyon (see A Hike Along the North Rim of the Grand Canyon), which he explored until shortly before his death in 2004.

Leo loved fly-fishing and I have vivid memories of being on vacation with him, Frances, and my brother. I loved being in the High Sierra, where we often stayed at the wilderness camps, reached only by hiking, that had been established by the Curry Company at Merced Lake, Vogelsang, and several other locales. George and I became interested in climbing the nearby peaks, and one day we asked our parents if we could take a long hike from the Vogelsang Camp and climb Mount Lyell, the highest peak in Yosemite National Park. They were not enthusiastic about the idea as my brother and I often quarreled, but they relented. Early one morning we started off on an indirect approach to Lyell, which involved going over a few peaks on the ridge and passing by Mount Maclure to gain the summit. We had some adventurous moments, one of which involved climbing up a very steep sun-cupped snow face which led into an icy chimney on the first peak we encountered, our introduction to the realm of ice and snow. As we approached Maclure I proposed that we climb this summit by an obvious and rather easy ridge. After this diversion, we finished up on Lyell and got back to camp before dark, to everyone's great relief. Only years later did I learn in Hervey Voge's *A Climbers Guide to the High Sierra* that we had made the first recorded ascent of the west ridge of Mount Maclure.

The years at Tamalpais High School passed uneventfully. My grades were reasonably good, but I really didn't get sufficient encouragement from my English teachers about the importance of reading and writing. Somehow the school let me graduate after only three and a half years, in January 1943. My parents thought that going on to college was a good idea, so I applied to enter U.C. Berkeley that fall. I didn't realize it, but I was too immature to start college that early. I failed the entrance examination and was faced with taking remedial English among my other classes. I was suddenly immersed in venerable English authors and poets, not the American writers I was more familiar with, unable to fathom what the former were trying to say. I was living with my stepmother and father at the time, and it was Frances who began to get me interested in the power of words. After finishing two semesters I faced my eighteenth birthday. We were still at war with Japan in the South Pacific and close to ending the fight against the Germans. And I was about to be drafted into the military.

I wanted to join the Navy, but my poor eyesight was a problem. Luckily, my father had a neighborhood friend, Commander Faigle, who was able to get that requirement waived. I eventually ended up on a diesel-electric destroyer escort, the USS *George*, in January 1945. Fortunately, active naval combat against the Japanese had ended by then, so our main purpose was anti-submarine patrols. We guarded the entrance to Guam harbor, did various other sorties, and quite often we'd be sent up north to rescue American pilots shot down during the heavy Air Force raids on mainland Japan.

My job was quite boring. For a while I was assigned to the engine room, but later I got to handle the electric power driving the ship. My mates and I sat in front of a large lever that we would move, when requested by the bridge, to a certain position that determined the ship's speed. We motored up past Iwo Jima to Okinawa, two islands that had cost thousands of American lives to secure. Once a typhoon blew through and all ships were ordered out of the Okinawa harbor, an unsafe anchorage during such storms. The wind and seas were chaotic and our little destroyer escort rolled violently, but luckily no ships foundered.

In early August, 1945, we learned of the nuclear bombs dropped over Hiroshima and Nagasaki. President Truman made the proper decision in unleashing this awful power, since the Japanese were not yet considering surrender. Nagasaki marked the end of the conflict and soon I was on my way home. I was discharged from the Navy in the spring of 1946 at the age of twenty and went to live with my father and stepmother at their new home in the Oakland hills.

I planned on re-entering U.C. Berkeley in the fall but had the summer free. Frances helped me with my desultory preparations for college, and finally suggested that it would be good for me to get out of the house and do something—anything. I found a Sierra Club outing schedule that listed many activities and joined the Rock Climbing Section. Every Sunday we'd meet in downtown Berkeley and proceed to local areas such as Indian Rock and Cragmont, where we beginners would learn rope work, knots, rappelling, and other basic rock climbing skills. Climbing soon became a passion, yet I still had absolutely no idea what to do with my life and just drifted along.

I chose business administration for my major and became engrossed in my studies for the next three years. Thanks to my father I had funds to cover my living expenses. After graduation in the spring of 1948 I took a job as a seasonal ranger in Yosemite National Park, and that fall went to Zürich, Switzerland, a fortuitous turn of events that would have a profound effect on my journey through life.

MARRIAGE, FAMILY, AND WORK

I returned to the Bay Area from my adventures with Karl Lugmayer in the fall of 1949 and again struggled with my future. My earlier studies had been business oriented simply because my father and stepfather were in that line of work. I had come to realize I did not want to enter that world. A friend got me a job with a crew building a road at a lumber mill near Auburn, California, which lasted until the spring of 1950. After some deliberation, I decided to go to graduate school in the German department at the U.C. Berkeley, with the intention of becoming a teacher. My parents were unenthusiastic about this change, though they did agree to help me financially. I'd start school again in the fall of 1950.

In the meantime, climbing was my dominant passion, and my thoughts often strayed to Yosemite Valley and the mountains beyond. Soon after returning from Mount Waddington, I entered graduate school. I still managed to climb in the local areas near Berkeley as well as in Yosemite. In early 1951, I met Cyla Siev in a folk dancing class. Born in Poland, she had come to America in 1938 when an uncle living in Illinois had helped her escape the Holocaust. Cyla was beautiful, loving, and much smarter than me, and we soon became inseparable.

In May 1952, Cyla and I married. Our interest in folk dancing continued, and one evening we decided to attend a Greek dancing session. I wasn't sure I'd like it that much, so I suggested that we take both cars in case I wanted to come home early. To my surprise I

An amicable gesture between sister and brother during our week camped at Cathedral Lake.

Me and Cyla, on our wedding day, May 1952, on the beach in Carmel.

was entranced by the variety of the dances and the power of the music, both of which have remained a lifelong passion. Soon after our brief honeymoon I went to Yosemite with Bob Swift to make the first ascent of Yosemite Point Buttress, and then headed to Peru later that summer for an extended expedition to the Cordillera Blanca. Cyla knew, of course, that I was an active mountaineer who would often be away on climbs. Undoubtedly, my absence must have caused her some concern, but I'd made these plans before our wedding.

I enjoyed my German studies immensely but even before my adventures in Peru, I began to have doubts about becoming a teacher. On returning to Berkeley I dropped out of school and began working at a local sporting goods store, The Ski Hut, in September 1952. At least I now had a job and had begun to earn a living.

Not long after I started at The Ski Hut, backpacking saw a huge increase in popularity. The business prospered with increasing retail sales as well as booming mail-order deliveries. I became manager of the retail department and soon my boss, George Rudolf, opened a modest sewing facility to manufacture sleeping bags, pack frames, and other products under the Trailwise brand name. I eventually managed this new enterprise and enthusiastically immersed myself in design matters. George had designed the chevron sleeping bag, which soon became the top of the line among our sleeping bag offerings. Later I started the production of a smaller, lighter sleeping bag called the Slimline. For most of the bags we used the highest grade of down possible, one ounce of which would fill 900 cubic inches. The Slimline used a differential cut, in which the outer portion of the bag was cut larger than the inner, thus helping the down retain its loft. The bag had no zipper, which greatly increased the warmth, but the user had to crawl inside.

I was doing well professionally and personally. I managed to get time off from work for my climbing adventures, and my marriage was going along smoothly. Cyla and I enjoyed time together in the mountains of California. We bought a house in Berkeley (where I still live) in March of 1955, and our daughter, Sara, was born a few months later on June 10. April 24, 1957, saw the birth of our son, Lee.

One time when the children were young we all went to Cathedral Lake near Tuolumne Meadows and camped there for a week. Sara and Lee loved playing in the small ponds chasing the tadpoles. At one point we went up to a small snowfield where new adventures awaited them. They were beginning to see the beauty of being out in the mountain landscape. On subsequent hikes to Cathedral Lake, rather than going by the established trail, I took them cross-country up the slabs near the creek that ran down to Tenaya Lake. It wouldn't be long

before my family would be able to do one of the most difficult cross-country hikes in the park: the descent of the Tenaya Gorge all the way down to Yosemite Valley.

But sometime around the early 1960s Cyla decided that she wanted to see a psychiatrist. She couldn't make it clear to me why she needed this help. After a few years she was going for five sessions a week. My entire family was in shock. I couldn't fathom this process and Cyla was unable to explain it. I spoke to many doctors, including a psychiatrist who told me that after five years of psychotherapy, we should explore other options to help Cyla. But she chose not to try them.

When our children were young, I would often go into Sara's room at bedtime and read to her. Cyla didn't like this at all and told me so. Only later did it occur to me that she might have been abused as a child. She once told me that she grew up in a one-room, cold-water flat in Poland. Why couldn't she have confided in me about her problems?

It seemed to me that her psychiatrist, had become a big part of my marriage, and I didn't like it. He was too important in Cyla's life. I finally decided on divorce in 1977. Cyla continued seeing him until she died of metastasized breast cancer in 1997. Our son, Lee, had wheeled her into his office for her last visit and was repulsed by the man who had such a grip on Cyla's mind.

Sara and Lee Steck at Cathedral Lake, 1960. The family spent a week at the lake, introducing the kids to their first trip into the Sierra.

The Steck family in our Berkeley backyard, 1962; from left: Cyla, Lee, myself, and Sara.

Myself, Lee, Sara, and Cyla in early 1972 in our Berkeley backyard.

ASCENT

ASCENT MAGAZINE

In 1966 the Sierra Club held its Publications Committee meeting in San Francisco to review various projects already underway, as well as consider new business. I had proposed that the Club initiate a new mountaineering journal under the editorship of Steve Roper and myself. For years the *Sierra Club Bulletin* had published stories of mountaineering accomplishments by local climbers, such as the first ascents of the north face of Sentinel Rock and the Lost Arrow Spire via the Arrow Chimney, along with detailed notes concerning new climbs throughout the West. The *Bulletin* naturally focused on environmental matters and could not devote much space to mountaineering articles and photographs. Climbing activity was increasing in Yosemite Valley, however, and there was a need for a publication to accommodate all the new material being generated there, not to mention stories from other popular climbing areas around the world. *The American Alpine Journal* could have been the vehicle for this new material, but its small format and poor photo reproduction was not suitable for the spectacular photo essays we had in mind. Adding impetus to the idea for a separate mountaineering journal was the publication in 1965 of the brilliant exhibit-format book, *Everest: The West Ridge*, edited by David Brower, in which Tom Hornbein and various photographers showed the power of climbing narrative and images.

Brower, executive director of the Sierra Club, was at the meeting as was Will Siri, the Club's president. Both of them were mountaineers, but surprisingly Brower was against

Cover of the 1974 *Ascent* magazine. This artistic image is a photomicrograph taken by retired scientist Edward Gelus. It is of napthalene and paradichlorobenzene crystals, the material for mothballs. Photo: Edward Gelus

the idea, a position that seemed to indicate his reluctance for the *Bulletin* to lose control of covering the climbing scene in California. Siri's persuasive arguments saved the day and ultimately Brower and the Publications Committee approved the project.

Our first meeting, a joyous occasion, was held at my home in Berkeley and Brower joined us to offer guidance in the early stages of this new endeavor. Much to our surprise, after watching my slide show about the Hummingbird Ridge, Brower said that we should use color for the cover, further suggesting that a photo from that expedition be featured in the inaugural 1967 issue. We agreed on the name *Ascent* for the publication. Little did we realize that we were embarking on a twenty-five-year association with the Club in which we published thirteen issues, culminating in 1993 with the book *The Best of Ascent*. All mountaineers owe an enormous debt of gratitude to the Sierra Club for encouraging *Ascent* to take root, and to Roper, whose editing and book layout skills far surpassed my own.

That first issue, forty-eight pages, priced at one dollar, and edited by Roper, Joe Fitschen, and myself, perfectly demonstrated our desire for innovation and whimsy, and met with critical acclaim. Two contributions stood out: the article "Games Climbers Play" by Lito Tejada-Flores and the beautiful drawing *L'Enfer des Montagnards* by the French cartoonist Samivel. Tejada-Flores' essay was an instant success and eventually became the title piece of a collection of climbing stories edited by Ken Wilson of Diadem Books in England.

During the next eight years we produced seven more issues, all in magazine format. Various writers and photographers, climbing friends all, came and went, among them Lito Tejada-Flores, Glen Denny, Ed Cooper, Chuck Pratt, David Dornan, Jim Stuart, Edgar Boyles, and David Roberts. Since some of these writers were professionals in their own right, Roper and I like to think that by publishing their material we were helping them along in their careers. Pratt, who eventually became a climbing guide for Exum Mountaineering in Jackson Hole, wrote a lovely, lyrical piece on desert climbing for our 1970 issue, "The View from Deadhorse Point." It was so well received that we later asked him to write another story, but, strangely, he wasn't interested. We asked again, and a bit testily, he replied: "I don't want to think about it, I don't want to photograph it, I don't want to write about it, I want only to do it!" Roberts, who went on to become a highly respected author with many books to his credit, wrote several brilliant, acerbic essays on such subjects as climbing autobiographies, expedition narratives, and how-to-climb handbooks.

Our *Ascent* meetings during those early years, often at lunchtime, were a delightful mixture of editing, poring over photographs, discussing layout, and putting empty wine bottles to rest.

Ascent cover, 1972. The first winter ascent of the east face of Keeler Needle, High Sierra. Photo: Galen Rowell

ASCENT

The *Ascent* wine label.

Roper and I would review and edit each of the chosen articles line by line until we were satisfied that the story held together perfectly. On one occasion, in 1970, a story by Ed Drummond came our way. It concerned the first ascent of a sea stack on the Isle of Hoy in the Orkney Islands just off the coast of northern Scotland. It had a rather bland title, so we renamed it "The Incubus Hills" after a sentence early in the piece:

> From leaving Jack Rendal's farm, swaying like camels under our masters, up the incubus hills, it took us two days to set foot on the untrodden beach of St. John's Head.

The story, well laced with metaphors and similes from Drummond's agile mind, was published in the 1971 *Ascent* and still has a special place in the magazine's lore.

Enough wine was consumed throughout all those luncheon meetings that we decided we needed our own label, so we arranged with Bynum Winery, then in Albany, California, to produce some fifty cases of wine under the name Incubus Hills. This was innocuous enough until we chose an etching by Gustave Doré showing three of the climbers on the first ascent of the Matterhorn falling to their deaths as the background for the label. When Davis Bynum saw the graphics, he said, simply, "You fellows really have a macabre sense of humor."

When it came time for the printing of a new issue, the various editors in town would go down to Pacific Rotaprinting in Oakland and deliver all the relevant material. When the color covers were being printed, one of us would "ride" the press with the operator and make final decisions about the color balance. It was an exciting time.

But it was all to change with the appearance of the 272-page 1980 volume. As we mentioned in the introduction to this soft-cover volume:

> The hiatus of four years that preceded the present volume ... resulted in part from our desire to shift the emphasis of the magazine-turned-book toward writing of less topical—and thus more lasting—interest. There are presently several magazines in North America and Great Britain that cover subjects that *Ascent* alone once reported; some of these magazines, in fact, reflect the influence of past issues of *Ascent*. This increased stress on creative graphics and writing has been a positive force in mountaineering literature.

In addition, Roper and I had spent much of the aforementioned "hiatus of four years" researching and writing *Fifty Classic Climbs of North America*. First published by the Sierra Club in 1979, it was a distinctive blend of history and guide. "Our routes are not the fifty classic climbs of the continent," we explained in the book's introduction, "but rather our personal choice of the finest routes in several major areas, which differ radically in length, type of climbing, and geographical setting." By 1999 nearly 30,000 copies of *Fifty Classic Climbs* in its various editions would eventually be sold, and the climbs therein remain sought-after to this day, often to their detriment. And yet, as George Bell Jr. noted in his 1989 *Ascent* article, "Fifty Crowded Classics," the book was valuable for introducing climbers to routes they might not otherwise find:

> In the Winds I was amazed as we completed climb after climb, all beautiful lines on excellent rock and of remarkably similar nature to the two Classics just across the way. It brought home a point that I had not realized on my first trip to the Winds: that in any area containing one of the Fifty, numerous other climbs of comparable quality lay nearby. It was only a matter of hunting them out.

But back to *Ascent*. The Sierra Club agreed to our proposal for the new book format and we no longer had to worry about press checks as the 1980 *Ascent* would be printed by Dai Nippon Printing Co., Ltd., in Tokyo. We inserted as an epigraph a quotation from the famous British climber Geoffrey Winthrop Young to provide encouragement to prospective authors:

> A young mountaineering author has of course the courage of his convictions; but he should also have the courage of his emotions. If he is to be read by human beings, he must write his adventures exactly as he himself humanly saw them at the time. General or objective description, such as satisfied the slower timing of the last two centuries, now reads too slowly, and is dull…. An artist of mountains will devote his whole skill to painting them as they are. A writer has a greater opportunity: he can picture them not only as they are, but also tell of their effect on man.

Let him take courage, and write himself into his story. He is not writing a lifeless scientific treatise. Wherever human beings are concerned, as they are in mountaineering, the writing, if it is to be true at all, must be human and personal; or it will soon die of dry detail and be forgotten.

The 1980 volume was, in my opinion, the most interesting and innovative we produced. Included here were several works of fiction, one of them, David Roberts' *Like Water and Like Wind*, the first novella with a mountaineering theme to be written by an American climber. Two color-photo essays capture the startling diversity of climbing: the wind-etched sandstone of the desert Southwest contrasted vividly with the snow-plastered Cathedral Spires of Alaska.

Two more elegant volumes of *Ascent* appeared: a 173-page hard-cover book in 1984 and a 207-page soft-cover volume in 1989, both containing the usual mixture of fiction, essays, gripping climbing stories, and stunning color graphics. It was the Sierra Club editors who suggested the six-by-nine-inch book format for our final volume, *The Best of Ascent*, published in 1993. We liked this idea since it meant much less work, though we did include a number of new stories that required our editing skills. The indefatigable Roper decided to include an annotated table of contents for every issue of *Ascent* (except the current one) and an alphabetical list of major *Ascent* contributors with their article titles and the year of publication for each. This has been a boon to subsequent researchers.

When it came time for another volume in 1999, the American Alpine Club offered to produce it and we parted amicably with Sierra Club Books. Three benefactors, Yvon Chouinard, David Swanson, and Ron Ulrich, contributed to AAC Press to help make this new volume possible. The noted climber, photographer, and director of AAC Press, Ed Webster, who was in charge of both design and layout, began to work on this new volume as Roper and I, together with our guest editor, David Harris, sent him the articles, poetry, and graphics we had been collecting. Even though the volume was the largest we ever produced at 309 pages, it was priced reasonably at $25. Unfortunately, it did not sell well despite being distributed by Mountaineers Books. For many reasons, primarily the lassitude of the editors, this would be the last volume of *Ascent* that Roper and I would oversee. But *Ascent* lives on. Big Stone Publishing of Colorado acquired the name in 2011, and since then has

published *Ascent* as an annual compendium of reflective essays, art, and photography about the climbing experience. The 2017 edition celebrated the fiftieth anniversary of *Ascent* with reprints of some of the best writing from the past as well as much new work.

The *Ascent* years were marvelous and we have much to be proud of when examining the fourteen issues we produced. The inside jacket cover for the 1993 volume sums it up well:

> Each successive edition of *Ascent* has become a revered artifact of mountaineering culture. Its stunning photographs, winning satire, surrealist fiction, and top-notch reporting—some of the freshest ever to grace the pages of a climbing publication—moved climber David Roberts to call *Ascent*, "Not only the finest mountaineering journal of the last quarter-century, but the most influential."

Ascent cover 1971. Doug Tompkins soloing on Hell's Lum, Cairngorms, Scotland. Photo: Yvon Chouinard

ASCENT

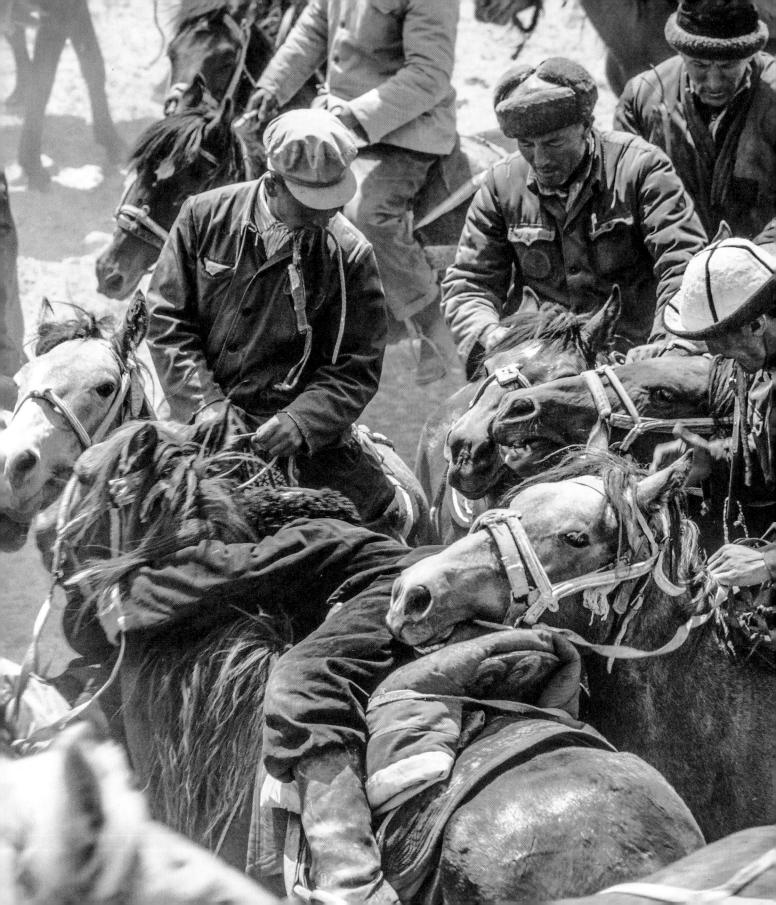

MOUNTAIN TRAVEL

As manager of the Trailwise division of The Ski Hut in Berkeley, I was extremely busy in early 1968 setting up a new manufacturing facility in West Berkeley. Our location at the retail operation on University Avenue was simply too small to handle the increasing demand for our sleeping bags, tents, pack frames, clothing, and other backpacking products. About this time, Leo Le Bon, a Belgian-born acquaintance who had been working at a local travel agency for over ten years, called me about leading a trekking group in Nepal that summer. Leo was working with a company called Mountain Travel in Kathmandu owned by Colonel Jimmy Roberts and had taken a group to Nepal the previous summer. This year there were enough people interested to set up two trips. With great sadness I had to decline Leo's offer due to the workload I was facing at Trailwise.

But that didn't stop me from thinking about it. I knew the Sierra Club had a successful international outing program and I believed there might be the possibility of forming a commercial adventure-travel business. Several of my associates thought the idea reasonable, so I suggested to Leo that we consider the idea. He knew the travel world well and I knew how to run a business. It seemed a good combination of our talents. Leo liked the idea and so he and his wife, Maxine, with their two children, and Cyla and I with our two kids, met at a restaurant in Bolinas, California, in June 1968, to set the idea in motion. The occasion was

A modern, less lethal, version of the ancient sport called Bushkashi is played for a Mountain Travel party in far western China. The sport is played by two opposing groups who try to carry the small body of a dead goat across the other's goal. Horsemen were often killed in the years past.

joyous, but I was quite apprehensive since I knew that the majority of small business start-ups were destined to fail in the first year. I'd also be giving up my job with Trailwise and The Ski Hut, where I'd worked since 1952.

By early fall we had the details ironed out. Stuart Dole, our attorney, prepared the articles of incorporation with a capitalization of $25,000 from friends and family. During his travels to Nepal, Leo had met Barry Bishop, who was working with the National Geographic Society in Washington, DC, and arranged with him to become a silent partner in our organization. Jimmy Roberts allowed us to use his company name, Mountain Travel, as our own. And so we opened our doors for business on January 1, 1969, in a small office in Oakland's Montclair district.

Those first months were filled with furious activity. We applied for and received our license with the International Air Transport Association and thus began our relationship with Pan Am, the carrier that would be handling the bulk of our business abroad. Leo's knowledge of the travel agency industry was extremely valuable in these first years of operation. Alla Schmitz, who would join our staff in 1970, was on the Sierra Club's outing committee and helped steer some business to Mountain Travel. In particular we ticketed seventy Pan Am passengers heading for Japan in 1969. One important cost-saving fact in these years was that all airlines offered a 75 percent discount for agency personnel, including trip leaders. Also, we began to work immediately on our 1970 catalog.

In 1970, we scheduled Canadian climbing and skiing trips, several trips to Nepal, and others to destinations such as Kashmir, Corsica, and Persia. The Nepal trips went as scheduled and I led one of the more adventurous treks, visiting the base camp used by the French to climb Annapurna in 1950. Our Kashmir trip, led by Ray Jewell, was also successful, and Jewell would become one of Mountain Travel's most experienced trekking leaders. A lot of people were interested in the Chamonix adventures. Imagine a twenty-one-day trip to France costing only $400—including room and board. Leo, who spoke French fluently, arranged for this one, renting the chalet Les Periades with its eight double rooms.

Mountain Travel Inc. (as we now called it) had recently acquired the Palisade School of Mountaineering (PSOM), located in the High Sierra just south of Bishop, California. The director for 1970 was Bob Swift, who would eventually become a valuable trek leader. Classes were held in basic rockcraft and guides arranged many ascents of nearby peaks.

Our 1971 catalog contained many new destinations. Leo began to develop itineraries in Peru and the Sahara, and stimulated by an interesting story about the southern coast of

Cover of the 1973/74 Mountain Travel catalog. The illustration was selected from *Voyage au Nepal*, by Dr. Gustave Le Bon, leader of French Archeological Expedition to the East Indies, 1885.

Turkey in *National Geographic* magazine, I decided to visit the area along with my colleague Steve Roper and his wife, Jani. At an Istanbul travel agency we discovered that few people knew much about this coastal region. There are wild animals down there, they told us, and few facilities. Nonetheless, they found a guide who spoke some English and we flew to Izmir and then in a rental car drove to Marmaris, a lovely small town on the Mediterranean. Our guide, Kazim, was able to find a couple of fellows with a seven-meter boat with an inboard diesel engine who were willing to take us to Antalya, six days farther east along the coast. It was a fantastic voyage, during which we learned that our boatmen, Aslan and Mehmet, were often involved in smuggling and had no permit to carry passengers, which meant that we could never motor right into the small villages along the way. So we slept on remote beaches, cooked eggplant, onions, and tomatoes over a small fire, and consumed copious amounts of good Turkish wine. We were visiting places along a route that would soon become world famous as the "Turquoise Coast."

I was also involved in starting trips to the Galápagos Islands, the mountains of Ecuador, Greece, and to Aconcagua, which at 6,962 meters is the highest peak in South America. Late in 1971, we began planning for moving our offices into a building that we had recently purchased in Albany, near Berkeley. Greece, in particular, was beginning to get my attention. Cyla had encouraged my involvement in Greek dancing so much that it had become a passion for me. We decided we should visit the country that produced such strong, exciting music. At the same time a letter appeared on my desk from Makis Idosidis, a part-time resident of San Francisco. It was written in perfect English, asking why Mountain Travel was not doing trips to Greece. Makis and I arranged to meet and I soon discovered he was 150 percent Greek but his English was somewhat lacking. The letter had been written by his girlfriend.

A scouting trip became a reality in 1973, and since four of our group knew the dances, our boom box with Greek tapes allowed us to dance when and where the spirit moved us, much to the delight of the locals. We visited Nafplio and then drove south and camped on a small hillside above the sea. In the morning, we were walking along the beach in the tiny town of Tolon, where we had a fine breakfast at a small restaurant. As I paid the bill I thanked the old fellow in my limited Greek. "*Apo pou eissai?* (Where are you from?)" he asked, to which I replied, "*Eimai apo to San Francisco,*" knowing full well nobody would know where Berkeley was. His eyes widened and he said in perfect English, "You're from San Francisco? You must know the Minerva Café. I was head chef there for ten years." What a small world moment! I often went to the Minerva Café with my daughter, Sara, to dance. The next morning we danced on the stage of the remarkable ancient amphitheater of Epidavros.

A Mountain Travel party reached this meadow in far eastern Afghanistan and was welcomed by a group of Nuristanis making cheese. Could these dancers be keeping the ancient art of the Greek dance alive so many centuries after Alexander came here?

We passed by many nomadic Golok yak-hair tent encampments on our return from Lake Kokonor to Xining, China. The inhabitants of the encampment we visited were most surprised to encounter foreigners from another world. The women went inside and came back out wearing ceremonial dresses and ornaments. The man is wearing a chuba, a yak-hair coat with long sleeves. The container in the front is used for making butter. [Right] One of the women, seen churning butter, showed us her delicately crafted silver ornaments.

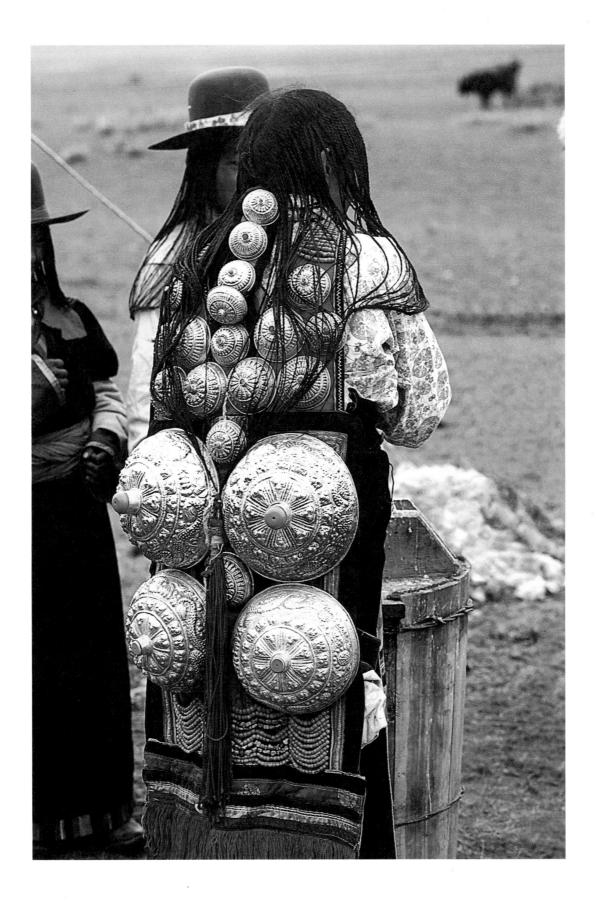

Mountain Travel was growing, and each year's catalog contained many new adventures. But events at the office were taking a strange turn. One morning Leo startled me by saying, with great agitation, "Allen, the trouble with you is that you are not a doer."

I'm still not sure exactly what he meant by this. Maybe I was not the "idea" man that he was? Leo had a powerful personality; mine was far more easygoing, with little desire to dominate. Did he want me to be like him? I'd thought, occasionally, that Leo suffered from overly grandiose ideas; he wanted Mountain Travel to be the biggest and greatest in the world in just these first years of operation. I remember well an occasion in 1973 when I happened to be with a group of French climbing guides and outfitters at a meeting near Grenoble. These were people who had successfully developed travel to Morocco, the Sahara, and other places in North Africa. To no one in particular I mentioned that I had founded Mountain Travel with Leo Le Bon, and a guide near me said, *"Oui, je le connais, Leo le crocodile."* Leo had probably tried to buy them out or push them to become part of Mountain Travel.

Leo didn't understand the skills I brought to Mountain Travel with my studies in business administration and my experience gained from managing The Ski Hut and Trailwise. And I had a better relationship with the staff, which by now had grown to around five people. Our relationship began to deteriorate.

But the business prospered. The 1976 catalog had more trips than ever, fourteen to Nepal alone, along with seven to South America. We had a dedicated group of guides and trip leaders, and a growing list of clients. In 1978, the economy slowed a bit and Mountain Travel experienced its first loss. It was not much but sufficient enough to encourage Leo to discuss the future of the business seriously with me. It was clear that our partnership was not going to last and I told Leo that I was willing to leave Mountain Travel. He liked the idea and immediately began looking for another partner. I knew Leo was unable to run Mountain Travel by himself. He partnered with Dick McGowan, a veteran of several major climbing expeditions with business experience in the outdoor equipment industry.

Though I had retired from the business side of Mountain Travel I continued to lead trips to China, Pakistan, and South America, and was the leader and outfitter for the Greek Kaiki program in the Aegean, guiding boat trips from Piraeus to Crete and back. In spite of our differences, I enjoyed working with Leo on those programs where we shared a mutual interest. The ten years with Mountain Travel remain among the most rewarding experiences of my life. Leo and I now enjoy a good friendship as the troublesome events of the past have faded into obscurity.

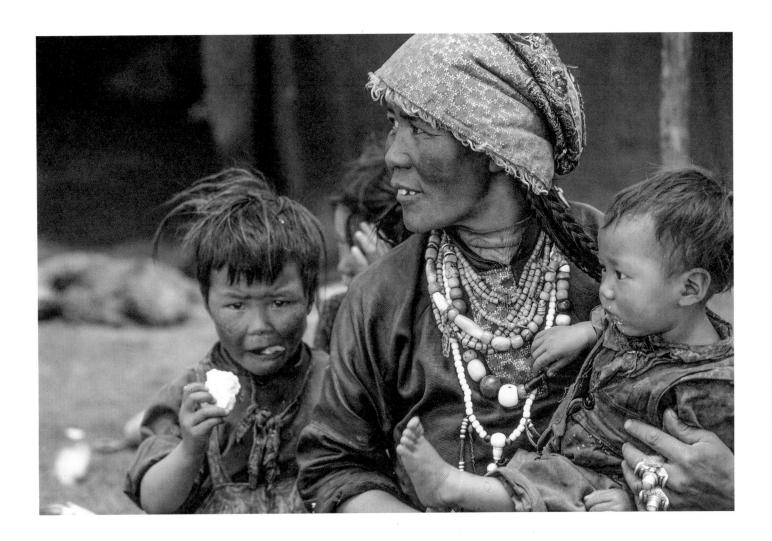

A Bhotia Nepalese woman with her children.

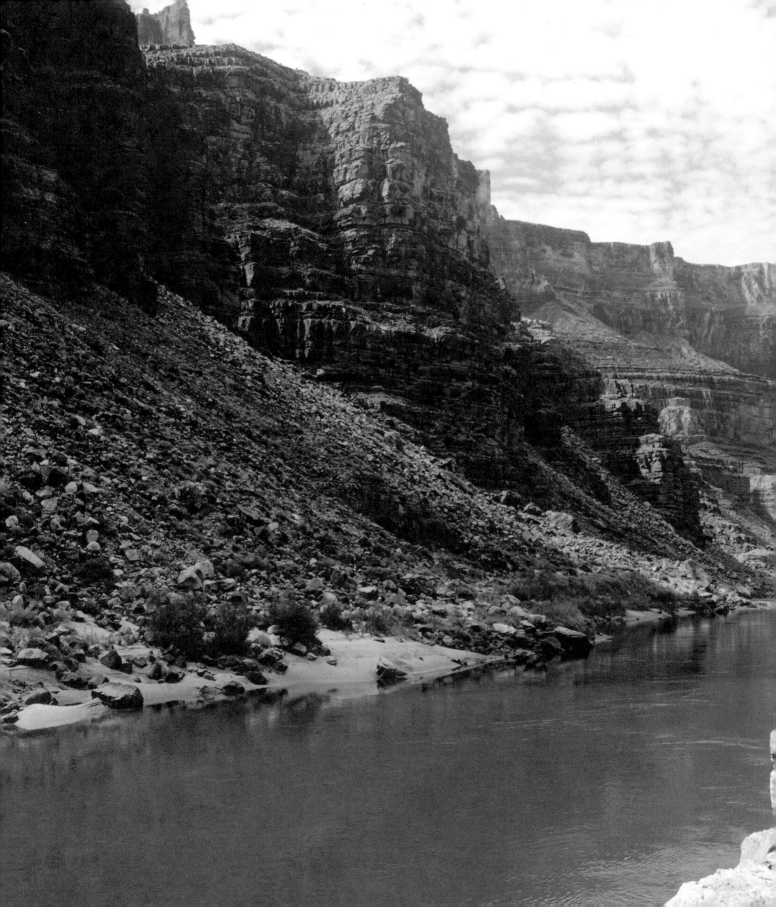

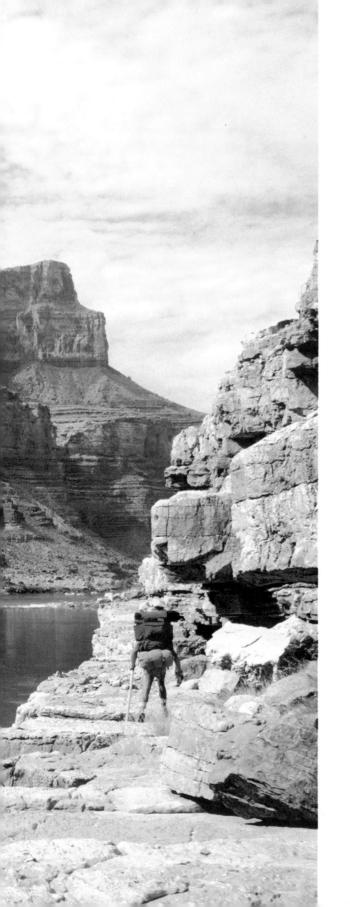

Close Calls and Other Adventures

A SKI WEEKEND AT ECHO LAKE

How we looked forward to those festive ski weekends at Ken Adams' cabin on upper Echo Lake, particularly when they involved celebrating the New Year, in this case 1955. From Highway 50, the main road that leads over Echo Summit to Lake Tahoe, we had all skied in across Lower Echo Lake in miserable weather. Much snow and rain had saturated our clothing, and we spent most of the evening drying ourselves in front of a roaring fire, pondering the approach of the New Year and discussing the objectives we had in mind for the next few days. Pyramid Peak was normally our first choice, but owing to the stormy weather and all the wet snow lying around, climbing something closer to the cabin seemed more reasonable. We decided on Mount Ralston.

We began preparations the following morning. Adams, Bill Dunmire, Dick Houston, and I departed around 9:30. Another group of seven would leave shortly after with the same destination in mind, but on a different route. Stormy conditions still prevailed, with wet snow and high winds. We skied across Upper Echo Lake and, on entering the forest, attached our climbing skins and discussed the route. Our spirits were high and we were enjoying this struggle with nature. Dunmire, Houston, and I had been together on Makalu the previous year, and although we failed to reach the summit, we had experienced many battles with the elements at very high altitudes. The present adventure on Mount Ralston seemed tame by comparison. Or so I thought.

[Previous Spread] George Steck hikes in the Grand Canyon in the first week of the odyssey. [Left] Unidentified partner digging out my ski pole from the site of the Echo avalanche.

"No skier has ever been buried in the Sierra," I said as we began the ascent. Little did we realize that we would soon become involved in a near-catastrophe.

The terrain around Ralston is not particularly complex and it is possible to reach the summit in a number of ways. The route we chose started in the meadow at the head of the upper lake and then ascended slowly along the gentle slopes forming the western side of the valley. We crossed one patch of avalanche debris and heard the dull crunch of the snow settling under us. We knew the snow was unstable but thought the avalanche conditions were not particularly serious. Had we paid more attention we would have realized that all the wet snow of the last few days had fallen onto a layer of cold powder. Surely, we would have proceeded in a more cautious manner had we not been so exuberant in the act of moving through this white wilderness.

We reached a rocky knob that rose 100 feet above the route as we approached the cirque north of Ralston. I started across the gentle slope near the knob, ascending gradually with Adams, Dunmire, and Houston behind me. About sixty feet into the traverse, an avalanche engulfed us. Adams later described the incident in the 1955 *Sierra Club Bulletin*:

> My impressions of the avalanche are vivid. The slope was concave and varied from 15 degrees at the bottom to 60 degrees at the top; we were moving on a slope of about 20 degrees. There was a low thud, and cracks appeared on the whole slope at once. I shouted, "Here it goes!" and felt myself side-slipping down the hill at not too fast a rate. I have no recollection of falling, or of seeing Steck in front of me, but I do remember thinking that this couldn't be happening to me.

My recollections were not so vivid. I must have gone under the snow rather quickly. It felt as if I were in a cement mixer, and I was unable to focus on anything until I came to a stop. The final surge of the avalanche squeezed me so severely against a large tree that my lungs collapsed. I couldn't breathe. The snow encased me like a plaster cast. I knew I was dead and said so out loud. There was no time to think about anything. I panicked and passed out.

The others were in slightly better shape. Houston ended up near the edge of the slide and was only partially buried, while Adams and Dunmire had no trouble breathing despite being well under the surface. The snow held them as firmly as if it were cement.

Adams could hear me moaning. He thought he might last several hours, and could only hope that the other group would somehow find us. He did not know that Houston was in

GEO. FLESSA, SPECIAL REPRESENTATIVE
TELEPHONES: BUS. TEMPLEBAR 6-2964
RES. LANDSCAPE 4-6139

JULES BLDG., 364 14TH STREET
OAKLAND 12, CALIFORNIA

Its name indicates its character

The Lincoln National Life Insurance Company

January 4-55

Mr Allen P Steck
2704 Derby st
Berkeley, Calif

Dear Mr Steck :

 I am reading about your recent experience.
It could have easily been the last one. I wonder, Mr Steck,
if you have any trouble acquiring life insurance, or accident
insurance because of your mountain climbing activities. If
you have, I should like to try and be of service to you.

 Respectfully yours

George Flessa

the process of extricating himself, although that would take an hour or more. Adams would occasionally call for help, only to be met with silence. After a while he heard movement on the surface. It was his old friend Morgan Harris, accompanied by the skiers who left shortly after we did. Harris was well known as one of the Yosemite climbers who made the first ascent of The Royal Arches and Washington Column in the 1930s. Upon arriving at the end of Upper Echo Lake, a few in the party wanted to continue up through the main valley, but Harris had convinced them that it would be easier to follow our indistinct tracks rather than make the strenuous effort to break trail in such deep, heavy snow. Thus were we rescued, and I was spared an untimely death.

Adams told Morgan to get to me first as I was obviously in the worst shape. The group dug furiously for forty-five minutes, using their skis to free me from the packed snow. Once I came to my senses, I became aware that someone was holding my hand. It was Marge Harris, Morgan's wife, saying in her bubbly, childlike voice, "Look how blue it is." Two of the rescue group went back to the cabin to figure out some way to transport me to the highway. They assumed that I would not be able to continue on skis. They could not locate the toboggan, and the motorized Weasel that was normally used to transport equipment around on the snow was out of commission. The phone lines were down. All this searching turned out to be unnecessary, however. As soon as I was able to breathe again and had warmed up by a small fire, I felt strong enough to ski back to the cabin on my own in spite of the fact that my left leg had been severely wrenched during the slide.

We were all back at the cabin by midafternoon, again lounging in front of a cheerful fire. There was much discussion concerning the events of the day. Several of the ski mountaineers at the cabin agreed that they probably would have chosen the same path across the slope that we had, but would have spaced themselves farther apart. We all knew that more rescue equipment should be kept at the cabin and that a couple of skiers in any party should be carrying lightweight shovels. But how often, taking off cross-country in the snow, euphoric in the joy of the moment, do we forget about these things? As for me, most agreed that I had only fifteen or twenty minutes to live by the time I'd been dug out.

A few days later I called my father, who was living in New York City at the time, to tell him of our good fortune. He had just come home from work with an unopened copy of *The New York Times* that included a brief mention of the Echo Lake avalanche. My wife, Cyla, had stayed in Berkeley since she was pregnant with our daughter, Sara, who came close to never meeting her father.

Upon being excavated after being buried for some twenty minutes, I look pretty good for someone who was so close to dying. On my left are Ken Adams and Dick Houston, two other survivors of the catastrophe.

A HIKE ALONG THE NORTH RIM OF THE GRAND CANYON

My brother, George, and I were about to enter a small grotto in the Grand Canyon just off Kanab Creek. It was a place of absolute beauty and quietness. As we approached we noticed a small stream of water, which made a whispering sound as it slid down a limestone slab into an exquisite pool. Around us were ferns and hanging gardens; broken cliff architecture rose above us, imposing and intricate. My brother called it "Whispering Falls" and my son, Lee, later renamed it the "Slide of Susurrus." It remains for me the most beautiful place in all of the Grand Canyon.

I was so grateful to my brother for introducing me to this place. He worked for Sandia Corporation and lived in Albuquerque and became deeply involved in designing intricate cross-country hiking routes off the north rim of the Grand Canyon. I'd joined him many times on these hikes, which started at one point on the rim and ten days later cleverly ended up at the same place, thus avoiding a car shuttle. George didn't follow trails but used intricate, half-hidden pathways to reach the Colorado River, which he would follow for a couple of days before finding a way back up to the car. In 1989, he published his first book, *Loop Hikes I*, which detailed four of these obscure and wonderful journeys, and in 2002, *Grand Canyon Loops*, which described ten additional routes.

In early 1981, I got a call from George asking me if I'd like to join him for a most ambitious project: a thru-hike along the north side of the Grand Canyon from Lee's Ferry, some

This grotto and pool with a whispering waterslide is in lower Kanab Canyon, not far above the Colorado River. George Steck christened this special place the "Susurrus" spot, for the soft sound of the water spilling into the pool.

fifteen miles downstream from Glen Canyon Dam, all the way to Lake Mead near Las Vegas. He calculated it would take eighty days, and had already mapped out where each night would be spent and places where seven caches of food and fuel would be placed. It seemed such a marvelous adventure that I could not refuse.

There are many strata in the Grand Canyon, the three most prominent being the Tapeats, a sandstone formation some 250 feet high close to the Colorado; the Redwall, a limestone cliff with few breaks in it, some 350 feet thick; and the Supai, another sandstone feature some 600 feet thick at the top of which is a level area called the Esplanade. Several major side streams have worn their way through all of these cliffs, among them Kanab and SOB Canyons. The latter (also known as 150-Mile Canyon) was an important segment of George's planned route. No one had yet pioneered a route down SOB Canyon to the Colorado River. There were several chockstones in this side canyon, and George wanted to be sure we could surmount them, as we'd go up SOB Canyon to reach the Esplanade and continue our thru-hike along this somewhat level formation.

A reconnaissance seemed in order, so in early summer 1982 we drove to near the top of SOB and prepared for the descent. We had a climbing rope, some light cord, and a bolt kit. We hammered in a bolt, with a hanger and carabiner, at the top of all five chockstones so that we could rappel the overhangs below. At each rappel, which averaged around seventeen feet, we left a light cord looped through the carabiner so we could pull our rope up from below. We reversed our route and left these cords in place to facilitate our ascent of SOB during the thru-hike. The reconnaissance went easily and by early afternoon we were back at the car.

We agreed that we would start on Labor Day. George undertook the job of arranging what went into each cache: ten days of food and fuel and for some, an ample supply of water. Though most of our camps would be at river level, much of our travel would be along the various strata above the river where water is not readily available. Luckily, George had an intimate knowledge of water sources gained from his many loop hikes. Various friends and relatives would join us for short portions of this long walk, but only one would be going the entire way. Robert Benson had extensive knowledge of difficult off-trail canyon hiking gained during many trips with George. He was thin and wiry with a wrestler's build and, and because he was in his early twenties—half our age—he could hike rings around us.

George's wife, Helen, drove us to Lee's Ferry at the arranged time and we began the long journey. For most of the next ten days we were at river level, hiking along gentle, sandy

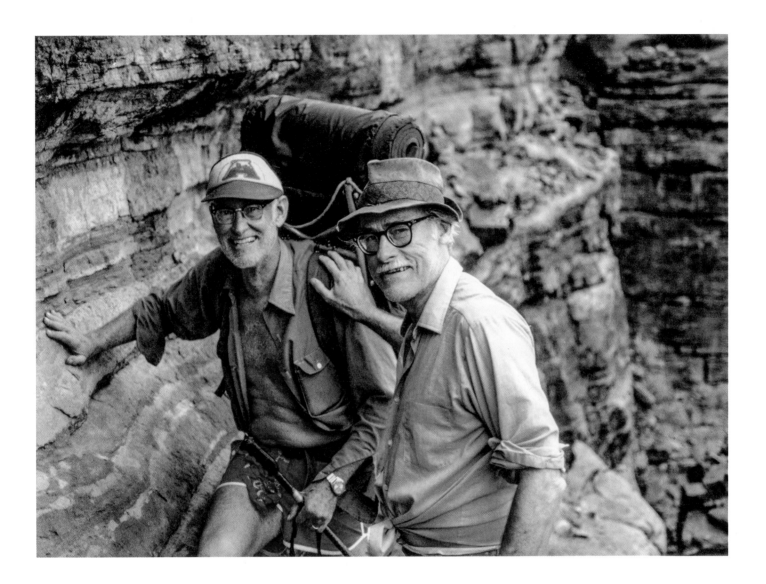

George and myself.

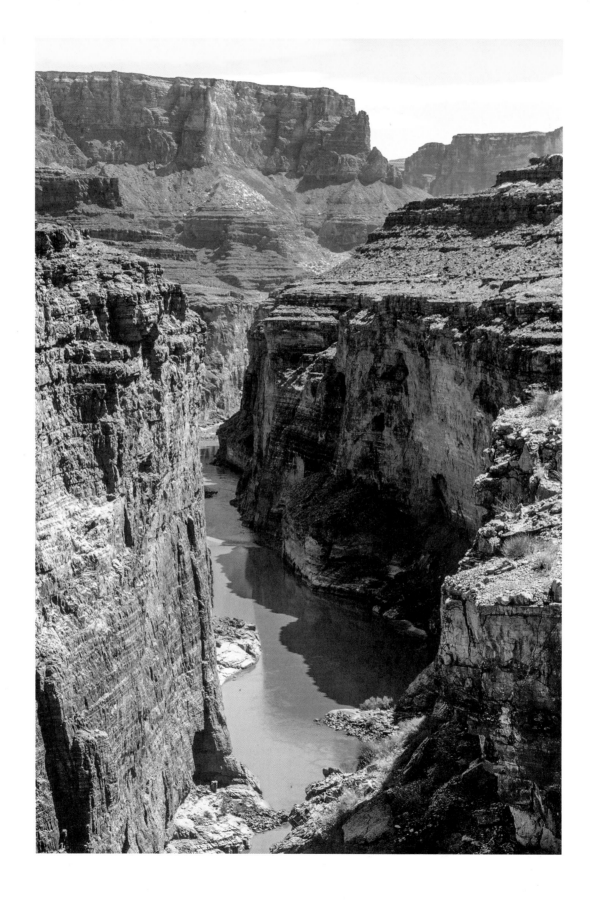

areas interspersed with a lot of rock scrambling. We had to be careful when camping close to the river; the Glen Canyon Dam released water during the night, making the river rise considerably. High sleeping spots were called for. We quickly got used to the daily passage of every conceivable type of watercraft since this was high season for the river-rafting companies. The boat people couldn't understand why we had chosen to hike the river rather than paddle it.

I knew that George liked margaritas and I was pleasantly surprised to find we were going to have them every afternoon of our trip. About 4:00 p.m. George would stop, pull out the margarita mix plus some tequila, and give us a cupful. Robert and I loved this moment of relaxation as the brew, even if warm, meant that the day's hiking was nearly over.

The days passed, some easy, some involving many hours of hard work. The trip was a great way for my brother and I to become better acquainted, since we had always lived separate lives. We were so different: he got his PhD in statistics and found a good position with Sandia Corporation, while I had always struggled to find my way. What we did have in common was our addiction to wilderness. Robert, too, was enamored of wild places. He told us that when this trip was over he was going to do a thru-hike along the south side of the Grand Canyon.

Finally, on day fifty-two of our odyssey, we arrived at SOB Canyon and made camp near the Colorado River. George's son Stan had now joined our small group. The following day, after breakfast and a steaming cup of coffee, we began preparations for the ascent of SOB. It was overcast with a good chance for precipitation, unlike the evening before when we saw twinkling stars as we bedded down. As we started up I noticed a thin root in my path, and on crossing it I realized it was one of the cords we had placed on a chockstone. We had enormous problems ahead of us, for all our cords had washed out in a flash flood. I had a two-and-a-half-inch Friend in my pack, a marvelous camming device used to protect climbing moves, plus a hook I used to hang my pack on at night. I thought it a good idea to take a small catclaw branch along, perhaps to reach around one of the chockstones or to wedge into a crack.

The clouds overhead were casting a slight drizzle on this gloomy, dark, narrow canyon. We didn't like the looks of this, but we went on. At the second chockstone a thirty-foot pool separated us from the obstacle. I swam across and was able to climb it using the camming unit. Getting the packs across was a lengthy, tiresome process. By now the drizzle had become a light rain, and besides being cold and tired, we were increasingly aware of the possibility of a flash flood coming our way.

The Grand Canyon.

Finally, we arrived at the second-to-last chockstone. I found it impossible to climb it. Here the catclaw saved the day. I tied the branch onto the end of the rope and threw it up over the huge chockstone hoping it would lodge, which it eventually did after several attempts. My fingers were cramping from the cold and I had to force them open. I couldn't see the branch but it seemed caught well enough when I pulled hard on the rope. Thus we were able to surmount the chockstone and walk to the short climb that would take us out of the SOB narrows to a small ledge under a roof of rock where we would be out of the rain. Dusk approached.

Our relief was immense with congratulations all around. My brother would later write that going up SOB in the rain was the most intense experience of his canyon life. We arranged our sleeping places and then turned to the serious business of the margaritas. We consumed them with more than the usual amount of pleasure. In this moment of happiness there was a sudden roar, and a waterfall gushed over the Redwall cliff opposite us. It was raining steadily now. Then an even louder roar heralded much water flowing down canyon. The flash flood had finally arrived. But we were safe, enjoying the frightening maelstrom just beyond our perch.

We were on top of the Supai formation and as we ventured out onto the Esplanade the following morning in clear sunshine, we were extremely happy that we didn't have to look for water. Everywhere around us were small pools full from all the rain the previous day. We bathed, we drank, we hopped about like gazelles. And the undulating Esplanade was beautiful. Rocks, bushes, and small trees were scattered about as though tended by a loving gardener.

It was Thanksgiving Day when we finally arrived at Pearce Ferry on Lake Mead. Helen was waiting for us and the sharp pop of a cork flying out of a bottle of champagne indicated the beginning of many festivities. We drove to the south rim and enjoyed an extremely tasty Thanksgiving dinner at the El Tovar Hotel, then luxuriated in a deep sleep on cozy beds with sheets and blankets.

I open a bottle of champagne after completing the Grand Canyon journey. Photo: Sara Steck

In a depressing postscript to a successful and harmonious adventure, Robert faced a looming problem. He had come to the States from Germany some years previously and owing to family difficulties, chose not to go home when his visa expired. Various friends managed to get him odd jobs but he was under investigation by the Internal Revenue Service. Robert completed his thru-hike on the south side of the canyon. Though this gave him great pleasure it was not enough to ease his mind. He tried every avenue to deal with his family and the US government but a year after our Grand Canyon trip, chose suicide to free himself of these troubles.

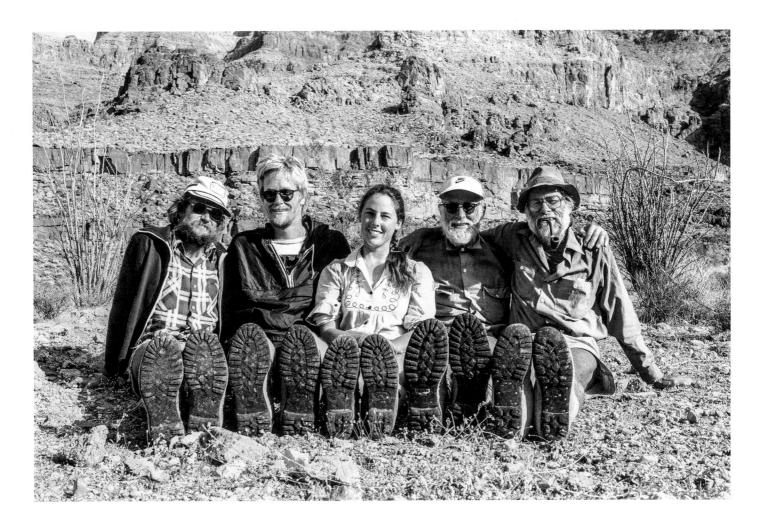

From left, Robert Benson, Stan Steck, Sara Steck, George Steck, and myself near the end of George and Allen's Grand Canyon odyssey. Benson, Stan (George's son), and Sara (my daughter) joined me and George for portions of the trip.

CLIMBING IN SOUTHERN ALGERIA

I had done many fine climbs with my French friend Robert Wainer, so when he invited me to join him and six of his Parisian compatriots for a climbing adventure in the Hoggar Mountains of southern Algeria, I quickly accepted. The trip was planned for the Christmas holiday season of 1989. Robert and his wife, Nadine, lived at that time in a gloomy fourth-floor apartment in the Montmartre district of Paris. They were both teachers at a local lycee; Nadine taught philosophy and Robert taught literature to graduating seniors. I arrived at their apartment in mid-December to allow enough time to get my visa.

When we left several days later our flight was full, as many Parisians use the holiday season to escape to the warm deserts of southern Algeria. From Algiers another flight took us farther south to our destination, the town of Tamanrasset. Here we met the crew of Tuareg tribesmen Wainer had hired to take us on an eight-day excursion by jeep to various nearby rock formations, ending eventually at Mount Tahat (2,908 meters), the highest summit in the Hoggar.

The countryside was beautiful with many volcanic rock formations jutting up from the barren desert plain. Sparse vegetation with small bushes and solitary acacia trees dotted the landscape. We passed many tiny villages as we traveled between campsites. I recall one where people had to lower small pots some two meters down a hole in the earth to reach water. Viewing life on such a primitive level saddened me, and the climbing was not particularly interesting either, as the rock was poor and hard to protect.

Climbing in Algeria.

Eventually we reached the mountainous area around Tahat where Robert and I decided there was enough time for a midafternoon ascent of a lovely 120-meter tower called Clocher du Tezoulag. Little did I realize that I was heading for the most serious accident of my climbing life.

We climbed several pitches on somewhat better rock than we'd encountered in the past few days. Finally, we got to the last pitch. I climbed up an easy, sandy area above the anchor and traversed six meters left to reach the final wall. I went up about two meters and placed some protection. It was a difficult position and I was unsure how to get higher. It was getting cold; the sun was low in the sky and the wind had gotten stronger. I made a hurried move, got to a marginal stance, and was trying to place additional protection when my right handhold broke. I fell onto the sandy ledge, shattering both ankles. If I had brought Robert up to the base of the final wall, there would have been less slack in the system and the protection I had placed would probably have prevented me from hitting the ledge.

The pain was intense. Wainer came up and we made two awkward and time-consuming forty-five-meter rappels to the base of the route. But there were still some twenty-five meters of steep, loose terrain to descend to the nearby road.

From my mountain rescue experience, I knew how to arrange for Wainer to carry me. I took one of our coiled ropes, split the coils, and placed them on his back. He put his arms through the two upper loops and I put my legs through the two lower loops. By this time some tourists had come by and two of them helped carry me down.

We found one of our drivers, who took Wainer, Nadine, and me to a clinic in Tamanrasset, where with the help of a Bulgarian X-ray technician, a good picture of one ankle was obtained and a cast applied. But for some reason the other ankle lay untouched. The following morning Nadine accompanied me back to Paris. She wheeled me out to the aircraft on a baggage cart and in extreme pain, I climbed the twelve steps up to the cabin door.

On our arrival in Paris we went directly to the main hospital, where better X-rays were taken and a cast applied to my other ankle, thanks to rescue insurance I had bought through the French Alpine Club. The doctor said he could operate the following day, but I resisted this offer. I was hoping that my climbing friend Dick Long, a highly regarded orthopedic surgeon, would do the operation when I got home to California. We returned to Nadine's apartment, where two unlucky fellows had to carry me up four flights since there was no elevator.

At 2 a.m. I lay on the carpet in the living room and called Dr. Long in Carson City, Nevada. A nurse answered and told me that he had just left and would not return until after the New Year holiday. I asked her to advise me where I could reach him, but she said it was staff policy not to give out this information.

Then I remembered something that Long had mentioned earlier. I told the nurse it was Fox calling. "Oh, Fox," she replied, "Dr. Long is at his cabin at Twin Lakes. Here's the number." He had told his nurses be sure to take care of Fox if he ever called.

Long agreed to take care of my ankles, and I was on the operating table within five days of the accident. All the connective tissue in my ankles was severely torn, but luckily, though some minor bones were broken, the major joint between the tibia and the talus bone remained intact. Long did a good job with the surgery but he didn't have much to offer regarding rehab. Six weeks in a wheelchair left my legs and ankles really weak, and once back on my feet again, I sought ways to strengthen them. Walking was obvious but I soon found the perfect method for getting the connective tissue working hard: I stood on a tilted slab of stone and did slow turns using ski poles for balance.

With every step I could feel my repaired tissues being stressed. In a few weeks I was able to climb again but only on very easy routes. Within a few months I'd regained most of my strength. My rehab was deemed successful and I resumed climbing and traveling without further complications.

CLIMBING AND TRAVEL

The accident in Algeria in late 1989 slowed me down for several months, but my passion for climbing remained intact. Although I still led a few trips for Mountain Travel, I had largely retired from the adventure-travel business and could now focus more on my own climbing.

Joshua Tree National Park was one of my favorite destinations and I made the eight-hour journey there from Berkeley numerous times over the next twenty years. Situated some thirty-five miles northeast of Palm Springs, Joshua Tree contains literally thousands of routes of varying difficulty on its beautiful rounded domes of quartz monzonite granite. Steve Roper, my collaborator on *Ascent* and *Fifty Classic Climbs of North America*, was a frequent companion on these forays into the high Mojave desert. We became part of a loosely organized group known as the "Golden Gathering," which included Joe Kelsey, John Thackary, Chris Jones, Eric Beck, and others who met the single criteria for inclusion: being older than fifty. We would set up our tents at Ryan Campground for a week at a time, making sure we had enough food, water, and wine to last the duration of our stay. We cooked our evening meals over an open fire as we solved the world's problems and reminisced about climbing glories past and present.

Most of our favorite climbs were one pitch long, usually with bolts for protection. There was one short route right in the campground I was so fond of that I would always do it as the last climb of the day. It eventually became known as the Allen Steck Memorial Route.

On our arrival at the small settlement of Wadi Rum, we set up our tents a short distance from the rest house.

On one of our visits to Joshua Tree, I rushed over to the route as the day was drawing to a close and started up solo, knowing that my belayer would soon be there. On the very first move I miscalculated the placement of my hands on the small holds. I rotated off to the right and was falling to the ground as Kelsey came up and caught me just before my head crashed into a large block of granite.

Some of the more difficult climbs featured incredibly small handholds, and we'd often leave those for the end of our stay after we'd gained the requisite strength in our fingers. On one of these occasions in April 1989, Kelsey, Roper, Beck, and I were heading back to camp after finishing an easy climb in the Wonderland of Rock area when we stopped for lunch just below Solid Gold, one of the greatest routes in Joshua Tree. The first pitch was a delicate, nearly vertical face climb up a beautiful water streak, protected with six bolts. From a belay on a small ledge I'd have to head up and left via face moves and cracks, protected by a few more bolts and some small nuts and cams. Rated 5.10a, Solid Gold was known to lacerate the fingers of unprepared climbers. As we ate, I casually remarked, "I'm going to see what it's like to get to the first bolt."

When I got there I sensed that my fingers were up to the task, so I called for someone to hand me the gear, rashly proclaiming, "I'm going to do this monster." I managed to lead both pitches—my companions declined to follow the second—and to this day I remember how fabulous it felt to struggle up those 200 feet of perfect rock.

When I arrived home after one of my many adventures in Joshua Tree I found a message from my French friend, Robert Wainer, inviting me to join him and his wife, Nadine, for several weeks of climbing in the Chamonix area. They had rented a small cabin in a meadow from a farmer with a view of Mont Blanc and had set a tiny room aside for me. We had a small kitchen for preparing our modest meals. A well-known Swiss climber, Michel Piola, had put up many new lines on the lower cliffs of the Aiguilles facing Chamonix. We managed to climb a number of these fine routes, which were on flawless granite and mostly in the 5.10a/b range, just within our abilities. There was a stormy period for several days and when the sun finally appeared we decided to climb on a cliff area close to the terminus of the Mer du Glace glacier. Many helicopters were flying by and I asked Wainer where they might be going; he told me they were probably bringing down the bodies of climbers who had not waited for the new snow on Mont Blanc to settle and had been caught in avalanches.

Finally, our stay at the cozy cabin came to an end, but Wainer had one more adventure for me. We drove to a huge craggy limestone area some 300 meters high. A stream had cut through the limestone over the millennia, forming long waterfalls before reaching the

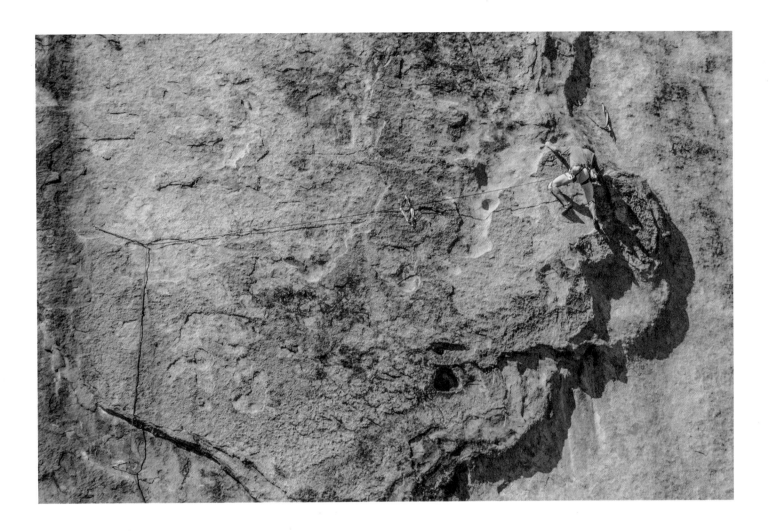

Jim Bridwell leading crux pitch on Figures on a Landscape in Joshua Tree, California.

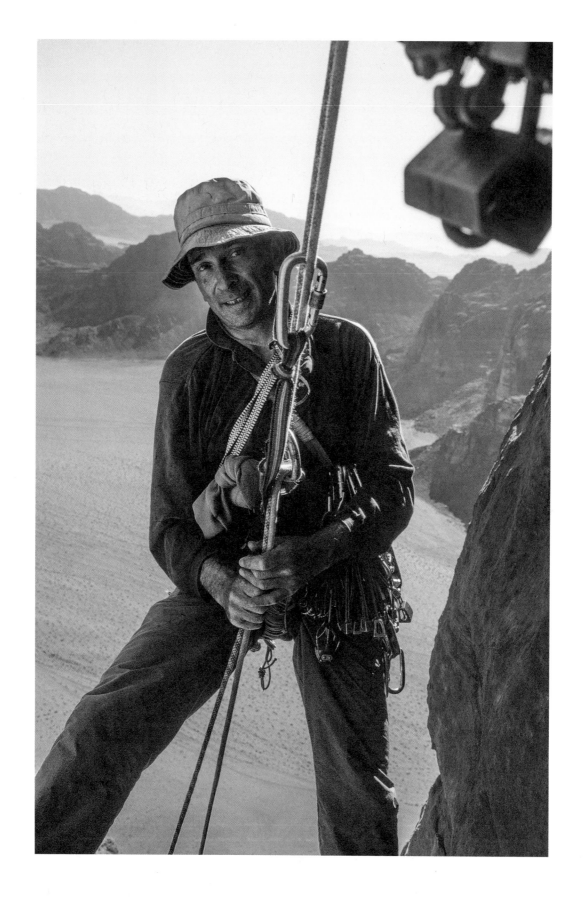

gentle terrain below the cliffs. We would be engaged in a fairly new sport called canyoneering, which involved rappelling down the successive waterfalls from bolts placed at their tops. This was exciting since the rappel would often end in a deep pool where you had to disconnect the rappel device and swim to the top of the next fall, being very careful not to lose anything. At one point Wainer rappelled into a pool; when I came down and started to pull the rope, he shouted back to tell me the rappel was not over—we needed to go down another fifteen meters of cliff to the next anchor. But it was too late; the free end of the rope was already beyond my reach. Wainer managed to climb down this section and, worried about my weakened ankles, he caught me as I slid down the streambed. Before us the final forty-meter rappel dropped right down in the middle of the falls. It brought us to the car—where Nadine was patiently waiting.

On the way back to his home Wainer told me of his plans to visit Wadi Rum, a rock climbing area in southern Jordan. I quickly asked him to count me in. Those who have seen the film *Lawrence of Arabia* will recall the scene where Lawrence is invited to Wadi Rum to dine with a Bedouin warlord played by Anthony Quinn. The region is dotted with huge sandstone cliffs and towers called jebel. Ranging from 600 to 750 meters high, these formations are mainly of a purplish hue, capped by a band of white domes, with all this sandstone resting strangely on a barely visible layer of igneous rock at the base.

The great beauty of Wadi Rum received its first accolades from T.E. Lawrence—Lawrence of Arabia—in his book *Seven Pillars of Wisdom*:

> Day was still young as we rode between two great pikes of sandstone to the foot of a long, soft slope poured down from the domed hills in front of us. It was tamarisk-covered: the beginning of the Valley of Rumm, they said. We looked up to the left to a long wall of rock, shearing in like a thousand-foot wave towards the middle of the valley; whose other arc, to the right, was an opposing line of steep, red broken hills. We rode up the slope, crashing our way through the brittle undergrowth.

In the mid-1980s the Jordanian ministry of tourism had asked the British to send some climbers over to see about climbing possibilities in the Wadi Rum region. The British contingent soon discovered that the rock towers offered incredible climbing, and by the time of our visit in spring 1996, Tony Howard had compiled an extensive guidebook listing more

Robert Wainer on rappel during our descent of the Pillar of Wisdom on Jebel Rum. 226

than a hundred routes. Wainer had invited a few of his French climbing friends to join us. Andre Leveque, Yves LeBissionais, Martine Bossi, Wainer, and I landed in Amman and got through customs at around 2:30 a.m. Suffering from jet lag and with no hotel reservations, we found two taxi drivers to take us and our pile of gear directly to the climbing area, which we reached at 6 a.m. There was lodging available at a nearby rest house in the village, also named Wadi Rum, but we chose to camp nearby on the dunes.

The rock varied considerably but was usually solid and fun to move on. Our rappel routes often went down huge, rotten chimneys, however. Sometimes the rock was severely weathered and the ropes got caught on spikes of sandstone four inches high, causing enormous rope drag and more than the usual wear. We had to repair the damage all too soon using duct tape.

Of the many routes we did, the Pillar of Wisdom on Jebel Rum was the most enjoyable. Located just to the west of the rest house, the 300-meter pillar was not too difficult except for the last six meters, which was protected by a short angle hammered into a drilled hole. During the climb we were close enough to the *wadi* (or valley) that we were entertained by the noises coming up our way: the braying of donkeys and retching of camels, the barking dogs and Toyota pickups backfiring, the *muezzin*'s constant call to prayer. Once we got to the top, getting over to the rappel anchors above the great *siq* (or chasm) was difficult because we had to find our way through all the white domes facing us. Passage was only possible between them. Hours went by before we found the anchors allowing us to rappel 120 meters to the bottom of the siq. Finding our way to the rest house was not easy in the dark, but great was our joy when we found that they were still serving a meal of lamb kabobs.

Simply being in Wadi Rum was an amazing experience. Living among the Bedouin and observing how they managed their affairs was unique, but the climbing was of course the ultimate adventure. Unfortunately, the time arrived when we had to say farewell to Wadi Rum. Luckily we found a local bus to take us back to Amman and the airport for our return journey to Paris.

The climb, Pillar of Wisdom on Jebel Rum, rises elegantly behind the guest house.

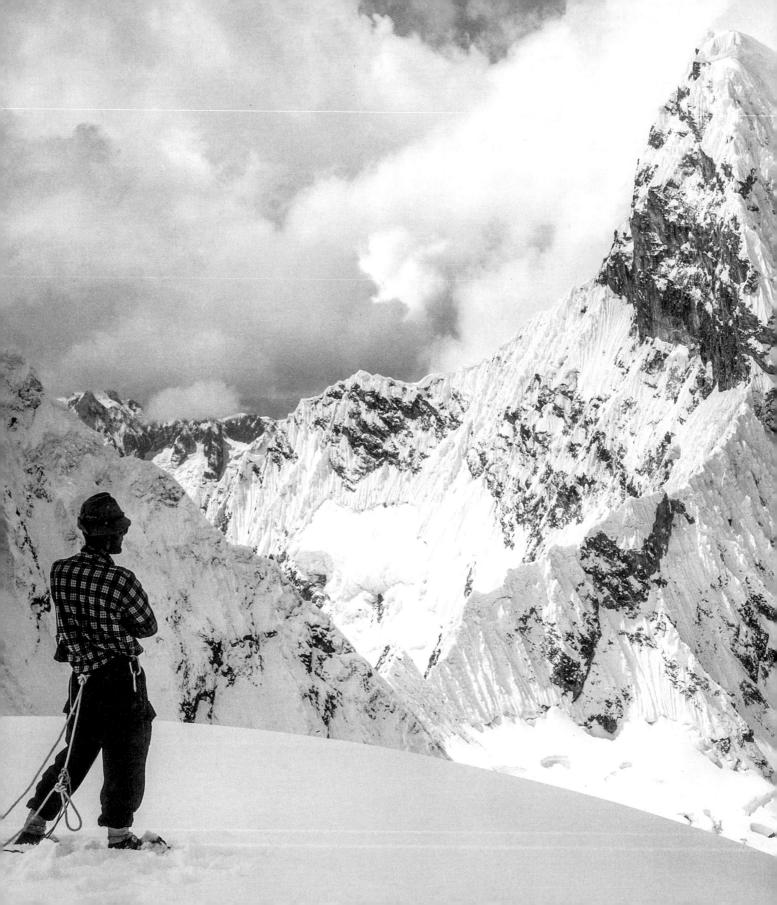

Perspectives

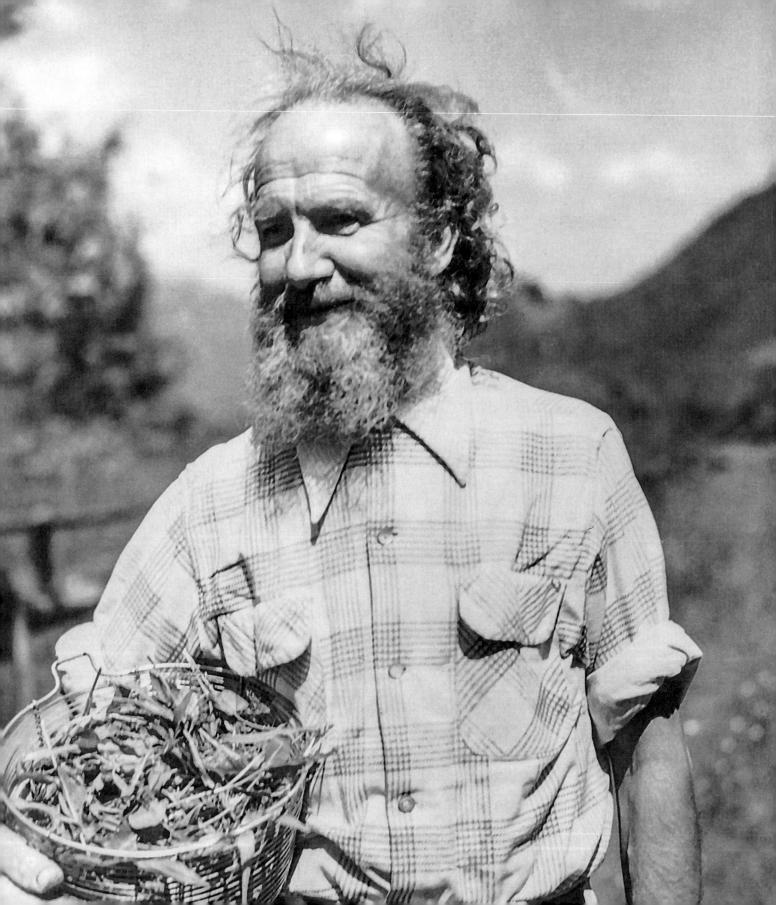

WHO WAS JOHN SALATHÉ?

One might well wonder why I'd devote an entire chapter to John Salathé. Our time together on Sentinel Rock in 1950 (see Sentinel Rock with John Salathé) was significant to my personal development, but this determined Swiss climber also accomplished much in his short career, influencing a whole generation of Yosemite pioneers. Salathé was the first to make pitons from high-carbon steel, and equipped with this invaluable tool, to undertake complex, multiday ascents on the sheer walls of Yosemite Valley. He was the undisputed father of this kind of climbing in North America and deservedly became an honorary member of the American Alpine Club in 1976.

"He was not an easy person to know," wrote Ax Nelson, with whom Salathé did first ascents on Half Dome and the Lost Arrow Spire, in an unpublished 1975 manuscript. "He was not very tall either, but John Salathé cast one of the longest shadows across the cliffs of technical climbing in Yosemite since George Anderson drilled the first bolt into Half Dome just one century ago."

[Previous Spread] The summit of Nevado Pisco looks out at the awe-inspiring Chacraraju. Photo: Leigh Ortenburger [Left] John Salathé gathering grasses and herbs for food near his remote cabin in southern Switzerland. He lived here during the 1960s. Photo: John Thune

Salathé was born in Niederschönthal, a small village near Basel, Switzerland, in June 1899. He had four brothers and a sister, but decided to study blacksmithing instead of getting involved with the family farm. Life in the village with such a large family became claustrophobic for young Salathé and he eventually sought his fortune in more distant places. He first went to Paris, but a terrible experience with bedbugs in his meager lodgings forced him to flee in the middle of the night. He ended up in Le Havre, where he took a job as a fireman on a coastal steamer. He eventually became an oiler on a bigger ship based in Hamburg, which took him to distant places for several years, such as the coast of Africa and Rio de Janeiro. He ended up in Montreal in 1925.

Subsisting on odd jobs, he met a professional cook, Ida Schenk. The pair married and had a son, John Salathé Jr., in 1928. In 1930, they immigrated to California, settling in the small town of San Mateo some twenty miles south of San Francisco, where Salathé opened a blacksmith shop named Peninsula Wrought Iron Works in 1932.

For several years the innovative Salathé produced a variety of ornamental yet still functional iron railings, fireplace screens, hinges, and small gates on his forge for local homeowners. The blacksmithing business prospered slowly during the Depression years, but in the early 1940s his life began to change. His marriage was gradually disintegrating and his health suffered. He didn't trust doctors ("Dey chust take your money und sell you pills") and soon sought solace in the mountains. Walking in Tuolumne Meadows one day, he happened upon the Sierra Club's Parson's Lodge and began talking with the caretaker there, who told him about the Club and its promotion of climbing. Her husband was out climbing that very day. Salathé had never heard of climbing or the Sierra Club, but that would soon change.

He returned to San Mateo and decided that changing his diet might solve his health problems. One day, as he was standing by his forge, he happened to look out onto a field behind his shop and noticed a horse eating the grass there. Suddenly a voice behind him—he would later say it was an angel—proclaimed: "Look, John, that horse and those other animals are quite healthy and strong and what are they eating? Grass! And what do you eat?" "I eat meat," he replied despondently. After that day, Salathé followed a diet of vegetables, fruits, dates, and nuts. His health improved, though his aura of eccentricity, which would lead eventually to paranoia, remained.

Salathé made his first visit to a Sunday gathering of the Sierra Club's Rock Climbing Section in spring 1946, at Cragmont Rock in the Berkeley hills. He liked the group dynamics

and quickly began to learn about the placement of pitons, rope management, and the extremely important technique for descending, the rappel. Who would have imagined that this stocky, barrel-chested blacksmith, who spoke with a heavy Swiss accent, would soon become involved in some of the boldest and greatest aid climbing adventures in Yosemite's Golden Age?

A few of the leading Sierra Club climbers of the day had expressed interest in climbing the Lost Arrow Spire, a rounded pinnacle that rose majestically some 175 feet from a notch in the massive granite wall to the right of upper Yosemite Falls. In August 1946, Salathé arranged to meet this group on the rim above the Lost Arrow to make an attempt. Through some misunderstanding, nobody appeared—or perhaps the other climbers didn't trust the inexperienced Swiss climber. Not to be deterred, Salathé decided to make a solo attempt, and after a good bit of reconnaissance he rappelled to the notch. There he faced the enormous problem of getting onto the spire. He had only soft iron pitons, though he did have a bolt kit, and it was here that he realized that hard steel pitons were necessary for use in granite, since the soft iron ones were unsuitable for repeated placements. He managed to reach a ledge, which now bears his name, before he retreated.

It was an extremely bold attempt and Salathé received some criticism for it. But he couldn't have cared less. He knew his craft well and he had the mindset for such climbing. He would soon become known for his fierce passion for direct-aid climbing. Also, he had recently made some of his soon-to-be-famous hard steel pitons on his forge at Peninsula Wrought Iron Works. It has always been said that Salathé made these pitons from Ford axles, but Steve Roper, in his book *Camp 4*, suggests that such tough 40/60 carbon steel with vanadium in it surely was already available in the marketplace. After all, Ford had to have access to it for use in its cars.

When Salathé returned to the Lost Arrow for another attempt, he wanted a belayer. He had met a climber, the twenty-nine-year-old John Thune, during that first visit at Cragmont. Thune was also a beginner, but nonetheless, Salathé asked him if he would mind coming with him to try the spire the following weekend. "It's an easy vun," Salathé said. Thune was skeptical, knowing full well that if the climb were easy, it would have been climbed. Nevertheless, he agreed. Thune later described the scene:

> Down we went to the notch. Salathé took the lead out to the face using the special wafer-thin pitons he had made particularly for this occasion, to

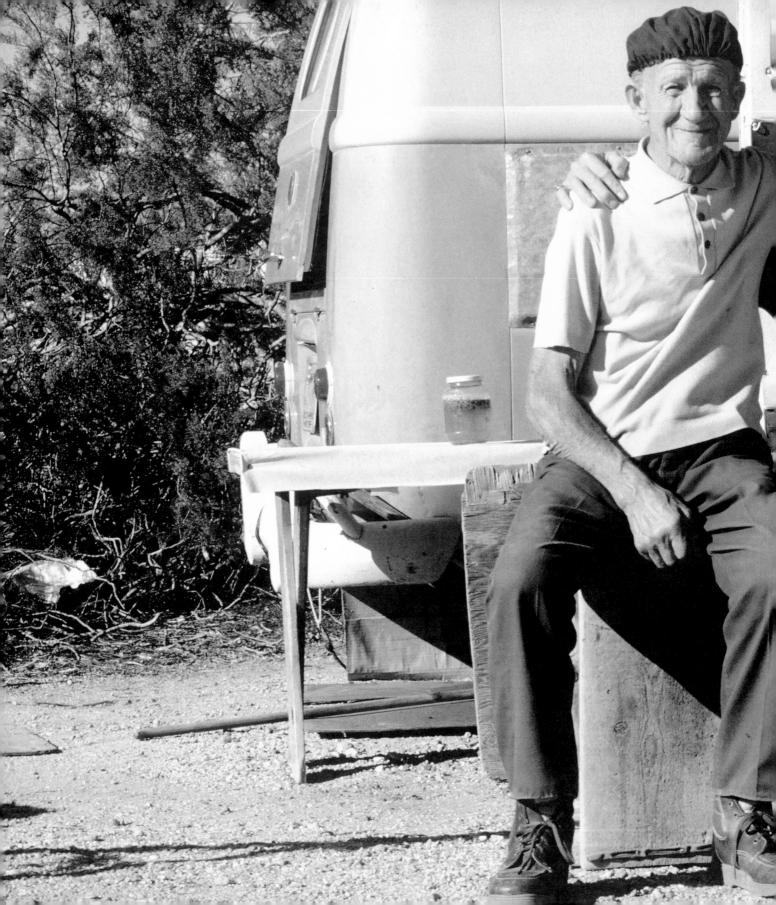

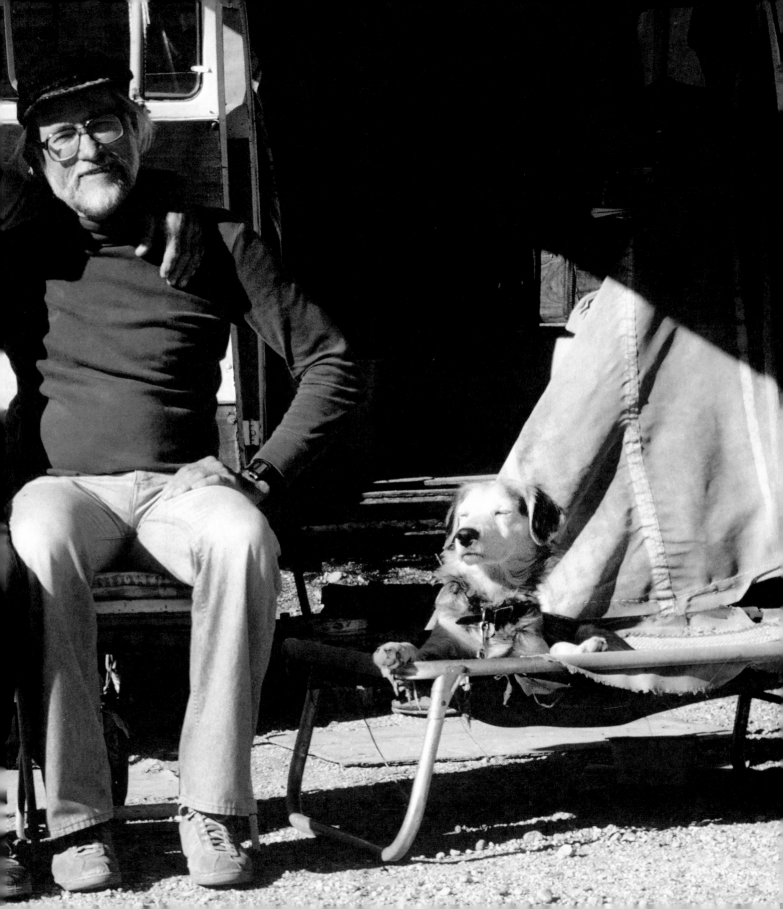

hopefully secure him to the almost nonexistent cracks. Wham! The rope grew taut. One of his pitons pulled out. With a howling wind setting up a roar and Salathé out of sight, verbal communication was impossible. Slowly John worked his way back up to the notch and said with a smile, "Vell, ve start again."

Salathé eventually climbed up to his ledge and after belaying Thune to the stance, began working up the discontinuous crack system above, leading some 100 feet to the summit. This effort took most of the day and in the late afternoon, Salathé called down to advise Thune that he had reached the end of the crack system but his drill bits were too dull to continue. Unfortunately, Salathé had to retreat just thirty feet from the summit. Only five months had passed since he had learned to climb.

Subsequently, something very interesting happened. Others were thinking about getting to the top of the spire and this group decided it would be easier simply to throw a rope over the summit from the rim and prusik up. Robin Hansen, Anton 'Ax' Nelson, Jack Arnold, and Fritz Lippmann, all friends of Salathé, did just this only a few days after Salathé and Thune nearly climbed the spire. A light rope was successfully thrown over the top and one of the group, Arnold, rappelled to the notch, climbed up to Salathé Ledge, reached the light line, and pulled a climbing rope over to his stance. This rope was then anchored to the rim. Hansen, Nelson, and Lippmann rappelled to the notch and prusiked up to the top, belayed by Arnold, who had already reached the summit.

The prusik knot, developed by the Austrian Dr. Karl Prusik, was the only way we had of ascending a fixed rope in those early days. Steve Roper describes the technique well in his book *Camp 4*. After three of these knots were tied onto the rope, "The upper one was then affixed to a chest loop, the others to foot slings. Each knot would be slid up the fixed rope with a bit of effort, but when body weight was applied, the knot would tighten and jam tightly onto the rope. One progressed slowly upward, moving the unweighted knots up one by one, with the weight mostly on one foot sling." Naturally, Salathé and others scoffed at this ascent, calling it a rope trick, which it indeed was. Salathé knew he could climb the spire, but it would be a year before he came back to this magnificent formation.

Salathé next teamed up with Ax Nelson in October 1946 to make the first ascent of the southwest face of Half Dome. It was a bold ascent over featureless terrain, but the harrowing nighttime descent caused them the most anxiety. During one rappel, Nelson ended twenty feet above a belay anchor. Much yelling and some very innovative ropework allowed Nelson

[Previous Spread] John Salathé and myself in front of Salathé's van at "Slab City," Niland, California. [Left] A ring piton and Lost Arrow piton forged by John Salathé. Photo: Dean Fidelman 238

to reach the anchor and let his partner come down to his stance. Obviously, Salathé was obsessed with climbing and this ascent was another example of his great passion. Salathé took a liking to his new friend, and in early September 1947 he and Nelson finally made the first ascent of the Lost Arrow Spire, not from the notch, but via the infamous Lost Arrow Chimney, which started from the Valley far below. It would become Salathé's most famous climb.

The Lost Arrow Chimney is a huge, horrifying gash in the massive wall to the right of upper Yosemite Falls that leads up more than a thousand feet directly to the notch that separates the Lost Arrow Spire from the main cliff face. It was difficult even to contemplate climbing it in 1947, but there were several climbers working on its defenses, particularly two from Southern California: Chuck Wilts and Spencer Austin. After several attempts, this talented pair had managed more than half of the route when they were stopped by an unclimbable chimney and bottoming cracks some 400 feet below the notch; their soft iron pitons couldn't handle the rotten granite. It was about this time that Salathé and Nelson began their final attempt on the monster chimney. When they reached Wilts and Austin's high point, Salathé's carbon steel pitons penetrated the decomposed granite enough to allow him to surmount this obstacle and, after placing three bolts in the difficult section above, he reached a belay stance. The rest of the climb went more easily, and soon they stood on top of the spire, after five and a half days of intense effort.

This magnificent ascent was groundbreaking in many ways. The Lost Arrow Chimney was the first big wall ever done in Yosemite Valley that required multiple and usually uncomfortable bivouacs. It was the first to employ high-carbon steel pitons and to use bolts for upward progress. It was the hardest climb yet accomplished in North America. Nelson's insightful article in the 1948 *Sierra Club Bulletin*, besides describing the ascent and the equipment used, discussed the motivation in climbing. "One cannot climb at all," he wrote, "unless he has sufficient urge to do so. Danger must be met—indeed, it must be used—to an extent beyond that incurred in normal life. That is one reason men climb; for only in response to challenge does a man become his best."

Many Salathé stories, some of them quite humorous, help us to understand his character a little better. The earliest concerned his remarkable first ascent of the Hand, a spectacular formation in Pinnacles National Monument, in February 1947. The volcanic rock is composed of small rocks imbedded in a fine-grained matrix. Some of these can be loose, but generally they are solid enough to hold a person's weight. Salathé started the climb, belayed by Robin Hansen. Soon it became apparent that piton cracks were not only poor, but they were scarce as well. Salathé reached a spot from which a fall would be fatal. Hansen got his friend Dick Houston to take over the belay; they exchanged the belay frequently since neither wanted to hold a fatal fall. At one point, Salathé lost his balance slightly and cried out, "Oops, I almost schlipped!" but he persevered and soon reached a good anchor. Salathé's route is popular even today, although several bolts now reduce the possibility of a fatal fall.

Another story, both humorous and illustrative of Salathé's courage and skill in handling a tough situation, happened during an attempt to find a new route on Washington Column, in Yosemite Valley, to the right of the Direct Route. He was climbing with Phil Bettler, an able climber who was also hard of hearing. They failed to find a route and, as the day came to a close, began to rappel. As darkness settled in, Salathé thought it would be possible to head directly for the Valley floor. He started down but soon the angle of the granite changed and he slipped, swinging out over an enormous void. He could tell from the headlights of the cars below that his ropes would never reach the ground. Luckily, Salathé had a knife and after pulling up the ends of his manila rappel rope, he cut off some lengths to make prusik slings so he could get back up the rope. It was nasty work, particularly in the dark. The pair later returned to the Valley to the cheers of those of us who witnessed this great adventure from below.

Nick Clinch tells another delightful story about his and Salathé's climb on the southwest arête of the Lower Brother in Yosemite. At lunchtime Salathé had given an apple to Clinch, saying, "All vot you need is in dis apple, Nick." Clinch started the next lead and was quite high up when he heard the distinctive, melodic sound of a piton being removed: *ching, ching, ching, ching*. Clinch realized his rope had run out and that Salathé was getting ready to climb. The problem? Salathé had forgotten to tell Clinch what was happening. Clinch quickly descended a few feet to a niche in the rock and started belaying since there was no time to set up a proper anchor. Salathé arrived and commented on the belay. "Nick," he said, "you don't haf an anchor, dot's not safe. You should always haf an anchor."

In 1950, Salathé joined me for the first ascent of the north face of Sentinel Rock. It was an honor to be climbing again with the legendary Swiss. The Steck-Salathé would be his last

climb on the cliffs of Yosemite Valley, or anywhere else in North America for that matter. Salathé dropped out of climbing shortly after our ascent and eventually experienced some sort of mental breakdown, his behavior becoming more and more erratic in 1953.

Salathé's paranoia became alarmingly evident when he drove the twenty-five miles from his home in San Mateo to Dick Leonard's home in Berkeley one evening around dinnertime in 1954. Leonard, an attorney and president of the Sierra Club at the time, was a member of the group that had made the first ascent of Yosemite's Higher Cathedral Spire in 1934, one of the first technical rock climbs ever done in Yosemite. The agitated Salathé produced a paper bag full of prunes, which he claimed had been injected with cobra venom by his wife, and asked Leonard if he could have them examined by a chemist. "Deek," Salathé said, "my vife eez going to keel me, but I vill get her first." A psychiatrist friend lived nearby and Leonard invited him to come over and talk with Salathé. The psychiatrist said that Salathé was dangerous enough to be locked up, but as there was no proof of his wife's intentions, they simply told Salathé that it would be best for him if he left the States and moved back to Switzerland. After Salathé left for San Mateo, the Leonards called his wife and warned her, suggesting that she leave the house and spend the night with neighbors.

Salathé eventually closed his blacksmith shop and moved to Switzerland, where he lived in a small stone hut, accessible only by a rustic path, high in the hills above Lago Maggiore, close to the Italian border. He found peace and contentment through a religious sect he belonged to called The Spiritual Lodge, located in Zürich. The publication of the Lodge, *The Spiritual World*, was printed in both English and German, and Salathé always sent copies to his various friends. He spoke often of the Lodge and its medium Beatrice, adding that angels were always nearby to protect him from the devil. His existence was austere: he grazed in the nearby woods and meadows for wild herbs, fruits, nuts, and edible plants. He grew vegetables in a garden near the hut. His Swiss pension of about $400 a year allowed him to buy necessities that weren't available in the forest.

In 1957, John Thune happened to be in Italy and decided to visit Salathé. He and a friend hiked up the long mountain trail and eventually came upon a stone hut. A bearded man stood in the doorway holding a basket. "Chon," the man said, "did you haf a nice hike?"

It was Salathé. Thune and his friend stayed for a couple of days, sleeping on straw matting on the stone floor and sharing his simple fare. It was a marvelous reunion. Thune later told me that when Salathé wasn't looking, they threw the boiled herbs and grass in their mugs out the window since the brew didn't rest well in their stomachs. Thune returned a couple years later

with a group from the Oakland YMCA, where he was general executive, intending to climb the Matterhorn. Thune invited Salathé to join them. The climb was successful and the group later assembled in front of the youth hostel in Zermatt. Salathé, who had given all his climbing equipment to the boys, told them: "Yesterday you started up the Matterhorn as boys, but you haf passed de test. You are now yung men. I am very proud of you. Dis vas my last climb. I am chust too old to go to de dop anymore. But learn to luff de mountains as I do. Gott bless you."

Salathé returned to California in 1963, where he lived in a VW bus and moved to various campgrounds as the seasons dictated. Life became a little more comfortable after he applied for and received Social Security benefits. He often stayed in Bridalveil Campground in Yosemite. But as the Park Service began imposing camping limits, Salathé moved to sites on the western slope of the Sierra where such restrictions did not exist. In the winter, he liked to stay down near the Mexican border in a place known as Slab City. A complex of concrete slabs left after the buildings of an abandoned Marine Corps base were removed, Slab City was home to all sorts of wanderers, hippies, people escaping the harsher winters farther north, and even retired middle-class folks. There were no fees to stay there; knowledge of the City was passed on by word of mouth and ads in RV magazines.

Salathé called Slab City home for several winters and I visited him there in the spring of 1981. I arrived in the late afternoon and found him parked near the Coachella Canal, which brings water to the Imperial Valley from the Colorado River. The interior of his bus was crowded beyond belief. Bags of nuts, toilet paper, darned socks, brushes, and many other items hung from the ceiling. The sleeping area was in the back and a stove rested on its support behind the driver's seat. Jars of barley, wheat, pinto beans, lentils, nuts, corn, rice, and other foodstuffs were neatly lined up on a shelf. Every five days or so, Salathé brewed up a concoction of these ingredients, enough to fill five jars, one of which he ate each evening until they were gone. Unfortunately, I arrived toward the end of one of these periods. He offered me dinner from jar number four; despite the beginnings of fermentation, it tasted moderately good, especially when covered with canned applesauce. But the tea was something else. The weird, unpleasant flavor luckily was enhanced by a couple of tablespoons of burgundy. Salathé was happy to see me and I found it most pleasant to be with him. He was eighty-two years old.

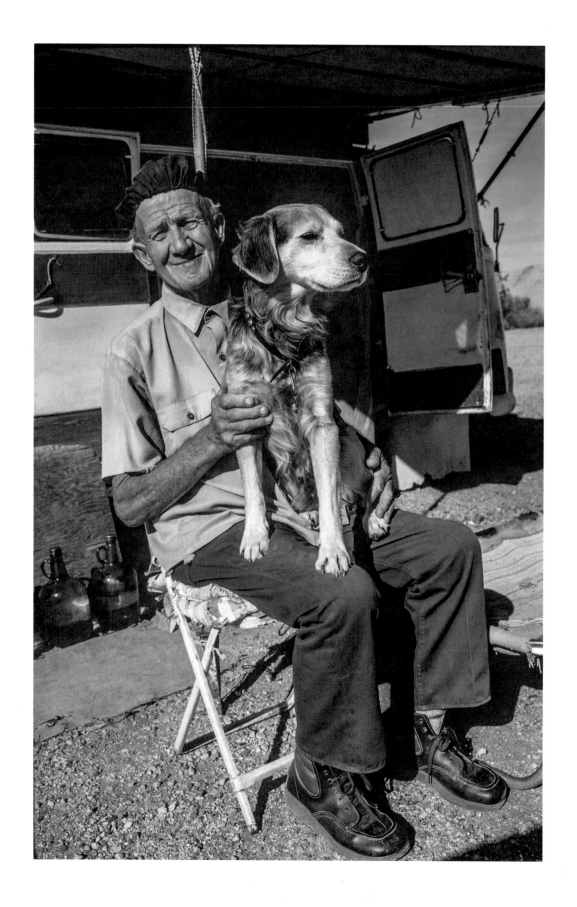

A dog named Mackie was tied up to the bus. "Mackie vas in de devil's hands some time ago," Salathé told me, "alvays running around to fight de bones and hassle de womans. A neighbor came by und told me Mackie vas bodering his dog und I should tie him up. So I did. I giff Mackie de same food I eat und dere is no more troubles. Al, it vas de devil's work dat got me de troubles. In de old days I vas eating all dat meat, God, de food vas goot. But de devil gets the human beanings und de animals und dey got no defense. It's de meat dat cause all de problems and makes us vant de womans. Look at me, I don't eat de meat and I don't need de womans no more. Look at Mackie now vidout meat; the devil no more makes him vant de womans. Und he's happy now." I looked at Mackie and wondered. When Salathé talked to him, Mackie began to howl softly with the wistful look of a dog missing something.

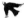

My last visit with Salathé was in February of 1991 when he was living in a nursing home in Holtville, California, near the border with Mexico. Steve Roper and I, along with Martha Roos, spent about an hour with Salathé. When we asked about the past he rarely would stay on the subject more than a sentence or two before talking about medium Beatrice, his hatred of the Catholics, or the angels who awaited him in heaven. He walked with ease, though with a cane, and he spoke clearly, though we did not always understand very much of what he said.

We asked about his hard steel pitons. "Of course, I don't tink it vas my invention," Salathé explained. "I tink it vas inspired by ... I had Ford axle lying dere ... und thirty-five pound trip-hammer." Maybe Salathé did make his pitons from Ford axles. This was the last time we saw him; he died in August 1992.

John Salathé and his dog, Mackie, his faithful companion. He kept Mackie tied up "so he vouldn't hassle de womans."

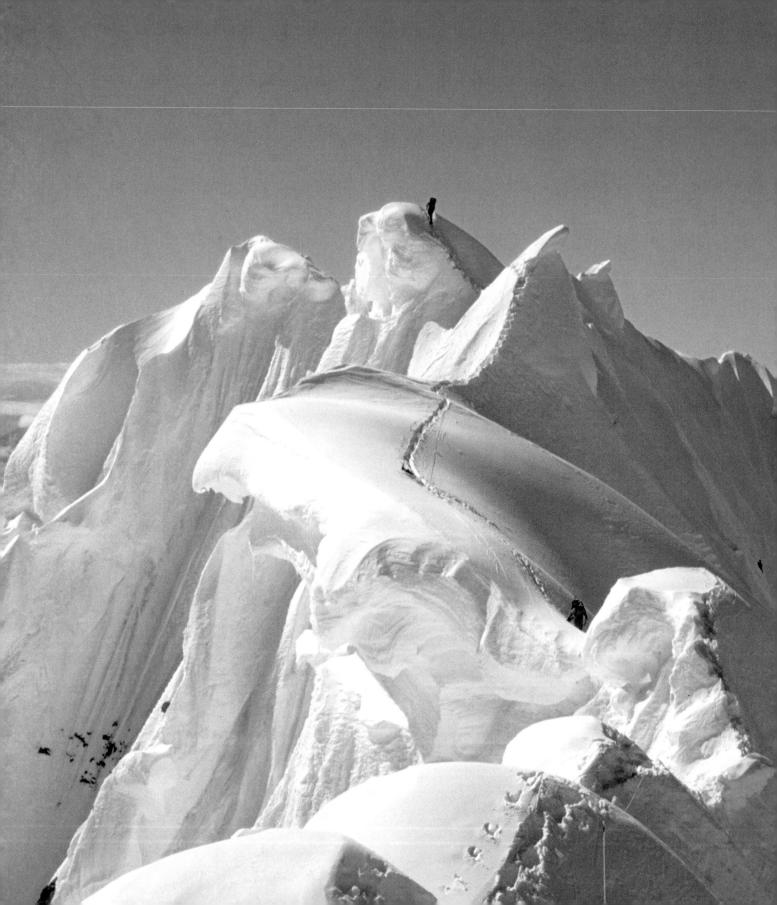

IS CLIMBING WORTH DYING FOR?

I was in the audience at the 1988 Banff Film Festival when the Austrian mountaineer Kurt Diemberger presented a lecture on the disastrous summer of 1986 on K2. That season twenty-seven climbers reached the summit; thirteen perished, including a few who had summited. The audience was rapt as Diemberger recounted how several climbers plummeted from the heights and one fell into a crevasse. A few failed to return to Camp IV at around 8,000 meters and were presumed lost. Finally, a storm trapped seven climbers at Camp IV for several days. They soon ran out of food and fuel. By the time the weather improved, one had died and another was incapacitated. Of the five remaining who were strong enough to begin the laborious descent to base camp, only two—Diemberger and Will Bauer—would survive. The morbidity of it all fascinated the audience.

The next afternoon a panel discussed "Risk in Climbing: Why the Attraction?" Sharon Wood, an experienced Canadian mountaineer who had made a difficult ascent of Huascarán in the Cordillera Blanca in Peru the previous summer, told her story of that climb, which had involved some serious rockfall. She said that in extreme situations her mind became marvelously focused, though she failed to acknowledge that the rockfall could have been fatal. In the discussion that followed, no one addressed the root problem: the heightened probability of death when venturing into the zone of extreme mountaineering. When the moderator, Geoff Powter, asked for comments from the audience, I brought up the idea

Cornices are formed by furious snow-laden winds, and sometimes face both right and left. Climbing along such corniced ridges is often quite dangerous because they can easily collapse. When we crossed these cornices the danger was less, owing to the fact that the warmer temperatures in August caused the snow crystals to bind more firmly together.

of a subliminal death wish. Powter quickly stated that death was never the motivation for climbing, that climbing was actually life affirming. The audience applauded this observation. I realized what I should have said is that as life affirming as climbing is, the possibility of death—not the wish for it—has a definite position in the complex web of motivation for extreme mountaineering.

So, the question remains. When you sift through the literature of mountaineering, it would seem that it is the only sport in which a small percentage of its participants will almost certainly die. We can achieve a better understanding of this loss of life by knowing what climbers have said and thought when they have faced this reality.

The English mountaineer Doug Scott has lost many friends to accidents in the mountains. While he was hauling loads on the west ridge of K2 with Nick Estcourt in 1978, an avalanche engulfed them both. Scott was caught only briefly but Estcourt was swept away to his death.

"I realized I was about to die," Scott later wrote, "and suddenly thought that it wasn't such a bad thing. I didn't want to die, but I had no fear of it." The most realistic approach to Himalayan climbing, wrote Scott, is to recognize a simple fact: "In order to climb properly on a big peak … you must write yourself off …. You must say to yourself, I may die here."

"If you're soloing at the razor's edge, you're performing at the ultimate level where, if you make a mistake, you die," mused the late world-class rock climber Todd Skinner. "There's nothing more intense." Soloing isn't worth dying for, he said, but it is worth risking dying for. Ironically, Skinner didn't perish climbing at the razor's edge: in 2006 he fell while rappelling in Yosemite when his harness tie-in loop failed.

"I have the courage to be fully alive only when I am most conscious of my death," wrote Dennis Eberl in a story about climbing the north face of the Matterhorn. "It is with this thought that I am able to rationalize these moments of imaginary death and return again to the mountains each summer."

Another extreme climber, Mark Twight, became a celebrity in the American climbing press in the 1980s and '90s for the uncompromisingly honest manner in which he wrote about his motivations for climbing. He was as close to the cutting edge of American mountaineering as a climber can get. Once, on a winter solo climb, he was hit by rockfall:

> I was in trouble, thousands of feet up in the winter quiet, all alone on eighty-degree ice, apoplectic. The pain arrested my breath … I didn't want

to die. I climbed up this North Face to suffer, to experience the masochistic pleasure of fighting for my life. But I hadn't intended to lose. The need for risk has always been inside of me, lurking and threatening. If I don't satisfy the impulses, if I let them build up untreated, they'll explode with finality. I'd kill myself trying to handle it.

In another story, Twight confides:

I can't imagine explaining to an outsider the passion for alpinism that drives me. The passion that dresses itself up as hate, as fear, as fatigue. The demon that will not leave me alone, that always comes back no matter how bad the last experience was. I can live momentarily with the fantasy that I've freed myself from the thing. I can make believe that I don't need to climb. But it always comes back and I have to give myself over to it.

The climbers I've quoted certainly are at the extreme edge of the sport, Twight perhaps to the point that climbing became a narcotic for him. Can risk be addictive to climbers? Perhaps. We find a marvelous kinesthetic pleasure in climbing. We love the movement, the danger. I recall reading about a young climber, Christina Chan, a graduate student at Stanford. She had died tragically while soloing an easy route on Eichorn's Pinnacle near Tuolumne Meadows in 2010, falling some 300 feet to the base of the climb. She was widely admired for her many ascents of El Capitan and other extreme routes. "There is no existence I love more than the moments spent on steep granite faces," she wrote on her website. Climbing them "was like chocolate."

Sounds like an addiction to me.

The English climber Julie Tullis was Kurt Diemberger's climbing partner when they became trapped in Camp IV during that terrible storm on K2 in 1986. She eventually died there in the chaotic conditions. Prophetically, she had written some years earlier about the possibility of death while climbing with Diemberger on Broad Peak:

If I could choose a place to die, it would be in the mountains. When we were falling in the avalanche on Broad Peak, I knew that I would not mind dying that way. There have been a number of other occasions in the mountains when

just to sit still and drift into an eternal sleep would have been an easy and pleasant thing to do, but hopefully the circle of nature will not close for me too soon. I have a lot to live for.

The climber-poet Michael Roberts spoke eloquently about climbers' acceptance of death in an address to the English Alpine Club in 1939:

> Climbing derives its most profound symbolic meaning from its gratuitousness, its apparent pointlessness … to justify mountaineering in the fullest sense, we must justify the loss of life, the deliberate taking of risks … man can preserve his dignity only by showing that he is not afraid of anything, not even death … the risk brings no material gain, but it offers something—the exhilaration, the sense of clear vision … it is a demonstration that man is not wholly tied to grubbing for his food, not wholly tied by family and social loyalties; that there are states of mind and spirit that he values more highly than life itself on any lower level.

There is no mystery about the "why" of mountaineering, nor is there any mystery about the exquisite kinesthetic pleasure we feel during the course of our acrobatic mountaineering adventures. We know this. The only mystery is that a state of mind and spirit may be attained, as Michael Roberts suggests, which those mountaineers operating in a high-risk environment perceive as having a greater value than their own existence, a perception that borders on the metaphysical. The acceptance of death in mountaineering remains a remarkable psychological conundrum.

Camp II on the Hummingbird Ridge was in a very dangerous location perched on this flat area we had carved out of a cornice.

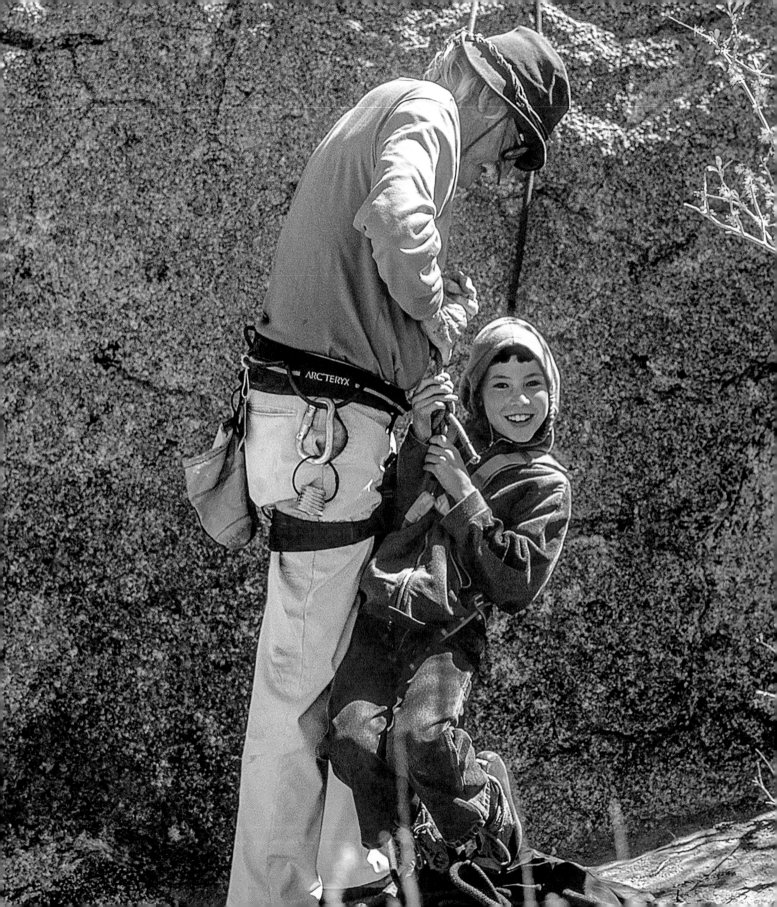

REFLECTIONS

It's been a remarkable journey through my fifty-four years of climbing around the world. I've seen such monumental changes in the climbing scene. When I entered Yosemite Valley for the first time in 1947, the most difficult route yet done was the normal route on Higher Cathedral Spire, rated at 5.9. This would soon change with the successful ascent of the Lost Arrow Chimney in September of that year by John Salathé and Ax Nelson, the first multiday struggle using direct aid yet seen in the Valley. Not a single line had been done on El Capitan, while today this cliff has over a hundred routes. Countless new routes have been done all over the Valley since my first visit. and the top climbers today are engaged in doing enchainments, where several of the hardest climbs are linked in one twenty-four-hour period. Then there are those who specialize in ascending major routes in the shortest possible time. Hans Florine and Alex Honnold accomplished the speed record for the Nose route on El Capitan—an astonishing 2 hours, 23 minutes, 46 seconds—in 2012.

In those early days I learned piton craft using the soft iron pitons available from Sporthaus Schuster in Munich. But this would change dramatically in the late 1950s when Dick Long and Yvon Chouinard began making hard steel pitons and the wider aluminum bong-bongs. Then clean climbing was introduced in the early 1970s and a plethora of chocks of all shapes and sizes came into common use instead of pitons. Climbing was changing slowly but surely before my eyes. And the ultimate shocker came with the invention of the fabulous camming devices known as Friends by Ray Jardine, an aerospace engineer, in 1971.

Belaying and mentoring grandson Michael White, while enjoying a day at the Alabama Hills, California, 2004.
Photo: Andy Selters

Climbing equipment would continually be improved, but what about the perception of climbing in Yosemite and the United States as a whole? When I started in 1946, climbing was little known or understood in America. Compare this to what climbing was like in France at the time, where the French Alpine Club was so vigorous that they easily funded an expedition to make the first ascent of Annapurna in 1950. In Yosemite Valley, climbing was simply tolerated; climbers had to check in with the rangers before attempting a route, and it was clear that they considered us rogues and vagabonds at best. The authorities in Yosemite ultimately went so far as to propose closing the climbers' Camp 4 in 1997. The outcry was intense; volumes of letters came in from around the world asking the Park Service not to oppose climbing but to foster it—even to consider Yosemite climbing a "national treasure." A lawsuit brought by Tom Frost and the American Alpine Club eventually led to the listing of Camp 4 on the National Register of Historic Places, and in recent years, climbing has been considered a valuable activity in the Valley.

As I sit now in my rocking chair in my ninety-first year, drinking an occasional glass of red wine to lessen the ravages of approaching bewilderment, I ponder the meaning of all my adventures. I have tested myself against wind, rain, rock, and snow, and have become a stronger person. Was it worth it? Absolutely, though I would prefer not to be caught in avalanches. I have no regrets. And I'm extremely happy that I no longer have to struggle with these same elements.

One of my most memorable experiences was spending the summer of 1949 in the Dolomites with the Austrian Karl Lugmayer, but my most intense and gratifying mountaineering adventure was the ascent of the Hummingbird Ridge on Mount Logan with Paul Bacon, Frank Coale, John Evans, Dick Long, and Jim Wilson. We were continually troubled by uncertainty, yet managed this lengthy ascent without injury or undue drama—and we were able to return home as friends.

Perhaps many of the readers of this book are beginning climbers. To you I would simply say: Follow your bliss slowly and carefully. Always be sure you have the necessary skills before undertaking your climbing adventures. And make sure your personal and climbing lives are adequately meshed.

Founding member of the "Golden Gathering" on a Joshua Tree classic.

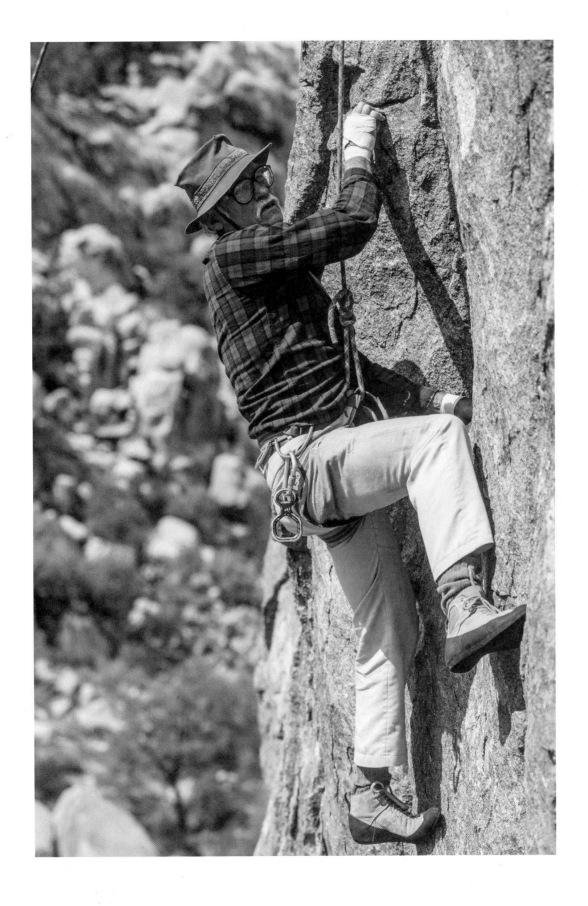

You ask me:
 Why do I live
on this green mountain?
 I smile
 No answer
 My heart serene
On flowing water
 peachblow
 quietly going
 far away
This is
 another earth
 another sky
No likeness
 to that human world below

—Li Po, Tang Dynasty. translated by C.H.
Kwock and Vincent McHugh, *Why I Live on the
Mountain: Thirty Chinese Poems from the Great
Dynasties*, Golden Mountain Press, 1958